Lives and Landscapes

Lives and Landscapes

A Photographic Memoir of Outport Newfoundland and Labrador, 1949–1963

ELMER HARP, JR.

edited and introduced by M.A.P. Renouf
with a contribution by Elaine Groves Harp

McGill-Queen's University Press
Montreal & Kingston • London • Ithaca

© McGill-Queen's University Press 2003
ISBN 978-0-7735-2517-7 (cloth)
ISBN 978-0-7735-3924-2 (paper)

Legal deposit third quarter 2003
Bibliothèque nationale du Québec

Printed in Canada.
Reprinted in paper in 2011.

This book was first published with the help of grants from the Johnson Family Foundation, the International Grenfell Association, the Historic Sites Association of Newfoundland and Labrador, the J.R. Smallwood Foundation for Newfoundland and Labrador Studies, the Memorial University of Newfoundland Publication Subvention Fund, and the Canada Research Chair in North Atlantic Archaeology.

McGill-Queen's University Press acknowledges the support of the Canada Council for the Arts for our publishing program. We also acknowledge the financial support of the Government of Canada through the Canada Book Fund for our publishing activities.

"How Shall I Remember Forteau?" was first published in the July 1962 issue of *Among the Deep Sea Fishers* and was reprinted in the January-April 2001 issue of *Along the Coast*. Permission to reprint was given by the Grenfell Regional Health Services, St Anthony, Newfoundland.

National Library of Canada Cataloguing in Publication

Harp, Elmer
Lives and landscapes: a photographic memoir of outport Newfoundland and Labrador, 1949–1963 / Elmer Harp; edited and introduced by M.A.P. Renouf; with a contribution by Elaine Groves Harp.
Includes bibliographical references and index.
ISBN 978-0-7735-2517-7 (bnd)
ISBN 978-0-7735-3924-2 (pbk)
I. Harbors – Newfoundland and Labrador – History –20th century – Pictorial works.
I. Renouf, Miriam A. Priscilla II. Harp, Elaine Groves III. Title.
HE554.A3H37 2003 387.1'09718 C2003-900296-9

Typeset in Apollo MT 11.5/14.5 and Stone Serif. Book design and typesetting by zijn digital.

Contents

Maps

Acknowledgments

I am very pleased to acknowledge grants-in-aid in 1949, 1950, and 1961 from the Arctic Institute of North America, which supported my first independent scholarly field research. Thereafter I received a substantial grant from the National Museum Foundation, Washington, D.C., covering two more years in the field, 1962–63. Also, in 1949 David Nutt of Hanover, New Hampshire, owner and master of the schooner *Blue Dolphin*, generously offered me and my student assistant free transportation to Newfoundland and back from Woods Hole, Massachusetts. What great voyages they were! Furthermore, I am happy to record here my indebtedness to Nicholas Dean, a student at St Paul's School and a member of the *Blue Dolphin* scientific party, who most kindly lent me an extra camera when mine became clogged with windblown dust; Nick saved the day for us all.

In preparing this manuscript I have had substantial help from two very significant women: my wife Elaine Groves Harp and Professor Priscilla Renouf of Memorial University of Newfoundland, who holds the Canada Research Chair in North Atlantic Archaeology. Aside from her talent as a wordsmith and her insistence on *le mot juste*, Elaine is a friend of commas and occasionally drove me up the wall in search of ultimate precision; however, her efforts did indeed improve my draft copy! For her part, Dr Renouf has contacts with all the right people throughout Newfoundland and the rest of Canada, and her energetic pursuit of their cooperation was invaluable. She willingly tapped into her research resources in order to expedite matters and has largely been responsible for securing additional grants for publication of this book with colour

illustrations. Her introduction to the volume reflects her broad experience in academic affairs and her understanding of social and economic conditions in northern Newfoundland. I believe we have had a most profitable and pleasing collaboration. Dr Renouf in turn has benefited from the assistance of two research assistants – Shane Green and Patty Wells – who helped her with the logistics of this volume. She is also indebted to Joan Ritcey, head, Centre for Newfoundland Studies, Queen Elizabeth II Library, Memorial University of Newfoundland, who generously provided information relating to several topics in this book. Discussions with Joan, Colleen Shea, and Catherine Dempsey helped define the title. Elaine Harp tirelessly collated an index of persons mentioned in the text. Roger Pickavance was a meticulous proofreader.

In this early stage our son Douglas was also very helpful, guiding the manuscript through the complexities of e-mail, across international borders, and within the maze of business connections. I also wish to thank Gary McManus, who drafted the excellent maps, and Thomas F. Nemec, who read and commented on parts of the manuscript.

This entire research project has benefited from the participation of numerous friends, family members, and virtually all of the outport families who befriended me, most of whom are further identified in the following pages. There were also special assistants who worked with me in the field for five summers through rain and shine and blackflies, sharing the adventure and tolerating the discomforts. I commend them all for their dedication and help.

1949 In this first summer my sole aide was Stearns A. Morse, already accepted as a freshman at Dartmouth College

1950 Elaine and Jack Harp

1961 Elaine, Geoffrey, Victoria, and Douglas Harp; Dartmouth students J. Timothy Bissell, Throop Brown, and Steven W. Kimbell; Bernice Northcott, household assistant to Elaine

1962 Ernest S. (Tiger) Burch, Jr, an upperclassman at Princeton; George C. Capelle III, Alan V. Davies, William W. Fitzhugh, Nicholas J. Listorti, and Kenneth E. Sack, all Dartmouth students; Geoffrey Harp, David Ahern of Hanover High School, Bernice Northcott of Port au Choix, and Mary Wells of Brig Bay

1963 William P. Bryant, John P. Cook, Nicholas J. Listorti, Raymond R. Newell, William W. Fitzhugh, and Alan V. Davies, all Dartmouth students; Geoffrey Harp and Jared Milne of Hanover, N.H.; Walter (Bud) Billard, John Gould, Dallas Rumbolt, and Gloria Atkins, all of Port au Choix; Mary Wells was our sterling cook and housemother for a second year, and I am saddened to have to report that she died shortly after our last visit with her in 1997. She contributed much pleasure to our household with her gentle nature and her versatile recipes and baking skills.

I am indebted to the following organizations and foundations for the additional financial support that has made it possible to publish my collection of photographs in colour rather than black and white: the Johnson Family Foundation, the International Grenfell Association, the Historic Sites Association of Newfoundland and Labrador, the J.R. Smallwood Foundation for Newfoundland and Labrador Studies, Memorial University of Newfoundland's Publication Subvention Fund, and the Canada Research Chair in North Atlantic Archaeology.

I would like to thank Joan McGilvray of McGill-Queen's University Press for efficiently coordinating the publication of this book, Carlotta Lemieux for her insightful editorial assistance, Susanne McAdam, McGill-Queen's University Press, for doing a fine job managing book production, and Garet Markvoort for her elegant design.

I again thank all the people on Newfoundland's northern coast, as well as those who live in the straits settlements of southern Labrador, for the ever-present hospitality they offered me and my family, not just in expedition summers but ever since our first acquaintance. Most

particularly I thank the dynamic triumvirate of the former mayor of Port au Choix, Ella Noel, and her associates Deputy Mayor Jenny Northcott and Town Manager Maurice Kelly, who invited us back to Port au Choix for the official opening of the trail out to Phillip's Garden and the unveiling of a bronze plaque at the entrance to the site in 1989, and who were our hosts for several days during the Shrimp Festival. I also extend my warmest thanks to Mayor Agnes Pike of West St Modeste, Labrador – one of the most persistent fundraisers for the colour printing of the photographs – who was our host for special celebrations in her town in 1996.

Elmer Harp, Jr
Hanover, New Hampshire, U.S.A.
February 2002

Editor's Introduction: Newfoundland Outports

One October weekend in 1998 I was travelling along the highway that hugs the west coast of the Great Northern Peninsula of Newfoundland, which also forms the east coast of the Gulf of St Lawrence and the Strait of Belle Isle. The winds gusted almost to hurricane strength, and on Saturday night a barge carrying pulpwood lost its cargo in the rough seas. On Sunday morning the seaward shoulder of the highway was littered with parked pickup trucks, as people scavenged to add to their winter wood supply from logs that had washed ashore. This image epitomizes a way of life that has characterized the inhabitants of both sides of the Strait of Belle Isle since earliest times. It is a life structured by resilience, opportunism, and self-sufficiency, made possible by a broad spectrum of economic activities based on the land, the coast, and the sea. This economic pluralism is eight thousand years old in southern Labrador and five thousand years old on the Great Northern Peninsula, practised by Maritime Archaic Indians and subsequently by Paleo-eskimo, Amerindian, and, most recently, European peoples. It is the way of life that is depicted in this book.

When Newfoundland joined Confederation on 31 March 1949, roughly 250,000 of the new province's 345,000 people were spread out along the lengthy coastline in approximately nine hundred coastal settlements that had populations of a few families up to a few hundred individuals. Most of these communities were not connected by road, and the Great Northern Peninsula and southern Labrador, the focus of this book, were particularly isolated.

These coastal settlements, called outports, embodied life on the small scale. Typically, each community consisted of just a few families represented by less than a half-dozen family names. People in a community were related, and consequently wives were usually from other outports nearby. Although each community was self-contained there was regular contact between them, facilitated by ties of kinship, friendship, and partnership all along the coast. Life took place at the local level and was only indirectly affected by the activities and decisions that emanated from political arenas in St John's, London, and eventually Ottawa. While the citizenry of these cities might have considered the Strait of Belle Isle remote, to those who lived there it was the centre of the world.

That world was a self-sufficient one, based on a multifaceted and largely subsistence economy. Although inshore and nearshore cod fishing was of prime importance, there was also lobster and salmon fishing, moose and caribou hunting, bird hunting, sealing, rabbit snaring, vegetable gardening, berry picking, meat and berry bottling, making jams and preserves, and storing vegetables for the winter in root cellars. Spruce, fir, and birch were cut for firewood and milled for lumber. In addition there was regular and part-time wage work, usually lumbering in the fall (after the fishing season ended) and, after Confederation, road and other construction work. Wage labour often involved temporarily moving to a town or camp, or even to the mainland.

A fisherman built his own boat, wharf, sheds, house and root cellar. He kept all this in repair, as well as his fishing gear and his boat engine if he could afford one. After the introduction of cars and bombardiers, he built add-ons, such as cabs and trailers, and repaired these as well. Although almost every man could do all these tasks, family and friends invariably helped, maintaining the balance of mutual obligations that structured much outport activity. Women were an essential part of fish processing, and their domain included gardening, caring for livestock, preparing and preserving food, and running the family.

After Confederation, small amounts of cash came in the form of family allowances, old age pensions, unemployment insurance benefits,

and welfare. As late as 1969 the average monetary income per family was around $3000; however, provisioning off the land, owning your own house, and heating it with wood cut by the family meant that the standard of living was higher than could ever be reflected in a strict cash count.

The fishing crew embodied a pivotal set of social relations in the community. The fishing enterprise was a family affair, and the fishing crew, sometimes a fishing company, usually consisted of two or three generations of males from one extended family. Brothers fished together with their sons, and with their father if he was able. The two older generations had a full share of the fishing company, while the youngest had a half-share only. When the grandsons were old enough to warrant a full share in return for their labour, the fathers split into their own crews, which then consisted of fathers and sons fishing together, each with an equal share. Wives were part of the fishing company, although they had no share, and they and the children processed, or made, the "fish" (lightly salted, sun-dried cod) on shore.

The fishing crew had a company account with the merchant. This account was the indirect link between the fisherman and the international economy which structured the price of fish. On the company account each shareholder exchanged fish for necessities, and if the value of the fish was insufficient to cover these goods, the merchant extended credit, to be paid back with the next year's fish. The price of fish was always low and the cost of supplies always high, so there was rarely any cash remaining; only credit.

Since the merchant set both the price of the fish he bought and the price of the goods he sold, he usually made a healthy profit from the fisherman. The merchant-fisherman relationship is often portrayed as purely exploitive, the merchant exerting power over the fisherman, who was then locked into this "truck system." However, the relationship was far more complex, for the merchant was a member of the community, and as such he was bound by the rules of acceptable behaviour. While he extended credit to the fisherman and was entitled to a return, to

ensure reimbursement he had to be a good and honourable man who did not press his client for repayment. The merchant was part of a delicate balance of mutual obligations and, like any Polynesian Big Man, his status and accumulation of wealth was contained within the limits of other people's tolerance.

This evolution of fishing crews in a community was etched onto the ground in a parallel evolution of "gardens." A family owned a garden, which included a bit of shore that contained fish sheds, wharves, flakes, and an area of land on which the family house stood. While the father worked with his sons on a fishing crew, they all lived in the same garden – in the same house or, if the sons were married, in different houses. When the crews fissioned, the gardens also segmented, often demarcated by fences, and new wharf facilities were built. However, no matter how segmented the original garden became over time, it still carried the original family name.

Houses occurred in clusters, reflecting the importance of familial and community social relations. They were located within access of the sea, where each crew had its sheds and stages. The community and its surroundings were communal property, whereas "owned" areas were the fenced-off gardens (including houses, stables, sheds, and vegetable gardens) and hay fields – in other words, anywhere that was invested with time and effort. Although legal ownership was unusual, adults knew who owned what and rarely overstepped the boundaries. However, "owned" did not mean private; the only private places were in the house, and they were limited to the bedrooms and outhouse, the latter eventually replaced by the indoor bathroom. The parlour was an official place, and the kitchen and porch were the interface between public and private.

Outport life took place in public. In a small community everyone knew everyone else, and anyone could enter any kitchen, although women were often too busy to visit, sending their children as silent emissaries. Visitors came in without knocking and sat down. Only strangers knocked on the door, or persons acting as strangers – for

instance, when collecting for charity or disguising themselves as Christmas mummers.

Although the outport was a permanent location to which specific families were tied, people often practised a kind of transhumance, moving between seasons. Commonly, families would move to a winter settlement a short distance inland, where they could be in the protection of the woods and at the same time close to the winter supply of fuel. During the summer, families from one outport would move to another location along the coast or on an island, from which there was better access to the summer fishing grounds. Some families "went on the Labrador" for the fall cod fishery, to specific places to which rights of use were inherited through the male line. This population mobility is perhaps best epitomized by the readiness with which people would move a house from one location or community to another.

This way of life meant that the people had the flexibility to respond to anticipated and unexpected changes in the environment. In turn, this resilience was made possible by occupational pluralism, population mobility, and a network of mutual support and obligations that bound people together into a self-reliant community.

This was the world to which Elmer Harp, Jr, a doctoral candidate from Harvard University, travelled in 1949. In June of that year he embarked by Bluenose schooner on an archaeological survey of the Strait of Belle Isle. He arrived at his destination seven days out of Woods Hole, Massachusetts, and less than three months after Newfoundland joined Canada. At the same time as he recorded evidence of prehistoric campsites on the landscape, he chronicled by diary and photographs the contemporary outports and the people who lived in them. That first summer Harp and one assistant sailed by schooner, mailboat, and coastal steamer along the southern Labrador coast, around the tip of the Great Northern Peninsula, and down its west coast as far south as Corner Brook.

In 1950 Harp returned to Newfoundland, this time with his wife Elaine and their eldest son, Jack. They drove to North Sydney, Nova

Scotia, where their car was hoisted onto the small ferry, the SS *Burgeo*. When they arrived at what was then the small community of Port aux Basques, their car was transferred from the ferry to an open flatcar, and the narrow-gauge railway known as the Newfie Bullet took them, car and all, to Corner Brook. After spending two weeks travelling around this region they left their car at the end of the road, at Norris Point in what is today Gros Morne National Park, and continued the northward journey by coastal steamer.

In 1961 Harp returned to Port au Choix, with PH D in hand, as a faculty member of Dartmouth College; with him were three Dartmouth undergraduates as well as Elaine and three of their four children. Harp planned to excavate the large 2000-year-old Dorset Paleoeskimo site, Phillip's Garden. His photographs show that a great deal had changed in the intervening eleven years, starting with the modern car ferry that took him and his crew from North Sydney to Port aux Basques. The road was paved for fifteen miles out of Port aux Basques, after which it reverted to gravel as far as Corner Brook. North of there, the coastal highway was just under construction and extended only to the Port au Choix junction, beyond which they could see the heavy machinery clearing the roadbed. Harp returned to the area in 1962 and 1963, continuing his excavations as well as his documentation of both prehistoric and contemporary life on the Strait of Belle Isle.

Times have changed since then. Route 430 connects all the communities along the west coast of the Great Northern Peninsula; the shorter paved road connecting a few communities on the Labrador side is currently being extended, and a seasonal ferry service links both sides of the strait. Many of the outports were abandoned in the 1950s and 1960s during the federal-provincial government resettlement programs, and of those that remained some became "growth centres" while others declined. Most of the old houses have been torn down and replaced by modern homes, and the landscape is dominated by cars, trucks, snowmobiles, and all-terrain vehicles, not to mention satellite dishes. In the growth centres there are large and modern hospitals and schools, chain

supermarkets, and government wharves; Port au Choix has one of the largest shrimp-processing plants in Atlantic Canada. Nevertheless, beneath the surface of material change, these communities are much the same as when Harp visited them. They are still small enough to run on a face-to-face basis, and each community is still dominated by just a few family names. People still join together to build a house or repair a boat. They maintain their cabins in the woods, though nowadays it is just a recreational retreat, and increasingly sons and daughters must go to mainland Canada to work for the winter, although many times it is for good. Wild food still takes up plenty of space in the freezer and, bottled, on pantry shelves, and wood still heats many homes. So when a bargeload of pulpwood washes ashore, people are ready, like generations before them, to seize what has been made available by a change in the winds.

M.A.P. Renouf
St John's, Newfoundland
30 October 2001

Lives and Landscapes

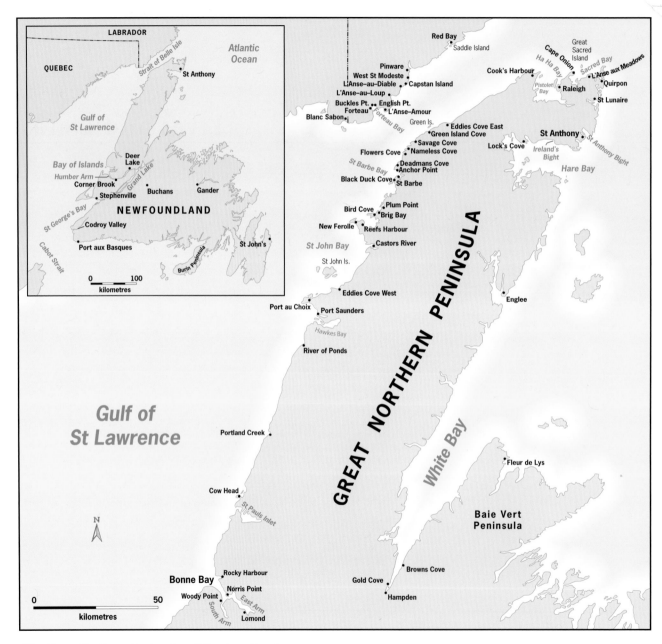

The Great Northern Peninsula of Newfoundland

Part One: 1949

A dim smudge of shoreline loomed out of the night mists off the starboard bow and slowly thickened into the black shape of Cape Ray, the southwestern tip of the Island of Newfoundland. The schooner *Blue Dolphin* slid through the gentle swells and maintained her northwesterly course across Cabot Strait, past the cape, and into the Gulf of St Lawrence while a dozen seagulls emerged from the fog to squawk and soar watchfully above our wake. Such was my first view of Newfoundland on a fine morning late in June, 1949. It was not the most spectacular scenery I had ever seen, but as a Yankee outlander I was fascinated nonetheless by this strange new country protruding into the Atlantic Ocean as the easternmost extremity of North America.

One hundred miles to the north of us on the west coast was a major industrial town, Corner Brook in the Bay of Islands, home to the largest paper mill in the world; some three hundred miles to the east the island capital, St John's, lay in its deep protected harbour, which had sheltered European fishing vessels for the last five centuries. Between these two primary settlements lay a wilderness of subarctic barrens and coniferous forest inhabited mainly by moose, bears, and woodland caribou. In the myriad coves and larger embayments around the island's peri-meter a scattering of small fishing villages clung to the rocky coastline. I had come here to explore for archaeological sites, places where the aboriginal Indian and Eskimo inhabitants had camped and hunted several thousand years before the coming of the earliest Europeans, and at this moment of personal discovery I was moved by a silent excitement that seemed to radiate from the dark, unknown land.

Crossing the Gulf of Maine under canvas, with Tony Morse, my archaeological assistant, standing informal bow watch. Fortunately, the voyage north was tranquil, so the few landlubbers were able to acquire their sea legs gradually.

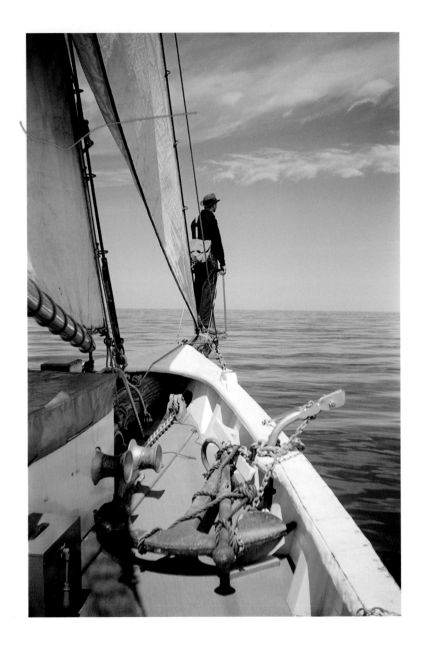

We approached southern Labrador on the seventh day out, 25 June, and headed into the ice pack, which had drifted through the Strait of Belle Isle in the Labrador Current. Lookouts were doubled; here David Nutt and first mate Reggie Wilcox are keeping watch in the foreshrouds.

Commenting on the tidal currents in the Strait of Belle Isle, The Labrador and Hudson Bay Pilot *states: "Off Forteau and Amour Points the streams are strong and very irregular, occasionally running in one direction at a rate of from 4 to 5 knots close to the shore, and in an opposite direction a short distance offshore"* (1965, 29).

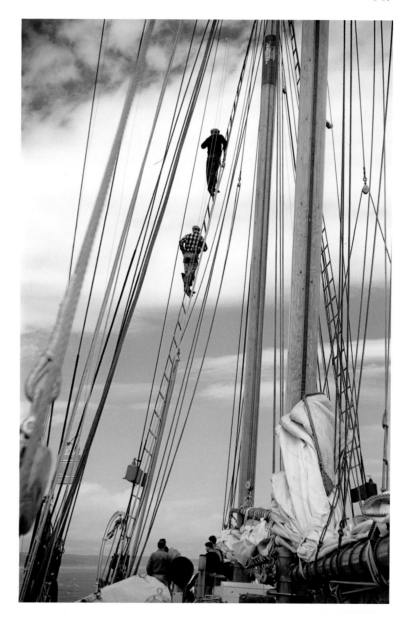

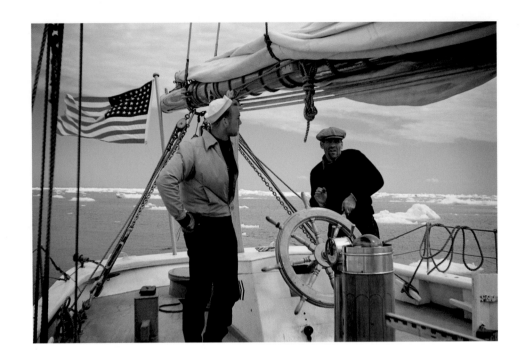

Easing through the ice into Forteau Bay, Labrador, with Reggie Wilcox at the helm and Ted Stahl standing by. Point Amour, at the eastern extremity of Forteau Bay, marks the narrows of the Strait of Belle Isle and lies slightly more than nine miles across from Flowers Cove, Newfoundland.

For the remainder of that day we coasted northward past the rising summits of the Long Range Mountains, heaving to for an hour outside the Bay of Islands to jig for cod and take samples of the offshore waters for measurements of salinity and temperature. Later, with darkness coming, the schooner eased out into the Gulf of St Lawrence to cruise at a safer distance from the lee shore, and by dawn we were in the approaches to the Strait of Belle Isle. Several miles ahead to port was the coast of Labrador, separated from us by a scattering of icebergs drifting southwestward in the offshore current. The weather was calm and beautiful, but as our vessel nosed into the strait — one of the most feared ships' graveyards in the world — the deck watch maintained a constant alert. The tidal rips and currents that sweep through this constricted channel are fast and changeable; the shorelines are studded with reefs, safe harbours are scarce, and dense fogs can blot out all visibility in

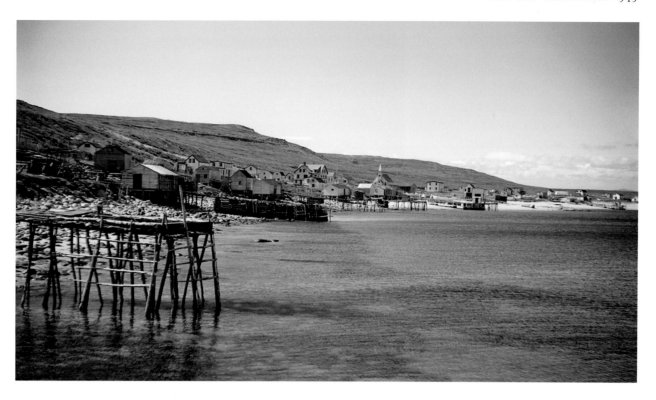

*Forteau, Labrador, our first anchorage in
the province of Newfoundland*

The fishing rooms and flakes of Forteau. The Blue Dolphin *lies at anchor in the bay, and beyond her is the ice-clogged Strait of Belle Isle. In the old days the work sheds and buildings associated with the docks, or landings, were known as rooms. In these shelters a fisherman could split and salt down his catch, store his nets and lines, and so on. The flakes were raised wooden platforms on which split cod or caplin could be spread out to dry.*

minutes. Forteau Bay, on the Labrador side of the narrows, is the best roadstead in the strait because it offers good summer anchorage for fishing vessels. So with lookouts doubled in the forward ratlines and first mate Reggie Wilcox at the helm, the skipper conned us through the ice into the safe haven of Forteau Bay. It was our seventh day out of Woods Hole, Massachusetts, and our first anchorage in Canada's newest province, Newfoundland.

The *Blue Dolphin* had been built in Shelburne, Nova Scotia, according to the hull specifications of a Bluenose fishing schooner, and at this time she was owned and captained by David C. Nutt of Hanover, New Hampshire. Dave was a research associate in geography at Dartmouth College, and he was now beginning a program of oceanographic research along the Labrador coast, using his vessel as a maritime laboratory for groups of students from Dartmouth College and elsewhere. In plan-

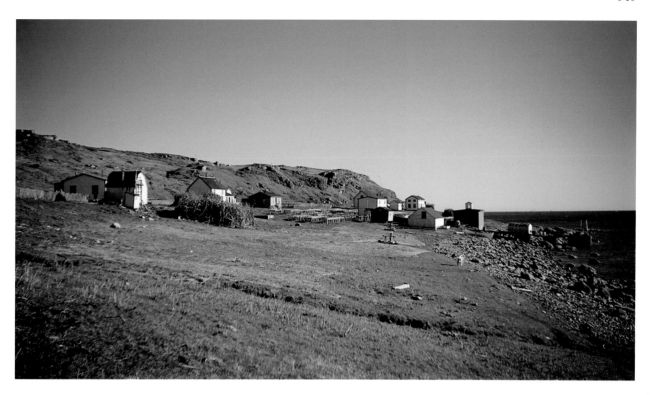

L'Anse-Amour, the small settlement nestled in the lee of Point Amour at the eastern end of Forteau Bay, seems to have been less desirable as a living place than the larger village along the western shore. It fronts on a small bay that is sheltered from the easterly winds of the strait, and on old sailing charts it is identified as L'Anse aux Morts.

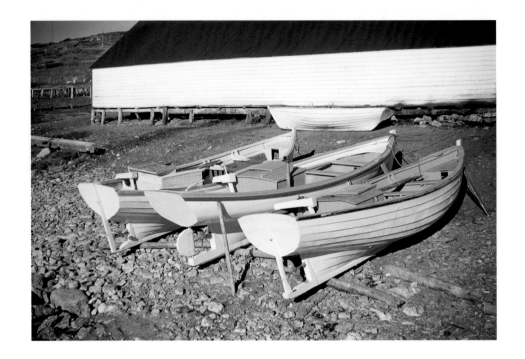

These boats at Point Amour were typical of the homemade craft found in all Newfoundland outports.

ning this first expedition, he had offered free passage aboard the *Blue Dolphin* for me and my student assistant, to and from our field area, and my initial idea was to leave the vessel in early July in St Anthony, Newfoundland, and rejoin it in Corner Brook at the end of the summer. Dave's welcome invitation eliminated a large travel-cost item from my budget, and my modest research grant from the Arctic Institute of North America could thus be spread further on other necessities. My summer assistant was Stearns (Tony) Morse, a young native of Hanover, who had already been accepted as a member of the class of 1953 at Dartmouth. We had both looked forward to a pleasant voyage from Woods Hole to Newfoundland and back in the company of college friends and colleagues, and now here we were at last, temporarily home from the sea and anchored in L'Anse-Amour, Forteau Bay, Labrador. On early sailing charts this bay was named L'Anse aux Morts, probably because there is

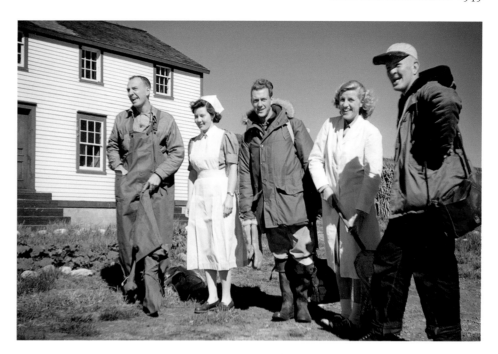

At the Grenfell Nursing Station, Forteau Bay. Left to right: *Tony Susen, MD, ship's doctor; Iris Mitchener, nurse-in-charge, Grenfell Nursing Station; Gifford Beaton, geographer, ship's company; Ann Thompson from Wellesley College, WOP assistant to Iris Mitchener; Nicholas Dean from St Paul's School, assistant to ship's company.*

an old burial ground behind the beach, and many shipwrecks have occurred nearby on the outer coast.

Our welcome from the shore was immediate and enthusiastic. Word of our coming had somehow reached Iris Mitchener, nurse-in-charge of the Grenfell Nursing Station in Forteau, and she and her assistants, as well as a small group of people from the village, were at the landing to greet us. At that time, except for a few college students known as WOPS, or "workers without pay," who came as summer volunteers at the Grenfell Mission, people from the outside world were extremely rare on the Labrador coast. So our minor invasion from the *Blue Dolphin* was a major event as we climbed up from our longboat onto the wharf and were immediately submerged in the growing crowd of local inhabitants.

Now I began to experience at first hand the warm hospitality and enthusiastic curiosity of Newfoundlanders, particular these people

Iris Mitchener, nurse-in-charge at the Grenfell Nursing Station in Forteau Bay

from an isolated outpost on the Labrador coast of the Strait of Belle Isle. I learned that some of their ancestors, mainly from the British Isles, had sought shelter in these bays generations ago, and that these present-day descendants were known as livyers in order to distinguish them from other, seasonal fishermen who visited Labrador only in summer. These livyers were universally enthused about social contact with the outside world because, by popular referendum, Newfoundland had joined Canada at the end of March 1949, becoming its tenth province, and many people hoped for substantial benefits from this new federalism. The shore party I was with was invited to stay overnight at the station, and some of them danced the night away, while others crawled into sleeping bags on the living-room floor and tried vainly to nap.

The following morning, after this somewhat raucous night, Tony and I set off to explore the northwestern end of the bay. We could see areas of sand barrens across the neck of Buckle Point as well as farther inland around the mouth of Forteau Brook, and I knew these duned areas would be an excellent starting ground for our quest. We followed a simple, basic precept for archaeological research in any strange, unknown country: if there are no superficial human or cultural remains immediately visible, one must look for ruptures in the natural ground cover, perhaps where foot trails have worn through the sod or ground moss, or where trees have been uprooted in storms, or where streams have eroded cut banks. Often these subsoil exposures will contain signs of flint-chipping industry or charcoal and hearth remains. This reasoning led us to the discovery of five different prehistoric occupation sites around the periphery of Forteau Bay, the first of them in the sand barrens of Buckle Point. The deep, wind-scoured hollows there were liberally sprinkled with flint chips and fragments of flaked stone tools and weapons, such as arrowheads, knives, and hide scrapers, most of which were readily identifiable with Archaic Indian culture.[†] The largest of these open sites lay behind L'Anse-Amour, covering an estimated 75–100 acres, and we could trace through the soil profiles in these blowouts two major terraces that were remnants of prehistoric beachlines. Most of the archaeo-

[†] *"Archaic Indian culture" refers to the prehistoric Amerindian people who lived in Newfoundland and Labrador from 8000 to 3500 years ago.*

logical finds came from the higher of these terraces, which was now forty feet above sea level.

Wherever we hiked that morning, as well as in subsequent days, we were trailed or accompanied by a variable male entourage. The curiosity of the men and boys seemed endless, but while they listened attentively to my brief explanations, they stood quietly at a respectful distance and did not ask any questions. The women never came with the men on these excursions, nor did they ever visit one of our camps for tea or coffee, as the men frequently did. Despite their wish to be friends, I soon realized that most of these local people did not understand or appreciate the significance of the archaeological remains beneath their feet. However, each summer that I was on the coast, some local man would visit our camp and after a discreet interval would draw from his pocket a peculiar stone that had turned up in his potato garden, and ask me to identify it. This specimen was often a perfectly formed stone artifact, such as a flaked spear or harpoon point, or perhaps a ground and polished stone gouge. In two instances we discovered major Archaic sites exposed directly in the middle of overland paths that were used on a daily basis. The livyers' frequent footsteps had worn away the thin surface vegetation, and they had tramped unwittingly through rich deposits of flint flakes, broken points, or knives.

Thus, in a general sense, I was indebted to all the folk in these outport communities, past and present. The European pioneers had chosen to settle in these sheltered bays for the safety of their onshore settlements, and it was only in these same valleys that coniferous forests could be found. However, within several generations, the new settlers had cut down all the forests for fuel and building materials, and the deltaic deposits of sand around the river mouths lay exposed to the sharp drainage winds that alternated back and forth between the icy strait waters and the warmer land. These barren riverine deposits were then transformed gradually into shifting dunefields, a process of aeolian erosion that has vitally shaped coastal lands throughout all time to this very day. Thus people's economic predation was followed by some ill

A cross-section of the sand dunes behind L'Anse-Amour in the northeastern part of Forteau Bay. The several bands of dark humus indicate previous land surfaces that were subsequently buried under wind-blown sand. For the archaeologist they may represent earlier occupation horizons. In this case, the thick black band is a remnant of the land surface that was occupied by prehistoric Indians. It contains fragments of their flaked stone tools.

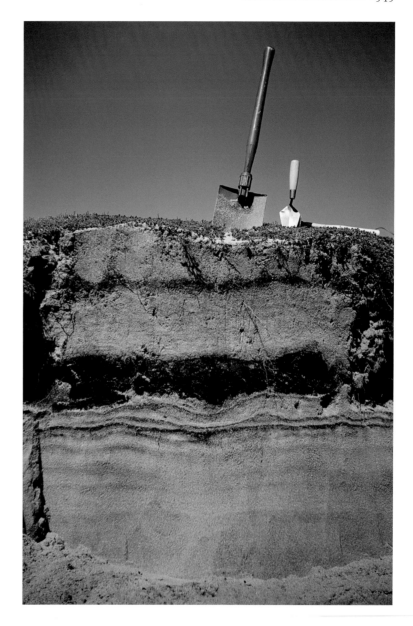

winds that blew to the ultimate good of archaeological research in Newfoundland.

These same topographical characteristics were repeated farther afield on the Labrador side of the strait as we explored west of Forteau around Blanc Sablon, Quebec, and to the north in L'Anse-au-Loup. In both locales we discovered more Archaic Indian sites on similar raised beachlines, 20–40 feet above present sea-level. Loup 2, the second in the sequence of sites we found at L'Anse-au-Loup, was a large stone tool workshop area situated on a terrace 105 feet above sea level. The main blowout there was covered with literally thousands of quartzite scrap flakes, and scattered among them were many broken points and hand axes, as well as partially finished biface blades, or blanks. This site with its broad outlook over the strait undoubtedly served also as an excellent vantage point for native seal hunters. Furthermore, as a modern traveller on the coast, I could testify to still another advantage: this high point above the sea would have been windy on most warm days and consequently relatively free of the swarms of blackflies that can make life miserable a short distance inland.

By 1 July the *Blue Dolphin* had proceeded north to Red Bay where we anchored in sheltered waters in the lee of Saddle Island. Oceanographic observations proceeded there while Tony and I scouted the mainland shore behind the small settlement. We found nothing in the brief time available to us, but our limited survey of the Labrador side of the strait convinced me that further exploration was definitely merited, and I decided to return there later in the summer.

As it turned out, Red Bay contained far more archaeological potential than I had known. In the late 1970s, some thirty years after my first visit there, the remains of a Basque whaling station were found on Saddle Island, a discovery that derived from archival research in Spain by the historical geographer Dr Selma Barkham. For several years afterwards, teams from Memorial University of Newfoundland and Parks Canada excavated twenty fat-rendering stations on Saddle Island and the mainland, as well as three sunken vessels and a cemetery that con-

tained more than 140 skeletons of whalers who had operated from this base. After these investigations, Red Bay was recognized as a major centre of whaling in the period AD 1550–1600.[†]

Leaving Labrador, we sailed east in clear weather across the strait, rounded Cape Bauld at the tip of the Great Northern Peninsula, and thence had a short run of about twenty-five miles south to St Anthony Bight. This deep and beautiful bay affords the best harbour in northwestern Newfoundland, and it proved long ago to be an excellent central location for the headquarters of Sir Wilfred Grenfell's medical mission. The main buildings of the settlement were widely dispersed along the southern shore of the bight: a large wharf with substantial cargo-handling facilities, a major warehouse, and next to that a dry dock where a two-masted schooner was being overhauled at the time of our arrival. This vessel sailed under the command of the Newfoundland Constabulary, the provincial police force, and at that time it was scheduled to transport District Magistrate Wade on his trial circuit around the northwestern outports.

A gravel road skirted the edge of the harbour, and other mission buildings were located along it, including a cooperative store and more storage sheds. Up on the hillside and well back from the water stood the hospital, a rather stark, blocky four-storey structure that looked serviceable and efficient. Off to the east, on a barren height, was the children's home and orphanage. None of these buildings were architecturally beautiful or appealing on the outside, but I soon learned that they were superbly functional inside and had a worldwide reputation for the miraculous medical help which their founder and his professional staff had brought to the people of the outports over many years.

After docking and arranging for watering and refuelling, we were met by Horace MacNeil, assistant superintendent of the station, and his official party, and were led up the hill to the residence of Dr Charles Curtis, the chief executive officer and superintendent of the entire Grenfell Mission establishment. Dr Curtis, a Yankee physician, had come north as a young man to join Dr Grenfell, and he had later succeeded to com-

[†] *See Tuck and Grenier,* Red Bay, Labrador.

The harbour of St Anthony, with its dry dock, is the major maritime facility in northwestern Newfoundland and the Strait of Belle Isle. St Anthony is also the world headquarters of the International Grenfell Association, and for some years during the cold war it was a station on the mid-Canada early-warning line.

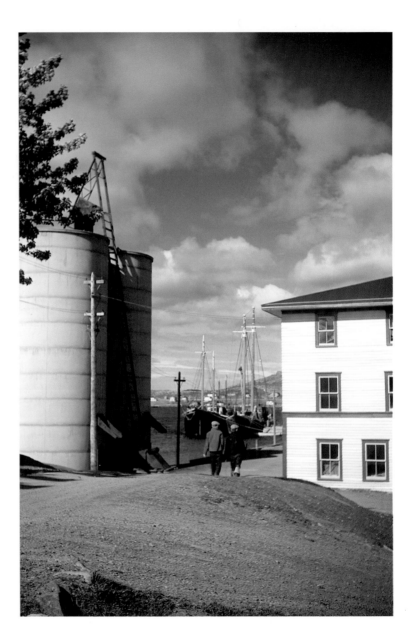

mand of the mission and its far-flung field operations in Labrador. He and Mrs Curtis bade us a very warm welcome and cordially offered any assistance we might need. The next day the doctor conducted several of us through the busy, fully occupied hospital, where we saw evidence of some of the marvellous surgical and medical healing accomplished by the mission.

After I coordinated plans with David Nutt to meet the ship in Corner Brook at the end of August, our gear was hauled ashore to a boarding house, and the *Blue Dolphin* sailed away to continue its program of oceanographic research in northern Labrador. The next day, 9 July, we loaded aboard an open fishing boat and were taken, together with the weekly mail, south into Hare Bay.

During a week's stay there we set up two camps, an eastern one in Ireland Bight near the mouth of the bay, and the other to the west in Lock's Cove, but the local terrain was heavily bushed in and yielded very little of archaeological interest. Levi Dawe and Levi Reid of Ireland Bight gave me large biface chipped blades of Archaic origin, found in their house gardens, but our search there was not productive. However, Ireland Bight was a memorable and charming exemplar of the northern outports of that time: small and compact, nestled in a southern exposure under protecting bluffs, with colourful houses set close together among fenced-in gardens and fish flakes.

Because all of the available flat ground was occupied, we had to settle for a less than suitable sloping campsite on the western outskirts of the village. To the east, the settlement was bounded by a sparkling trout stream, where I had a late afternoon session of superb fly fishing, though I was fairly well chewed up by blackflies because I had forgotten my insect repellent! I vividly remember that little village, so geographically and peacefully remote from the outside world. While we were camped there the police schooner arrived with Magistrate Wade, who spent a day or two ashore on his judicial business while the schooner lay anchored at a safe distance from a stranded iceberg. Forty years later, in 1989, I returned with my wife to St Anthony and was

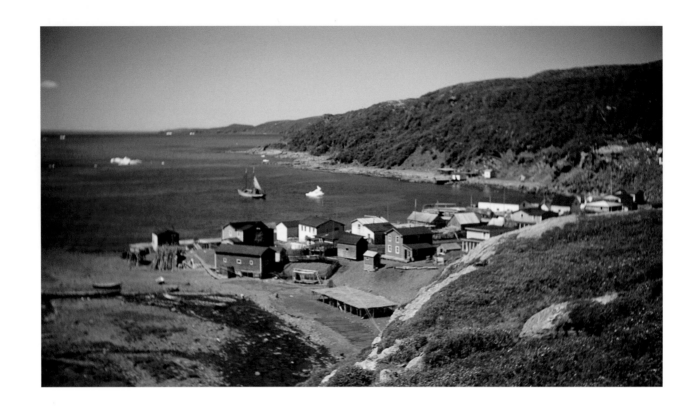

The entire settlement of Ireland Bight was nestled in this beautiful cove, and for me it was undoubtedly the most charming of all the outports that I have seen in Newfoundland.

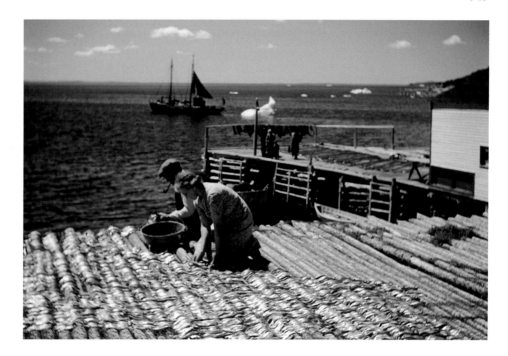

A family couple spreading caplin on one of the large flakes at Ireland Bight. Note the loose floor construction of the flake, allowing for ventilation from beneath, compared with the tight deck planking of a conventional deck. Caplin is a small fish of the smelt family that spawns in warm shallow water along sandy beaches in the early summer. It is netted and seined by the boatload at such times, then air-dried for use as food and fish bait.

greatly looking forward to revisiting Ireland Bight to show her this magical place, but to my sorrow I learned that it no longer existed. Its young people had left to pursue more modern lives elsewhere, and for several years it had been an abandoned ghost village.

So after a largely unprofitable but thoroughly pleasant week in Hare Bay, we returned with the outgoing mail to St Anthony to await the coming of the coastal steamer. The SS *Northern Ranger* docked there on an irregular schedule, either westbound from St John's to southern Labrador and Corner Brook or eastbound on the reverse circuit. Usually that service was supplemented in the opposite direction by the SS *Springdale* or MV *Clarenville*. During the months of ice-free navigation these steamer routes were the chief means of communication and shipment of goods among the northern outports, supplemented of course by

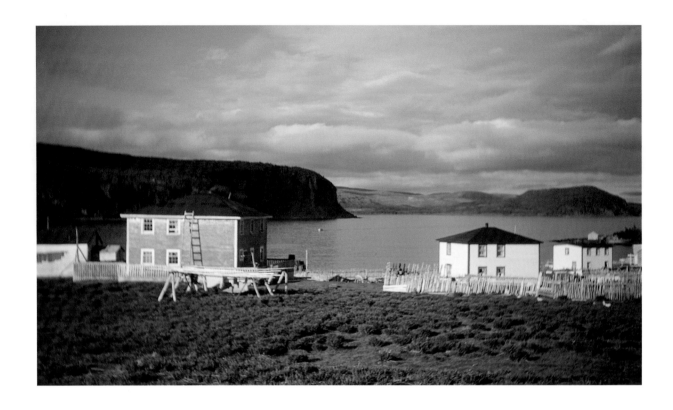

*The very small settlement of Lock's Cove
in the northwest bottom of Hare Bay was
apparently an extended family grouping.
Even this miniature settlement shows the
standard physical character of the
outports: situated close to the sea and a
satisfactory boat anchorage; square-built,
two-storey clapboard houses with
low-pitched roofs, painted white or
occasionally a bright colour; and fenced-in
yards and gardens for protection against
free-grazing sheep, horses, and the
odd cow.*

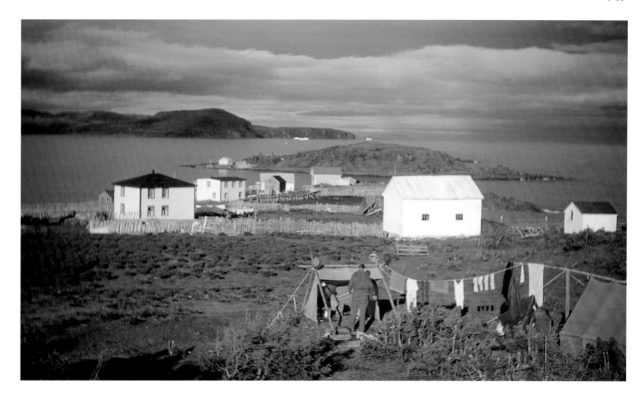

At this time Lock's Cove could boast of a nearby camp inhabited by two strange American archaeologists. The residents Lot and Rachel Elliott were most cordial and helpful, touring me around in the western portion of Hare Bay and pointing out potential sites. John le Maire also was very friendly. He was a Frenchman from St Malo, who as a teenager had been pressed into the fishing fleet. He had jumped ship in the Strait of Belle Isle and thereafter lived happily in Newfoundland. We had some fine talk together.

*The steamer wharf at Cook's
Harbour*

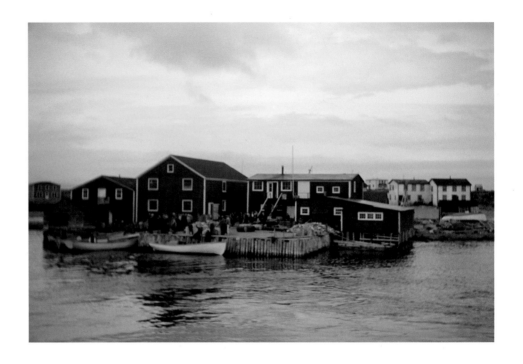

† Doyle's Bulletin *was a
Newfoundland radio program,
1932–66, which broadcast news
and public service announcements,
including provincial shipping
traffic.*

the open motorboats of local fishermen. Otherwise, one travelled on foot
or by dog team, as there were not yet any roads.

The movements of these coastal ships were broadcast on *Doyle's
Bulletin*† every evening, and each household quieted down religiously as
the message crackled through on the battery-powered radio. Fortun-
ately, I had been warned that midsummer was peak travel time
among the outports, for tourists as well as local people, so I had reserved
a cabin on the *Northern Ranger* for two nights. After passenger and
freight stops in Raleigh and Cook's Harbour, the *Ranger* crossed the Strait
of Belle Isle to Cape Charles, where we eased past a large iceberg that
had grounded in the entrance to the harbour. It was an entertaining,
boisterous voyage, as the vacationers partied around the clock. Final-
ly, after stops in Red Bay and Pinware River, the *Ranger* anchored

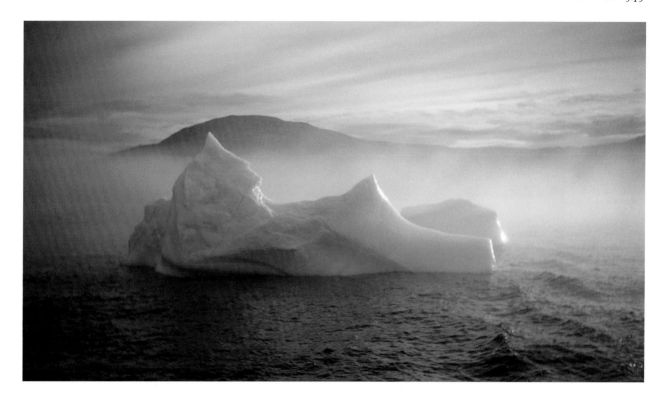

Stranded iceberg in the entrance to Cape Charles harbour, near the northern approach to the Strait of Belle Isle. Belle Isle itself, in the entrance to the strait, is one of the main hazards to navigation in these waters. The U.S. Hydrographic Office Chart N 0924 ("North and East Coasts of Newfoundland and the Strait of Belle Isle") states that at the southern tip of Belle Isle there is a "depot of provisions for shipwrecked mariners."

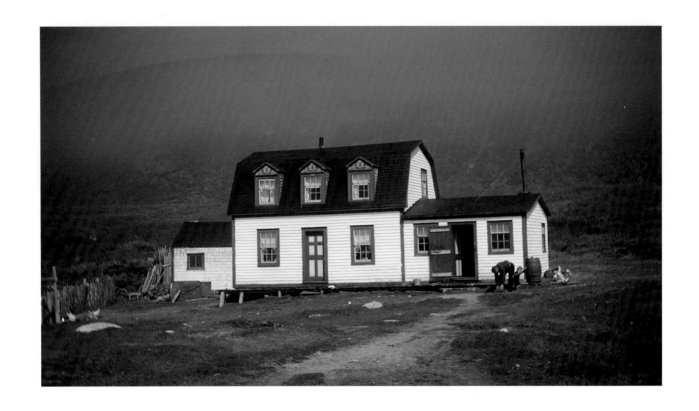

This beautiful small house on Capstan Island was built in 1932 by Ambrose Buckle for the Fred Fowler family. Note the brightly painted gables on the second-storey dormer windows, a most unusual feature.

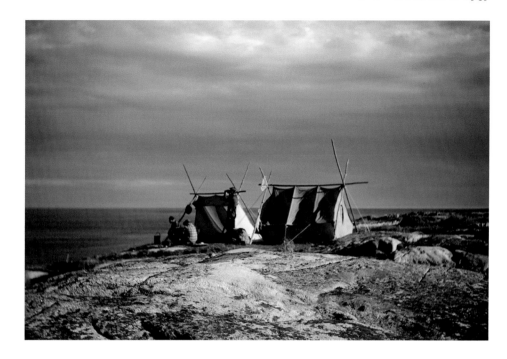

Our camp at West St Modeste was on the bluff about fifty feet above and directly behind the village. The view over the strait was gorgeous, and on a clear day we could see the low Newfoundland shoreline some thirteen miles to the southeast. A constant breeze kept the blackflies under control.

off West St Modeste, and Tony and I were ferried ashore to the village on the mainland, behind a sheltering island.

Our camp on the bluff above West St Modeste gave us easy hiking access to a dozen miles of coastline between Pinware River and L'Anse-au-Diable. This section of shoreline was backed by four-hundred-foot cliffs of banded red sandstone, pierced every few miles by streams with large sandy deltas. We could trace some of the buried turf horizons through the dunes and blowouts from one valley to the next, and we found numerous archaeological sites all along the seafront. Further, all of them produced evidence of Archaic Indian culture dating back into prehistoric centuries. From our campsite on top of the bluff at West St Modeste we had a perfect view across the strait, and in clear weather we could easily see the low-lying Newfoundland coast some thirteen miles to the southeast. Below the steep drop directly in front of the camp was

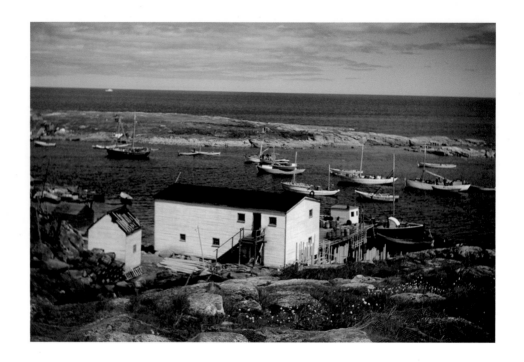

a fish-packing plant, operated by the Organ family of St John's; also there was the household of Mike Pike, who became my good friend and mentor during our stay. Offshore a mere four hundred feet from Pike's dock lay St Modeste Island with its lighthouse. The channel separating it from the mainland is one of the rare protected small-boat anchorages in the strait. This narrow stretch of navigable water, open at both ends, is called the tickle, which is the Newfoundlander's generic term for all such constricted waterways. On Sunday morning we watched it fill with fishing boats as families came from up and down the coast to anchor there and attend church.

We seemed to perch in splendid isolation on our eminence above the strait, though in fact we were immersed in an encompassing social environment. Every evening during our stay four or five men and boys from the settlement would climb the bluff and sit in a circle around our camp-

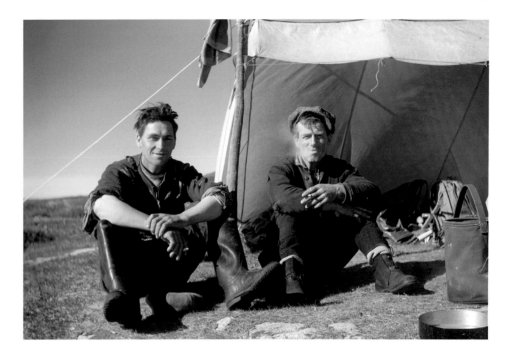

Two men from below visited our camp regularly and we became good friends: Mike Pike (left) *and Jack O'Dell* (right).

fire. Nobody spoke to Tony or me after our initial greeting, but the watchers would enjoy a cup of tea and a biscuit while they closely observed every move we made and commented in soft voices among themselves about my field equipment. I believe they enjoyed our silent bond of friendship as much as we did. Two other men were regular visitors: Mike Pike from down below and Jack O'Dell from the west end of the settlement. When Tony and I crawled out of the sleeping tent around seven in the morning of our first day at West St Modeste, there were Mike and Jack hunkered down quietly by the cold fireplace waiting patiently for me to get breakfast started. I told them about the archaeological survey we were conducting, confident that they would spread the message through the village, which they did shortly thereafter. Two nights later David Bulger, a neighbour of Jack O'Dell's, arrived in camp with a small parcel of pottery fragments as a gift for me to take home.

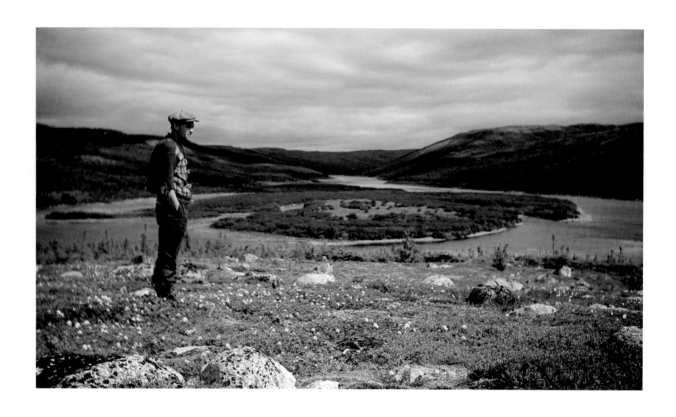

View over the mouth of the Pinware River

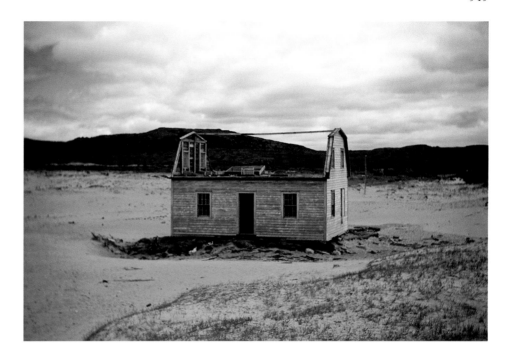

Several of the main rivers flowing from the Labrador interior built up extensive sand deltas and, with the recent postglacial upwarping of the coast, have emerged as great sand flats. Obviously, as in the case of this house at Pinware River, it is not wise to build on such unstable surfaces. When the vegetative cover is ruptured, the strong coastal winds begin to erode the underlying sands, carrying the material away to peripheral dunes.

He described how his grandfather had salvaged them from the vessel *City of Toronto*, which had been wrecked in the strait back around 1860, and he apologetically hoped that I could repair the breakage. Mr Bulger refused to accept any money, but he was glad to take the three packs of Camels that I offered him. The reconstruction now sits in my study – a handsome pint-sized, brown ceramic flask modelled to resemble a Beau Brummel, with a cork hole in the top of its head and holding a scroll that reads "Irish Reform Cordial." Across the base of the flask is the name Daniel O'Connell, Esq., to whom I offer posthumous thanks for this attractive century-old memento. Too bad it was empty!

In succeeding days we explored the sand barrens and blowouts around Pinware Bay, locating seven sites within a radius of one mile. Most of the occupation areas that I had found so far in the Strait of Belle Isle related to prehistoric and early historic Indian cultures, and we had

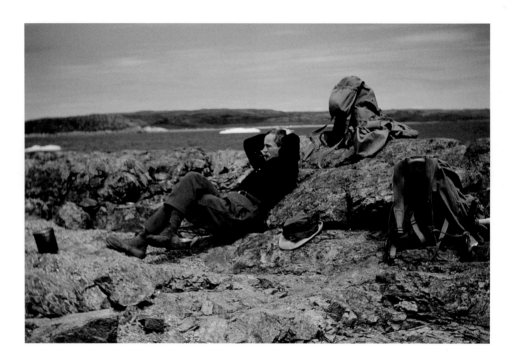

Elmer Harp having a postprandial pipe on the trail at Ship's Head, Pinware Bay

seen only one small site with indications of early Eskimo people.[†] Our movements often led us through the settlement, and we were welcomed everywhere by friendly people, in particular by Father Alphonse Tessier, OMI, the parish priest. We enjoyed several long conversations with him and were invited to dinner at his rectory one evening. He told me much about the local history of the coast, about the French seigneury that had been established at West St Modeste in the late seventeenth century and later abandoned. This evidently accounted for the large buried cache of European roof tiles that we had discovered at the western end of the tickle – building material imported from France almost three hundred years before our time but never used.

Finally, Father Tessier kindly offered to take us across the strait to Flowers Cove in his own small schooner, *Our Lady of Labrador*, and when the designated morning came he was waiting for us at the wharf

[†] *"Early Eskimo people" refers to prehistoric arctic-adapted peoples who, although possessing an Inuitlike culture, are not directly ancestral to Canadian Inuit. These prehistoric cultures are sometimes referred to as Paleoeskimos to distinguish them from the Inuit. Paleoeskimos lived in Newfoundland from 2800 to 1200 years ago and in Labrador from 4200 to 600 years ago.*

Father Alphonse Tessier, West St Modeste

in the tickle. Mike Pike helped haul our gear down from the bluff and then came along with us for part of the day's voyage. It was glorious summer weather for sailing in a small boat through the Strait of Belle Isle, past L'Anse-au-Loup and the Point Amour lighthouse to Blanc Sablon, where Father Tessier had a brief appointment to keep. Then across the strait, flat as a millpond this day but alive as always with deep currents, to Flowers Cove on the Newfoundland side. The narrowest part of the strait lies between Flowers Cove and Forteau, a distance of slightly more than nine miles.

While in the Pinware area earlier I had met Harold Whalen of Flowers Cove, who at that time was ferrying a team of four Swedish botanists along the coast. He invited us to stay at his parental home in Flowers Cove and also agreed to hire on as our boatman on the Newfoundland coast, so Father Tessier offloaded us at a wharf close to the Whalen

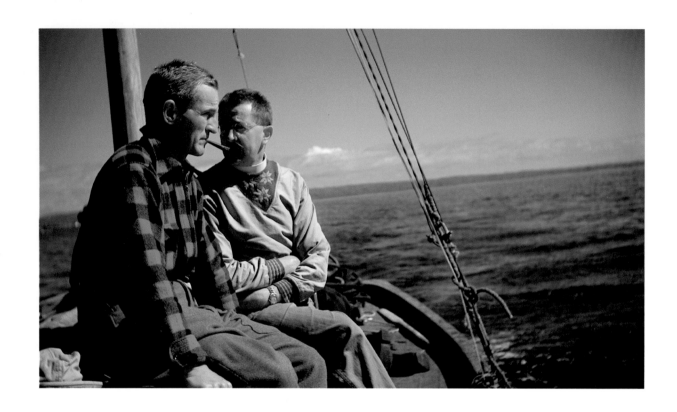

Elmer Harp with Father Tessier aboard
Our Lady of Labrador, *crossing the Strait*
of Belle Isle on a rare day late in July

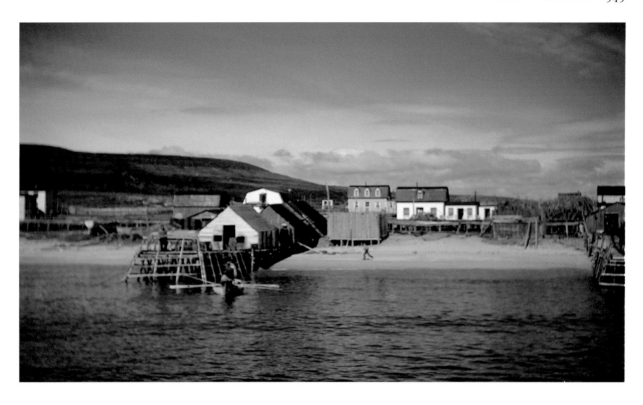

*Fishing stages at L'Anse-au-Loup, the first
settlement east of Forteau Bay*

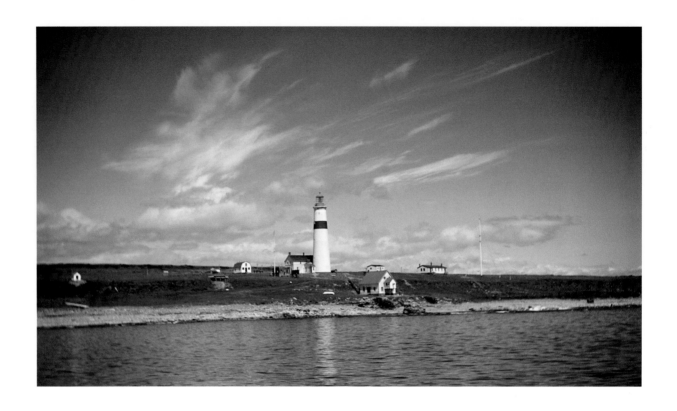

*The lighthouse at Point Amour, the
narrowest part of the Strait of Belle Isle.
The fog signal emitted by this station is
an almost constant underlying element in
the ambience of the strait.*

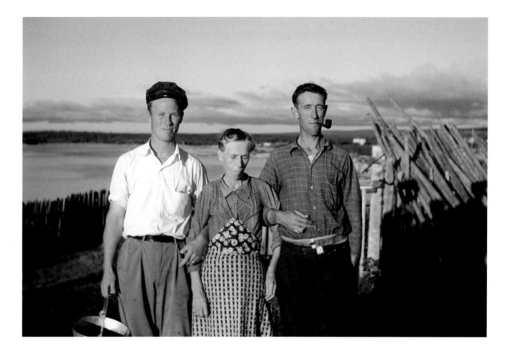

Right to left: *my friend Jim Allingham of Brig Bay, his mother, and his neighbour Pierce Sheppard*

house, and we were graciously welcomed by Mrs Steve Whalen, Harold's mother. For three nights there we slept in the attic on a concave mattress stuffed with grain husks, because the Swedes had preempted all the good beds. However, Mrs Whalen served us delicious breakfasts and we had a fine opportunity to explore the coast southward through St Barbe, Black Duck Cove, and Plum Point.

On the second day, as we were exploring some house gardens in Brig Bay, a local resident, Jim Allingham, joined us, saying he had heard of our coming on the coast and he insisted that we return home with him for dinner. Far from being a mere lunch, this was a full-course affair in company with a large family that included grandparents, two young adult couples, a neighbour, Pierce Sheppard, and numerous grand-children.

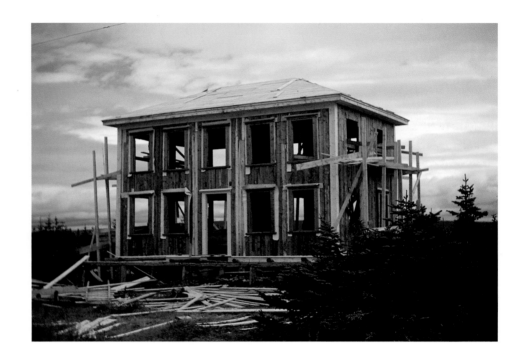

An unusually fine and rich example of housebuilding in Bird Cove, Brig Bay

I had noticed that many of the neat two-storey wooden houses in the outports were home to such multigenerational families, and clearly the patrilineal nuclear family was fundamental to them all. These households were the basic, independent units of provincial society, and they were almost totally self-sustaining, with the women fulfilling the traditional work of the home, bearing and rearing children, doing the gardening, and other countless daily tasks. The men – including boys at a very early age – went to sea for the fishing and did the fish processing, though women frequently aided in these tasks. Each man built his own frame house with unseasoned timber, which he had cut in the nearest available patch of forest and processed himself in a waterfront sawmill. Similarly, he built his own sled, or komatik, for winter travel by dog team, as well as his own fishing boat – whether lapstraked or smooth-planked – his own wharf, and his own fish room and drying flakes. Of

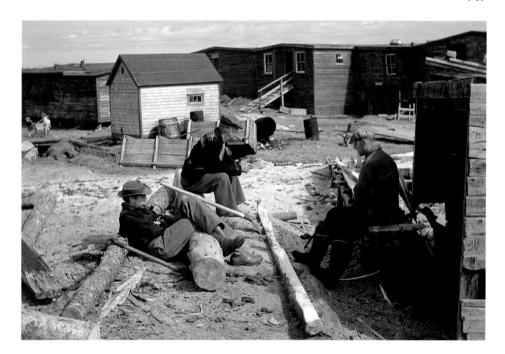

Tony Morse (left) *with Alfred Darby and Francis Offrey mulling over the problems of the day at Mr Darby's waterfront sawmill, Port au Choix. The mill was used to cut lumber for all boat building and other construction in the village.*

A newly painted komatik drying on top of a stack of freshly cut lumber. Until the coming of the roads, beginning in the 1950s, all travel around the Northern Peninsula and in Labrador was by dogsled in winter, by open motorboat in warm weather, on foot trails for short distances, or by the occasional coastal steamer. Sights like this komatik always demonstrated to me the basic independence of the families in the outports.

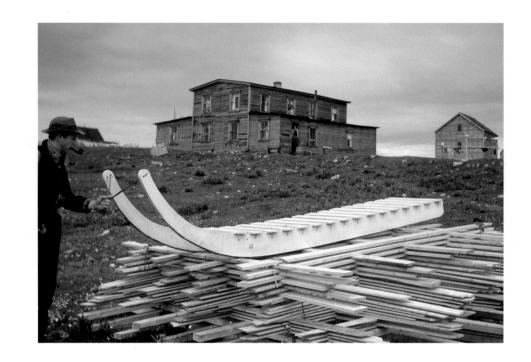

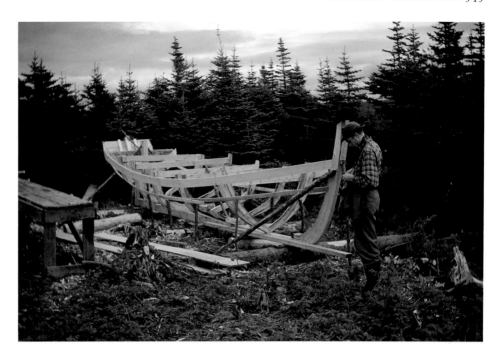

A homemade fishing boat under construction in a backyard, such as this one at Bird Cove, was a fairly common sight. They were built mostly of local spruce, with minor supplementary use of birch or maple, and were twenty to thirty feet in length, round bottomed, and wide of beam. I saw both lapstrake and carvel-built boats, and all were designed to be driven by an inboard one-cylinder marine engine – though within ten years many of the old engines had been replaced by powerful outboard motors. In my experience, these were seaworthy craft in heavy weather, but they were open to sea spray and very wet for passengers.

course, cooperative village labour was available when needed for unusually heavy work. Fishing for cod and other groundfish, or salmon and lobster, was the age-old basis of the outport economies, and each household had one or more boats drawn up on the beach or anchored offshore. Also, there was an occasional dog team staked out behind a house, poorly sheltered and suffering from underfed summer uselessness while waiting for winter rations and travel activity. House gardens in the side yards were devoted primarily to potatoes and other subterranean, tuberous vegetables, and they were always enclosed with pickets or wattle fences so that the few head of horses, cows, and sheep could graze at random through the village. These fences were often put to use as drying racks for household laundry.

At some point I suddenly became aware of an anomaly in these settlements on the Newfoundland shore: many of the households had a pile

*Anchor Cove men and boys stretching
nets out to dry*

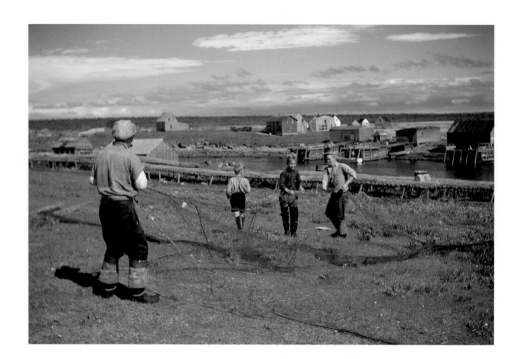

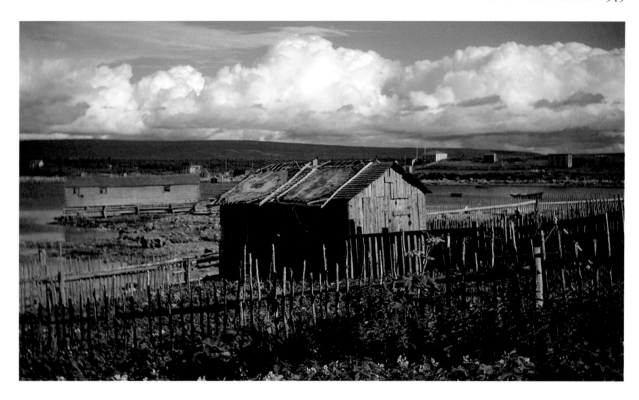

*Sealskins in stretching frames spread to
dry on a shed roof in Brig Bay*

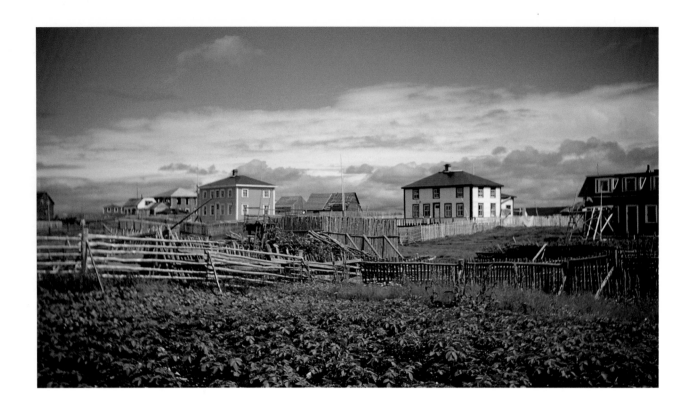

*Looking across a potato garden in the
main village at Bird Cove, a well-kept and
apparently prosperous outport*

This unusual wickerwork fence made of willow withes enclosed a garden in St Barbe Bay. I never saw another like it in Newfoundland. I suppose it was meant to shut out small animals such as dogs or perhaps chickens.

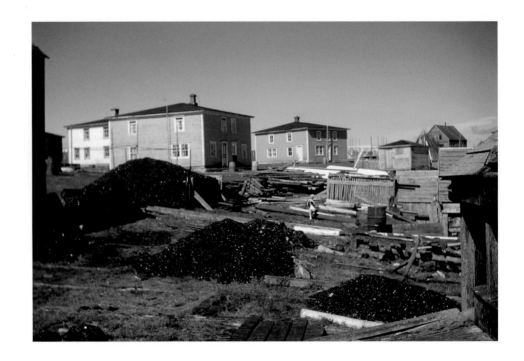

In Anchor Cove I was startled to see these piles of coal in several back-yards. I was told that the coal had been salvaged from a cargo ship that had gone aground outside St Barbe Bay, but it could not be used until coal-burning grates arrived from Montreal.

of coal in the side yard, and this puzzled me because I had seen only wood-burning stoves for cooking and heating. Then a villager told me that within the past year or two a Greek cargo vessel laden with coal had run aground outside St Barbe Bay. In the hope of lightening ship and saving his vessel, the captain had declared the coal to be free for all who would come and get it. The local fishermen responded immediately en masse and swarmed out with such enthusiasm that within hours the cargo was completely transferred out of the hold into their small boats, and the Greek ship floated free on the next high tide. Unfortunately, however, the coal could not be burned locally because the grates in the wood-burning stoves were not the right size. So the coal sat piled in everyone's side yard for months while people waited for new grates to be shipped from Montreal.

Such examples of salvage operations on wrecked or abandoned vessels have been common for centuries around the world. Many of them have been perfectly legitimate and many piratical, but probably all have exhibited a high degree of human ingenuity and resourcefulness. Aside from the ceramic cordial flask, I know of two other intriguing salvage operations in northern Newfoundland. One yielded a seventeen-inch seal-netting needle carved from dark teak, which was given to me by my late friend Walter Billard of Port au Choix. He had inherited it from his grandfather who, many years before, had stripped some teak wood from the binnacle of a shipwreck in Gargamelle Cove and converted that prized material into various useful products. The other is the steel chimney that I first saw in 1949 projecting through the two-storey roof of Steve Whalen's house in Flowers Cove. This had once been a king post on the deck of a freighter that had gone aground in Deadmans Cove. (A king post is the main vertical column of a derrick used for supporting tackle or booms for hoisting cargo.) It was a thick steel tube about eighteen inches in diameter and close to twenty feet in length, weighing perhaps a thousand pounds, which had been cut loose from the ship's deck with an acetylene torch, manoeuvred over the side, lowered into a makeshift raft, and towed round the point into Flowers Cove, where it was erected inside the Whalen house by hoisting it through holes in the ceiling and roof. It had surely been a splendid cooperative project, enlisting much neighbourly muscle power, and when my wife Elaine and I stopped by forty years later to visit Steve's son Harold and his wife, the king-post chimney stood proudly there in Harold's former family house!

Next, I wanted to look over the coastal country north of Flowers Cove, so we set up camp in Nameless Cove and readjusted ourselves to outdoor life. As we explored toward Savage Cove and Green Island I could not find any archaeological signs of previous human presence. The low-lying, featureless country was vastly different from the Labrador side: behind us the remnant hills of the Long Range Mountains tapered away

Split cod drying on a gravel beach in Savage Cove. This exemplifies the dry-cod method of fish processing practised mainly by English sailors in the early historic period. It requires a protracted stretch of good weather, not always available in Labrador and Newfoundland, as the split fish must be hard-dried for lengthy storage and shipping time. In the sixteenth century, as the Atlantic fisheries developed into a major basic food resource for Western Europe, fish-curing methods and shipping times became crucial to profit margins in transatlantic commerce.

The French had access to plentiful supplies of salt and were able to cure and pack their catches for immediate transport to European markets, whereas the dry-cod fishermen were generally slower in sailing home because of their dependence on fine drying weather. In due time, however, the English were freighting salt to their main storage base in St John's, and soon their Atlantic fishermen were competitive on equal terms with the French.

Left to right: *Winifred Burgess, station nurse at Flowers Cove Nursing Station; Charles Curtis, MD, superintendent, International Grenfell Association; Ivy Durley, also a station nurse at Flowers Cove*

into the interior, and the shoreline was open and unprotected. Even the local house gardens had not yielded up any signs of prehistoric hunters.

However, we also visited the nearby Grenfell Nursing Station and were delighted to meet Ivy Durley and Winifred Burgess, the two English nurses-in-charge. They invited us for dinner that very evening and we learned that Dr Curtis was due to arrive soon on one of his regular inspection trips. When Dr Curtis did come a day or two later in the mission boat, he was shortly followed by Dr Noel Murphy, superintendent of the government hospital at Norris Point, Bonne Bay. Dr Murphy also was making an inspection of the Grenfell field stations, travelling in his own inboard cruiser, and he suggested that we visit his home base later, when on our way south to Corner Brook.

This unexpected gathering in the Flowers Cove nursing station was a wonderfully interesting and profitable meeting that led to my enduring

friendship with both doctors. After Dr Murphy departed for home we were beset by a wet three-day nor'easter that washed out any possibility of outdoor work. Tony and I were securely battened down in our camp and well prepared to ride out the storm, but Dr Curtis sent Ivy Durley to our tent with a polite command for us to join him forthwith at the nursing station. After a brief, perfunctory protest we duly arrived for supper, and for the next three nights, as guests of Dr Curtis, we slept in the empty maternity ward.

There was no possible way to repay our hosts for this exceedingly generous hospitality, but they seemed to enjoy the company of new, non-medical outsiders. Also, we helped with all the household chores, and one morning I assisted Nurse Durley in her dispensary, holding the heads of several patients while she extracted decayed teeth. The stoical sufferers never uttered a sound, and I can still recall the hollow clank of teeth as Ivy tossed them into a metal bucket. Twice I stayed up into the early hours swapping stories with Dr Curtis, but mainly listening raptly to tales of his early years in the service of Grenfell. On those nights I sat up even later in the ward to record notes on some of his amusing yarns, for he was a marvellous raconteur. Although somewhat cool on first acquaintance, he was imbued with warm affection and respect for the people of the coast, and it was a grand experience being stormbound with him in northernmost Newfoundland. All in all, I can affirm that the social benefits of that encounter far outweighed the lack of archaeological discoveries on the island side of the Strait of Belle Isle.

For the previous two weeks our reconnaissance had been disappointingly negative, so we struck camp for the next move and loaded aboard Harold Whalen's boat in Nameless Cove. It was another perfect cruising day as we rounded Cape Ferolle into St John Bay and nosed into the mouth of Castors River, less than forty miles to the south of Flowers Cove. As usual, I borrowed some tent poles from a tipi stack of firewood at the edge of the village, and we set up camp in a beautiful grassy meadow beside the lower rapids. But again, our preliminary search was fruitless in the vicinity of the settlement because the small harbour was

John Rumbolt of Castors River was my fishing guide on that beautiful stream, and a few days later he ferried us to Port au Choix in the teeth of a soaking southwesterly blow.

surrounded by dense scrub forest. Our first camp visitor was John Rumbolt, one of the local elders and an amusing storyteller, who the next day rowed us upstream in his dory to the salmon pools, where we had a rewarding session of great fishing.

That evening at dusk a young man strolled into camp and crouched down by the fire to visit with us. As we chatted, he pulled forth a bottle of homemade rum to share with us, and that was my first taste of screech, as the potent drink is now popularly known. I must say it made a fine nightcap, especially when sipped around an open camp fire in the northern bush! Our visitor was intensely curious about the outside world, particularly about job possibilities, and even asked if he could work for me. I answered his questions as fully and diplomatically as I could, for I sympathized with his yearning for adventures beyond life in the outports. On my subsequent trips to northern Newfoundland I was

Port au Choix

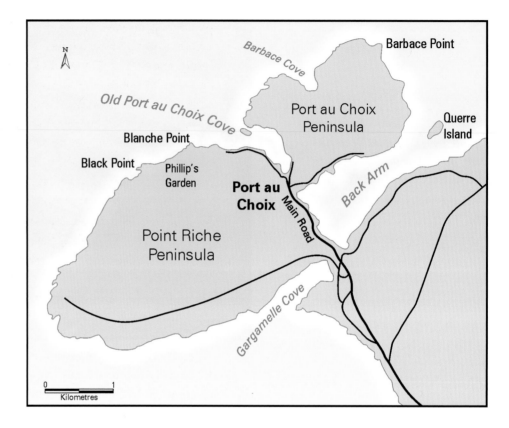

approached on several occasions by young fishermen who had similar desires, and the best advice I could offer was to suggest that they be patient and give Confederation a chance to work on their behalf. I hope this was the right thing to say.

On 11 August we loaded into Rumbolt's thirty-foot lobster boat and headed across St John Bay toward Port au Choix. Normally this would have been an easy run of little more than twenty miles, but this time it was rough and wet, sailing directly into the teeth of a twenty-knot southwesterly wind. So we landed at Darby's wharf in the Back Arm at Port au Choix almost four hours later, well soaked in salt spray despite our oilskins. We had finally come to Port au Choix, the place that was potentially the major focal point of my field research, and soaking wet though we were, our arrival there filled me with great satisfaction and anticipation.

At this point I should explain more about the background of this project, which was primarily dissertation research for my PH D at Harvard. My thoughts about fieldwork in Newfoundland and Labrador derived originally from conversations with my early mentor, Frederick Johnson of the R.S. Peabody Foundation for American Archaeology at Phillips Academy in Andover, Massachusetts. In the summer of 1948 I had been his field assistant on a five-month expedition to the Yukon Territory, and our evening talk around the campfire had sharpened my interest in the Strait of Belle Isle country. In this easternmost extension of the continent there are elements of the temperate zone, subarctic boreal forests, and coastal arctic tundra, and because these habitats require specialized human adaptations, this marginal area might well have stimulated cultural diffusion and mixture among the first people who dwelt here.

Although there was widespread evidence of aboriginal occupation throughout the area, scientific information was scanty. In 1915 J.P. Howley[†] had compiled a monumental descriptive study of the Beothuks of Newfoundland, but the true identity of these extinct people was still in doubt. There was also a tantalizing mix of reports from both sides of the strait, beginning with T.G.B. Lloyd's 1875 and 1876 publications in

† *Howley,* The Beothucks or Red Indians

which he described an assortment of stone artifacts from Newfoundland and southern Labrador.[†] In 1930 W.D. Strong published an account of his discovery in northern Labrador of what he called an "Old Stone" archaeological complex, and he suggested that it might have been ancestral to both early Indian and Eskimo occupations there.[††] A few years later, Junius Bird's research around Hopedale, Labrador, uncovered further evidence of early Eskimo settlement, and he suggested that Strong's "Old Stone" complex should be linked to the Dorset Eskimo culture that had recently been described by Diamond Jenness of the National Museum of Canada.[*]

Dorset culture, named for its type site on Cape Dorset in southwestern Baffin Island, was first isolated from a mixed collection of artifacts that were predominantly related to Thule Eskimo culture. For the next decade and more this claim for a discrete Dorset cultural entity caused widespread controversy among Danish, American, and Canadian arctic archaeologists. All authorities recognized the peculiar character of Dorset artifacts, but all such field evidence had been found in confused contexts with the remains of other Eskimo cultures and even Archaic Indian materials. Then, in 1929, the uncertainty was lessened when W.J. Wintemberg of the National Museum of Canada carried out field reconnaissance in western Newfoundland, including the Point Riche Peninsula and, in particular, Phillip's Garden.[**] The local collections that he observed or found there included many Dorset types that could be attributed to that prehistoric culture with a high degree of confidence. There were still some puzzling artifacts in these collections, such as polished stone gouges and plummets, but these indications of a former Indian presence were numerically minor. Dorset Eskimo culture was thus positively associated with at least one specific locale, the northwest coast of Newfoundland near the Strait of Belle Isle. This was not an arctic location such as we normally expect with Eskimo culture, but at least it could be called subarctic and thus be considered as transitional to far northern environments. Wintemberg's discovery remained obscure for lack of substantial interest among scholars; but twenty years later, after

[†] Lloyd, "Notes on Indian Remains Found on the Coast of Labrador" and "On the Stone Implements of Newfoundland"

[††] Strong, "Stone Culture from Northern Labrador"

[*] Bird, "Archaeology of the Hopedale Area"; Jenness, "A New Eskimo Culture in Hudson Bay"

[**] Wintemberg, "Eskimo Sites of the Dorset Culture in Newfoundland"

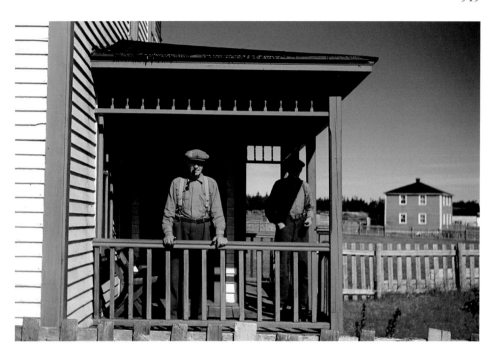

Mr Alfred S. Darby standing on his front porch. He came to Port au Choix as a young man from the Burin Peninsula, about 1909, and he told me there was no settlement then at Port au Choix. However, I believe that several French families already dwelt on the peninsula, including the Billards and Ange Cadet, who built their houses on the ridge of the isthmus between Old Port au Choix and the Back Arm; there also was the Hellary homestead just below them on the Back Arm. Ange Cadet once told me that as a young boy he had been apprenticed in the French fishing fleet and had jumped ship at Port au Choix, and there he had begun a fresh and independent life in the New World.

the Second World War, a new generation of arctic archaeologists appeared on the academic horizon, and the Point Riche Peninsula, with its outport Port au Choix and the nearby site called Phillip's Garden, were rediscovered and thus exposed to further attention. Tony and I were the vanguard of this new generation, and, wet and bedraggled from stormy travel, we had finally arrived in this place that held so much archaeological promise.

As soon as we climbed ashore I could sense the interest and friendly concern shown by the people of Port au Choix. News of our coming had preceded us, and Mr A.S. Darby was there to greet us on his wharf, which was the main landing facility in the Back Arm. We offloaded our gear and supplies into one of Mr Darby's storage sheds, changed into dry shirts, and walked up the bank for a welcome cup of tea at his house. He was a most pleasant gentleman in his middle seventies, and

In Port au Choix in 1949 the waterfront street, along which everyone lived, was a narrow gravel path, perfect for walking or driving dogsleds and small horse-drawn wagons. It was a picturesque trail with slight bends and twists, soft spots and mud holes, and never had a traffic jam.

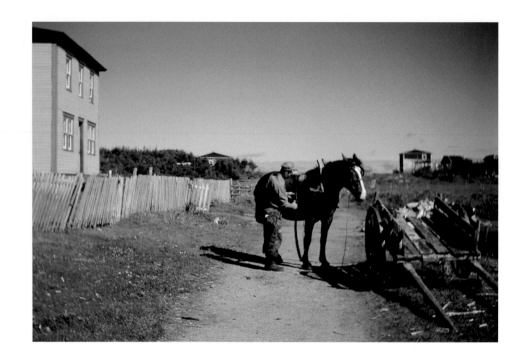

had been the earliest of the modern English settlers in Port au Choix, having come here from the Burin Peninsula in 1909. At that time several French families may already have occupied western portions of the Point Riche Peninsula, including the Billards and Ange Cadet, who built their houses on the isthmus between Old Port au Choix and the Back Arm. Point Riche Peninsula marked the southern boundary of the so-called French Shore, which extended north from there through the Strait of Belle Isle and then east to Cape Bonavista. According to the Treaty of Utrecht of 1713, the French were permitted to carry out unlimited fishing operations along this section of the northern coast, but they could not establish permanent settlements ashore. However, there are many modern French inhabitants of the shore who are descendants of sailors who jumped ship in search of freedom.

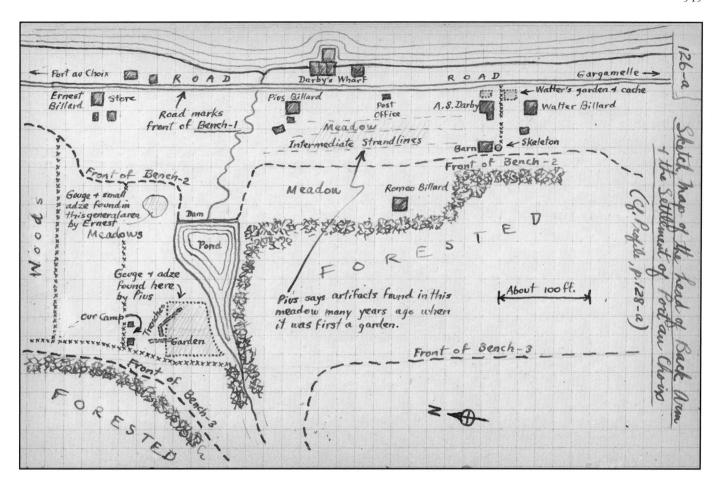

*Author's sketch-map of the main waterfront
street in Port au Choix*

View from a slightly higher terrace behind the front line of the village of Port au Choix. The first white house was Mr Darby's and the yellow one next door was Walter Billard's. Beyond was the Farwell family's white house.

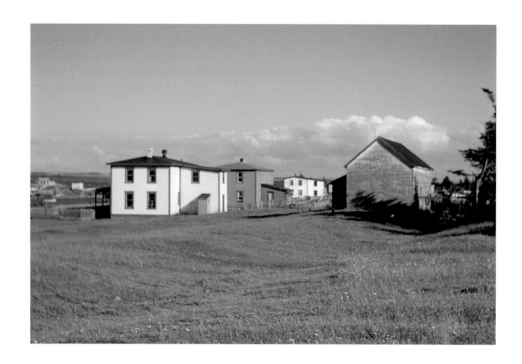

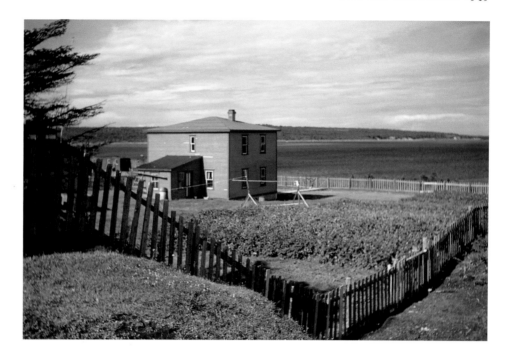

Looking down through Walter Billard's potato garden, past his house, and north to the Back Arm, Port au Choix. This shows the sharp difference in elevation between the raised sea-cut terraces.

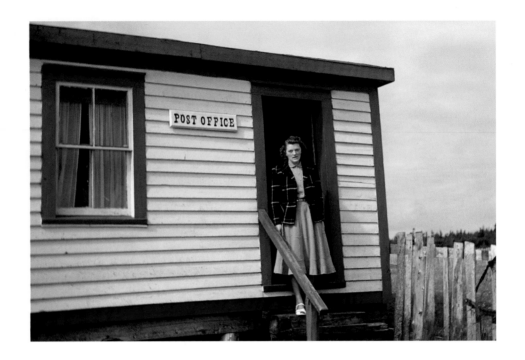

The postmistress of Port au Choix, Lizeta (Dete) Billard, Walter's wife. Beginning that year, Dete and Walter became our closest friends in Port au Choix – though in fairness I must add that virtually all the people there have been our warm friends throughout the years since 1949.

Mr Darby's house stood across the roadway from his fish plant and wharf, and the road itself was the main waterfront street, along which a half-dozen dwellings were scattered. However, this main thoroughfare was merely a mud and gravel pathway, adequate for walkers and dog sleds or small horse-drawn carts. It meandered rather picturesquely through the soft wet spots and mud holes, but in that era it was always free and open, with no threat of a traffic jam. Mr Darby's immediate neighbours were the four Billard brothers and their families. Facing seaward, to the right, was the house of Walter and Dete (Lizeta) Billard and beyond them the household of the Bert Farwells, who were also old-timers in Port au Choix. To Darby's left was the tiny post office, in the charge of postmistress Dete Billard; farther left and opposite the wharf, Romeo Billard had begun to build his house. Beyond this was the house of Pius and Ella; and still farther, up a low hill on the west side of the

Pius Billard in his hayfield,
Port au Choix

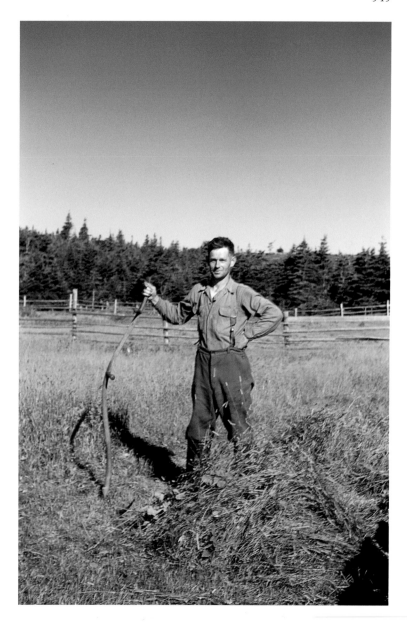

brook, was the house and store of Ernest, the eldest of the siblings. Mr Darby, along with Walter and Pius, had built a rock and earth dam across the brook that drained through their fields, thus creating a small trout pond that also served their three homesteads with gravity-fed running water during the warmer months of the year, a unique feature in the village at that time.

We roamed through the village in search of a campsite, but wherever we turned we met new people who were anxious to talk with us, all friendly and welcoming. I realized that we had to gain some degree of privacy or this incipient social life might soon overwhelm our work ethic, so we retreated back uphill toward the pond and pitched camp in a protected corner of Ernest's high pasture. I was anxious now to get out to the site in Phillip's Garden, but every time we appeared in public for the first couple of days some local man would approach us with a stone artifact dug up from his garden, or to pass on information about a new site, or to invite us into his home for tea, coffee, or a bottle of beer, or to bring us a freshly caught salmon, or simply to pass a little time in conversation. These overtures were, of course, a vital precursor to our acceptance in the community, and I deeply appreciated this expression of warm generosity. Walter and Dete, who became two of my closest friends in Port au Choix, had us to dinner several times during our stay; Ella sent one of her seven children up to our camp with a loaf of fresh bread every other day, and once she even sent a freshly baked lemon pie. Also, on our second morning there I crawled out of the tent to find a brown paper bag containing four fresh eggs and two Jamaican cigars from Mr Darby!

Only very seldom could we repay this hospitality in some slight way – as, for instance, on the rainy morning when the *Northern Ranger* docked with a large cargo of general freight from Corner Brook and a crowd of 180 summer tourists. I went aboard to visit with Captain Jim Snow and the purser, Boyd Tremblett, whom I had met on our previous trip on the *Ranger*, and Boyd cashed some travellers' cheques for me. Then, under the curious gaze of the passengers, Tony and I pitched in

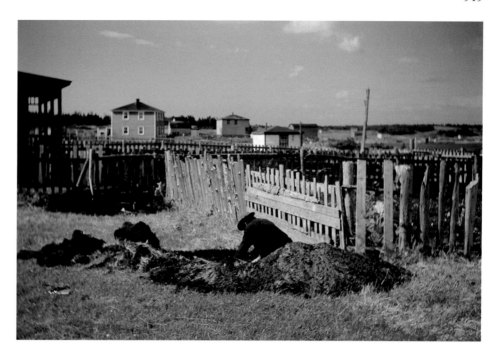

A year or so before we came to Port au Choix, Walter Billard had dug up a cache of large flaked stone biface tools in his front yard. We could not excavate further there because his summer crops were ripening, so I dug a test trench outside his fenceline, but it was unproductive. This photo shows Tony Morse in the trench and a view of Mr A.S. Darby's front porch (far left), *Pius Billard's green house* (left), *the one-storey white post office* (centre), *and Ernest Billard's house and store* (right). *Port au Choix was prettily and sparsely settled at that time, comfortably sprawled along the raised wave-cut terraces that ringed the beachline of Point Riche Peninsula.*

to help the Billard brothers unload the cargo consigned to Port au Choix. Included in that freight was a new double-bed mattress and a matching set of coil springs, which were presently claimed by a local fisherman who had come in from Eddie's Cove West. As I helped him transfer these precious items into his fishing boat he grinned at me and said, "That ought to help boost my baby bonus!" He was referring, of course, to the monthly child subsidy payments that were now being made by the federal government in this newest of Canada's provinces.

Meanwhile, it was increasingly evident that we had come to a place that held a wealth of archaeological evidence from a long continuum of human occupation. During one of our visits Mr Darby gave me a fruit crate full of discoloured human bones that had been dug up in front of his barn about ten years before we came. There had been a skull, he said, but an itinerant dentist from St Anthony had asked to have it for

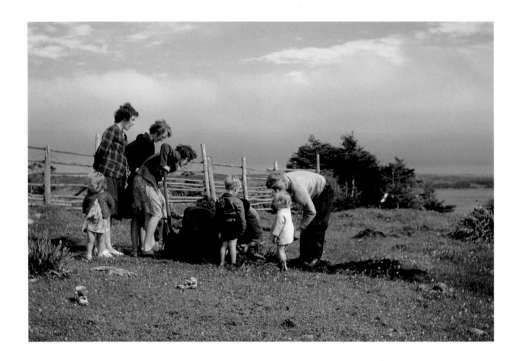

Harold Northcott's children and others examining one of our test excavations on the isthmus between the Back Arm and Old Port au Choix. Many of the local families showed intense interest in our operations and were eager to learn about Newfoundland's past.

research purposes. However, in the bottom of the crate I found three bone needles, or perforators, which clearly identified the burial as early Indian. Then Pius presented me with two excellent polished stone tools that had been found in a potato garden near our camp, an adze and a gouge that derived from Archaic Indian culture. Next, Walter dragged out a heavy wood box loaded with large bifacial axes and knives flaked from translucent quartzite, also Archaic Indian in provenance, which he had found in a buried cache in his front yard potato garden. He did not want to turn over the entire collection to me, but he let me select eight representative specimens for the sum of three dollars and upon closing the transaction invited us for supper that evening. Several days later we excavated a thirty-foot trench across the rear line of his garden and also a shorter one in front of the Darby barn next door, but these tests were unproductive. Altogether, this fragmentary evidence indicated that the

*The triangular meadow surrounded by
scrub forest in the middle distance is the
place called Phillip's Garden in the folklore
of Port au Choix. To the left in the far
distance lies the entrance to the Strait of
Belle Isle, and to the right are the Long
Range Mountains, which form the spine
of the Great Northern Peninsula.*

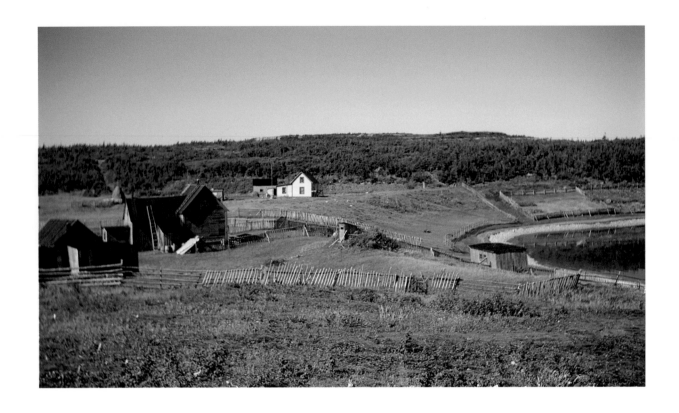

*The home of James Billard and his wife
Eugenie on the isthmus above Old Port au
Choix. Their weatherbeaten house stands
at the left, and Ange Cadet's freshly
painted one is beyond. Until the modern
era, the major settlement developed around
the Back Arm, which was preferable as the
most sheltered harbour on Point Riche.
Old Port au Choix, with its exposure to
westerly storms, had only one dwelling
and a fishing room until the 1960s.*

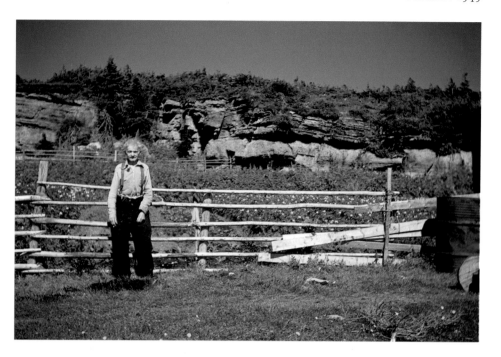

Frank Hellary stands by his fenceline along the western shore of the Back Arm. In the limestone bluff behind him is a cave where he found two native burials in 1904, later identified as Dorset Eskimo remains.

Back Arm had been occupied first by ancient Indian people, but we had not yet seen any traces of prehistoric Eskimos in the immediate vicinity.

My chief interest was still focused beyond the village in Phillip's Garden, along the outer coast of the peninsula, so on the first fine afternoon we hiked along the beach in that direction. Of course, before we could reach our objective, protocol required that we pay our respects to James and Eugenie Billard, the family patriarch and matriarch, who lived on the isthmus between the Back Arm and Old Port au Choix. They were a charming old couple, in their late seventies, and James at once produced some of his home brew and a jug of heavy wine made from molasses, strawberries, and blackberries.

We tried to be abstemious, but the afternoon got off to a slow start. James told of finds made in his own garden, but he had nothing diagnostic to show me because his collection had been given away over the

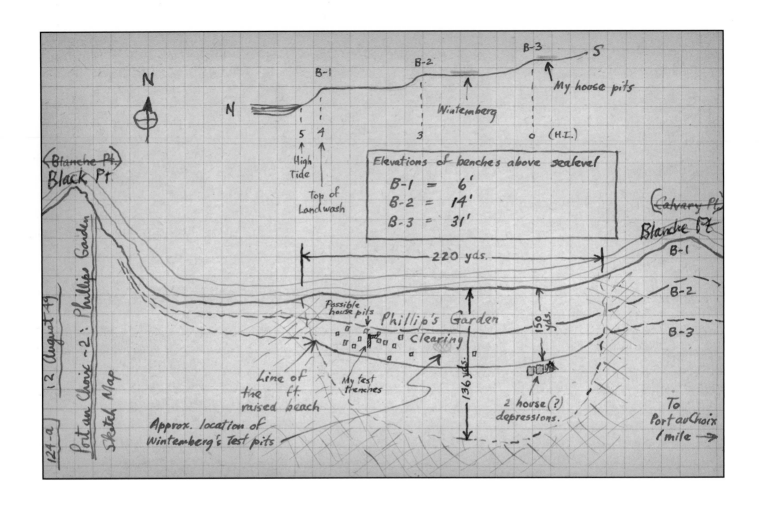

Author's sketch-map of Phillip's Garden,
Port au Choix

years. Eugenie was more intriguing, however, as she reminisced about her youthful days when she had accompanied the menfolk out to Phillip's Garden to cut hay. She remembered seeing some large whale bones lined up across the field, and there were bare spots in the sod that showed many flint chips and arrow points.

After the Billards there was a final visit to be made, at the fish plant of Joe Noel near the mouth of the west arm, or Old Port au Choix. Joe showed us through his establishment, which included a dozen large concrete pickling vats, where split cod were put down with salt before being shipped directly to Boston. Joe had a Scottish war bride from Glasgow, Cassie, who in later years became a good friend of my family when she was our landlady in Port au Choix.

Eventually, we were finished with our socializing and we got back onto the trail. There was a short climb between the lichen-covered limestone outcrops that ring the outer coast, and then we followed an animal trail through undulating meadows of grass, purple iris, and occasional patches of spruce brush, known locally as tuckamore. Joe's description of Phillip's Garden was more helpful than others I had been given, and at last we came upon it less than a half-mile farther on. As I recall that moment now, my initial reaction to the place was rather indifferent; it seemed to be just another attractive grassy stretch of meadow bordering on a beautiful sandy beach, a place perfectly made for swimming if the water had not been ice-cold. However, by the end of that afternoon my enthusiasm for it had surged by leaps and bounds.

From our point of entry on the eastward perimeter, we observed a broad shallow amphitheatre of short grass, mosses, and scattered clumps of flowering iris that lent the place an irregular lavender tinge. From the upper rim where we stood, it sloped down to a concave frontline along the beach, and to the sides and rear it was bordered by a dense growth of wind-stunted spruce.

Upon pacing out the dimensions, we found it to be roughly 220 yards wide across the front and 125 yards deep from the shorefront back to the trees. The eastern extremity of the field was partially rimmed by a low

limestone outcrop, shown on the charts as Blanche Point, while the more prominent, clifflike Black Point marked the western end. Three concentric terraces stretched across the site from side to side — ancient wave-cut beach lines formed by upwarping of the land in postglacial times. The lowermost of these terraces, or benches, averaged five to six feet above sea level; the middle one was fifteen feet above the sea, and the uppermost about thirty feet above the high-tide line. We traversed the meadow back and forth, looking for exposures of the subsoil or other signs of past excavations, because Wintemberg was reputed to have dug test pits near the centre of the field, but we could see no traces of such work.

So I decided to do some testing of our own, and with a trenching shovel I began to scalp back the turf here and there to expose the underlying soil layer. The results were magical! Virtually every shovel scar revealed numerous scrap flakes of black chert, fragments of animal bone stained dark by the soil, occasionally an artifact such as a chipped stone knife or scraper, or a fragment of carved soapstone pot, blackened with carbon on one surface, presumably the result of cooking. I was amazed and delighted by the great quantity of evidence that we uncovered across the high and middle terraces, though the lowermost bench seemed to be sterile.

We lost track of time while test-pitting back and forth across the meadow, and, before we knew it, the afternoon was waning into evening. Then, as the sun dropped lower in the west, I suddenly became aware of two shadowed depressions near the eastern end of the highest terrace, or Bench 3, as we now called it. These shallow pits measured close to fifteen feet square; their interiors were a foot below exterior ground level, and there was a low earthen ridge surrounding each depression. Clearly, these were semisubterranean house pits, intended for prolonged occupation – probably during some cold period of the year – and judging from the artifacts that we had recovered in our test digging, these houses had been constructed and lived in by prehistoric Dorset Eskimos.

Then, as I gazed across the terraces more intently, ten or twelve similar house pits emerged in the lengthening shadows – farther along on Bench 3 and also below us on Bench 2. These varied somewhat in size, and most of them were further delineated by richer growths of grass and purple iris in their interior hollows. Eureka! This was not a small encampment; it had been occupied by numerous hunting families, and later study showed that these prehistoric Eskimos had camped here while hunting harp seals during the annual whelping period on late winter offshore ice. Phillip's Garden was thus shown to be a phenomenally rich source of archaeological information about an extinct aboriginal people, and of the eight sites that we discovered in and around Port au Choix, this one offered the greatest potential for future investigation of these people.

In addition to the chipped stone and bone artifacts occurring throughout the black soil zone, there was a profusion of seal bones, darkly stained and very well preserved. All the evidence available to me then – though it was only a small sample of what still lay buried – affirmed that Phillip's Garden had been a significant seal-hunting site in prehistoric times. Indeed, it had remained so into our modern era, as my friends in the village testified. A regional herd of harp seals winters over annually in the Gulf of St Lawrence, corralled there by frozen seas to the north and in the Strait of Belle Isle. By late winter and early spring, the pack ice begins to break up at the edges and retreat slowly north through the strait. Pods of seals follow this meltback, and the gravid females climb out on the whelping ice, as it is called in Newfoundland, to bear their young. During the nursing period on the ice, both cow and pup are vulnerable and fall easy prey to hunters, whether prehistoric or modern.

Thus, the archaeological interpretation of Phillip's Garden was substantiated by analogy with recent hunting cultures. For successful cold-weather living, there were sturdy semisubterranean houses large enough to shelter entire families of the Dorset people; for exploitation of a major food resource, such as seals, there was a specialized technology

adapted for sea-mammal hunting, including chipped stone harpoon points set into detachable bone heads, stone knives for butchering and skinning, and innumerable snub-nosed stone scrapers for the preparation of raw skins; there were cooking pots, carved from monolithic chunks of steatite, or soapstone; and of ultimate significance, there was a huge quantity of food-bone debris throughout the culture-bearing stratum, representing both mature adult and immature young specimens of harp seals.

With this much evidence in hand, I was satisfied to move on into the final leg of the summer survey; in fact, we had barely a week left for working our way south through Bonne Bay to Corner Brook and a rendezvous with the *Blue Dolphin*. I went to see all of our local friends to say farewell and express hope that I might return the next summer. Three nights before our departure, we dropped in on Pius for a visit and to listen to *Doyle's Bulletin* for news of the MV *Clarenville's* northbound progress in her west coast run. As usual, we traded a few stories, and I learned that it was Pius's paternal grandfather who as a teenager had jumped ship on the French Shore and later sired the Billard clan in Port au Choix. To do homage to his ancestral line, Pius then brought out some of his private stock – a compound of Booker's Demerara rum, whisky, and muscatel wine – thus adding a warm tinge to the evening. At 10 PM the *Clarenville* rounded the point into the Back Arm, and we all went down to the wharf in a drizzling rain to watch her dock. She carried a heavy cargo for Port au Choix, more than two hundred parcels of every kind, from barrels of pork and kerosene to new heating stoves, canned goods, sacks of flour, etc. So Tony and I pitched in again to help the Billards unload the vessel, and we had the freight all stowed away by midnight. This small gesture, gladly offered, was a mere token of my esteem for these people, who even after such relatively brief acquaintance had become much like family to me. They were the best kind – honest and uncomplicated, generous and sincere.

The next day we finished cataloguing and packing the last of the field collection, a total of 674 specimens to date, and on the morning of 26

August we broke camp, hauled all our gear to Darby's wharf, and sat down to await the *Clarenville* on her return trip south. I understood that this was scheduled as an overnight trip to Bonne Bay, so I had naively wired ahead to Corner Brook for reservations, including two bunks. It was late afternoon when the *Clarenville* again rounded the point into the Back Arm, and as she eased toward the wharf, my vague notion of private accommodation dissipated abruptly. Her decks were literally swarming with people – well over a hundred – and boarding her was like trying to cram oneself into a subway car at rush hour. With some paper money I persuaded the mate to lower our gear into the hold a little more gently than I had seen other cargo handled, and we then elbowed our way into the companionway to inspect the only two sleeping cabins on the boat. Each of them had four bunks, which were already full of bodies: men, women, and/or children. There was also one eight-seat mess table folded against a bulkhead. As we moved out on deck and around the vessel, I met a half-dozen men whom I had known earlier in the summer in more northerly outports, especially Pierce Sheppard from Brig Bay and Steve Whalen from Flowers Cove, he of the wondrous king-post chimney sticking through the roof of his house. Whalen was manager of the local lobster pools in his area of the strait, and was on his way to Gander to attend a convention of all Newfoundland pool managers with representatives of fish buyers from Boston. Most of the other male passengers on the *Clarenville*, having completed the summer fishing season, were on their way south to various Bowater lumbering camps to work as wood cutters for part or all of the winter. A large contingent of them disembarked in Hawkes Bay shortly before dark, but they were soon replaced by a new crowd that came aboard in Port Saunders.

Tony and I took our rucksacks up to the boat deck, dragged out air mattresses and sleeping bags, and laid claim to a patch of deck space along the starboard side of the exhaust funnel. Then, after a snack of dried emergency rations, ideal for just such an occasion, we bedded down – to the general amazement of our fellow travellers, who them-

Looking over the settlement of Woody Point, Bonne Bay, to the tablelands

selves had no place to go for shelter and no place even to sit, except on the deck. Fortunately, the night was clear and not too cold, and sleeping under the stars was good, in fact made better by the gentle roll of the boat. During the next several hours I awoke twice to the thrumming of the diesel engines and the movement of bodies shuffling around us, as the more curious of the passengers climbed topside to look and wonder at the strange sight of two Yankees stretched out there in sleeping bags. At one point, a man leaned over me for a closer examination and softly said, "Now you talk about that!"

Late in the morning we sailed through the shadow of the two-thousand-foot spine of Western Head and then beyond into Bonne Bay, which many travellers consider to be the most beautiful place in western Newfoundland. This spectacular deep-water harbour with its three separate arms, or bays, is enveloped by rugged headlands and moun-

The home of Noel Murphy, MD, and his family at Norris Point, Bonne Bay. Dr Murphy was chief of the Norris Point hospital, which served the coastal communities between the Bay of Islands and Port Saunders to the north.

tains, and its shoreline is spotted with small villages. The dark slopes rise above the treeline to windswept plateaus, known locally as deer barrens, which are seasonally visited by migrating caribou. Bonne Bay is a classic fjord, and during the First World War it safely sheltered battleships of the British navy in its deep, protected anchorages.

We unloaded from the *Clarenville* at Norris Point, on the north shore of the bay, and made a quick reconnaissance through the village. It was clear that we had returned to the verge of a more urban life because here were outlying gravel roads that connected to the Deer Lake and Corner Brook network through the medium of the ferry between Norris Point and Woody Point. I was lucky to round up a man with a Ford pickup, one of only three cars in the village, who hauled us up the trail toward Rocky Harbour; and little more than a mile out we found a pleasant campsite sheltered by woods and hidden from the road. The government

Noel Murphy driving his yellow jeep along the road at Norris Point

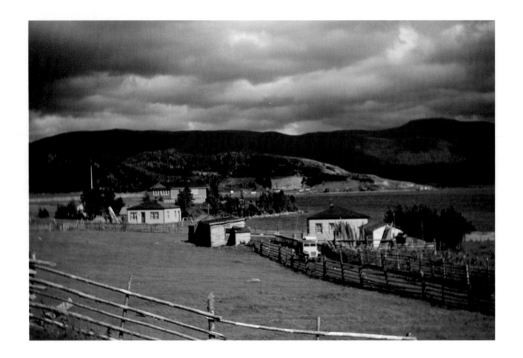

hospital and the residence of Dr Noel Murphy were not far away, and we had barely set up camp when the good doctor himself skidded round the corner in his Jeep. Riding with him was his sister Maureen, who was visiting from Boston. As before, the local system of informal communication, the Newfoundland variety of bush telegraph, had signalled our coming precisely.

I had a major interest in Bonne Bay because Howley's study on the Beothuks had identified many archaeological finds here in various gardens, particularly at Norris Point and across the inlet at Woody Point, the village at the entrance to the South Arm. Wintemberg also had mentioned the area in his report. As I soon learned, these sites were already part of the local folklore, and for the next several days Noel Murphy cheerfully led us around to all of them. He toured us by Jeep or in his cabin cruiser, *Tinker Bell*, to nearby and outlying sites, and we explored

other segments of the shoreline between Norris Point and Rocky Harbour. We even jigged for cod in the East Arm. He also introduced me to the people who knew most about local history, particularly Bryant Harding, a major property owner and a resident of Norris Point for forty years, who remembered Wintemberg's visit. Mr Harding told me that ever since that time, all the boys of the village had been ardent diggers and collectors of Indian artifacts, and they had made a handsome business of selling these spoils to the tourists on the *Northern Ranger*. Bad news for us! But it explained why the primary site on the point now looked like a shell-pocked battlefield, and why so many of the other sites yielded only a few scrap flakes.

The situation on the south shore of the bay at Woody Point was similar, for the prehistoric occupation there had apparently been concentrated around Lighthouse Point. When Noel took us over for a reconnaissance of various house gardens, we found only a few scrap flakes, but the few specimens that people had occasionally found in recent years all indicated a former Archaic Indian occupation. I was told that a large collection of stone artifacts had long ago been culled from these gardens around Lighthouse Point, but it had disappeared, most of it lost in a disastrous fire that had destroyed the entire waterfront in 1922.

Nevertheless, everyone I met at Woody Point was as helpful as possible, and several became valued friends who aided me greatly on future expeditions. Among them were the men of the Blanchard family, who operated a bus and trucking service between Woody Point and Corner Brook as well as a ferry link across the bay to Norris Point. Now, in 1949, they were building a new ferry boat large enough to transport trucks.

Then there were Mr and Mrs Edgar Roberts, who lived in a large house close to the ferry landing; they sometimes boarded overnight guests, including District Magistrate Wade (and the Harps in 1950). Across the road from their house, Emma Tapper was the proprietor of a newly opened lunchroom named the Seaside Lunch Room; Emma was a delightful person, a sister of Mrs Roberts, and renowned in Newfoundland as the first woman to be licensed as a hunting and fishing guide.

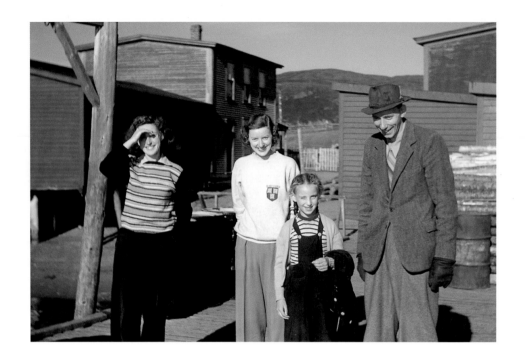

The Murphy family saying goodbye at Norris Point. Left to right: *Edna (Noel's wife), Maureen Mosher (Noel's sister from Boston), Edwina Murphy, Dr Noel Murphy*

Finally, we met the elders of Woody Point, Mr and Mrs William Prebble, a grand couple in their seventies, who lived in an elegant Victorian house on the waterfront. Bill Prebble was the son of a Maine fisherman who had come here in his youth to settle and trade with the French, and his descendants had lived in Bonne Bay ever since.

Noel and Edna Murphy, and Maureen too, were endlessly hospitable during our visit, repeatedly having us for dinner or luncheon, while we could reciprocate only meagrely on one occasion with an outdoor supper around the campfire. They even insisted on keeping us overnight before we departed for Corner Brook, then drove us down to the early morning ferry and waved us away on the first leg of our trip home. They made us feel like visiting royalty. The three-hour drive south was uneventful but beautiful; we climbed over the height of land past the Bonne Bay ponds,

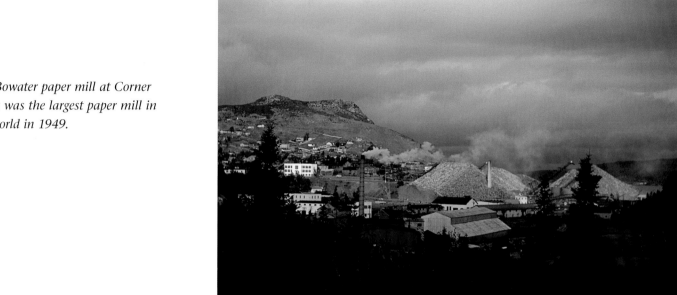

The Bowater paper mill at Corner Brook was the largest paper mill in the world in 1949.

then down to Deer Lake and along the lower Humber River to the Bay of Islands and Newfoundland's primary west coast town, Corner Brook.

I had wired ahead for a reservation at the Glynmill Inn, and Mrs Vatcher, the dynamic manager, welcomed us warmly even though we were rather grubby-looking after a summer in the field. When we presented ourselves for dinner, we had showered and scrubbed and changed into the cleanest clothes left in our bags, but we had no jackets or ties and were therefore somewhat substandard in appearance. That particular evening Mrs Vatcher was supervising an important and elegant dinner party in the main dining room, an event that preceded the impending arrival of the governor general of Canada. She scanned our attire with evident consternation and asked if I would mind being seated over in a corner behind some potted palms. Of course, we did not

Viscount Alexander, governor general of Canada, leaving Corner Brook on his special train. His visit to Newfoundland helped celebrate the former British colony's confederation with Canada.

object to that delicate treatment at all, and we enjoyed a fine dinner in distant obscurity, in our blue jeans and moccasins.

Viscount Alexander, the governor general, arrived the next morning with Lady Alexander and an official party that included Premier Joseph R. Smallwood and Sir Eric Bowater. We watched them come in by private train at the nearby station and then joined the local crowd to hear Lord Alexander's ceremonial speech welcoming Newfoundland as a province of Canada. It was a most memorable morning for two foreign visitors, and afterwards we compounded our pleasure for the day by going on an official inspection tour through the vast Bowater paper mill, the largest of its kind in the world.

Sometime later that night, the *Blue Dolphin* sailed into the Bay of Islands, and in the morning we saw her anchored off the western terminal's wharf, our prearranged rendezvous. Dave Nutt sent a launch to

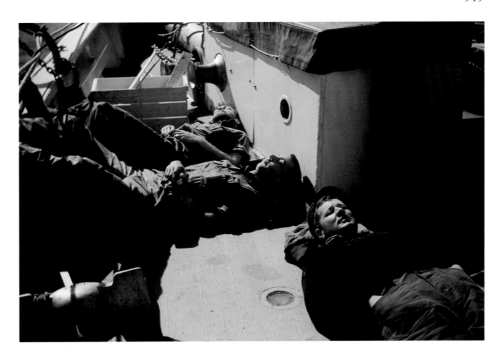

The crew of the Blue Dolphin *sacked out on deck after a successful summer of research along the Labrador coast*

fetch us, our gear was loaded aboard, and before noon we were underway and outward bound for the Gulf of St Lawrence. I was delighted to see that all our friends, the crew and the oceanographers, were in good shape and had been splendidly successful in their summer research, and plenty of sea stories were soon being traded back and forth. Tony and I rejoined the watchlist, thus relieving others for ongoing bathymetric observations along the coast, and so we sailed for home at summer's end. It was a smooth voyage most of the way, except for one night of very heavy headwinds off Nova Scotia in which our jib and the taffrail log were carried away. But at last we entered Boothbay Harbor, Maine, in the late morning of 9 September, to be welcomed by an enthusiastic crowd of families and friends.

*Port aux Basques is the Newfoundland
terminus of the ferry that runs south to
North Sydney, Nova Scotia. In 1950 it was
still a quiet port, with the settlement
oriented around the ferry docks and a
scattering of fishing vessels tied up in the
rocky coves.*

The summer of 1949 had been a hugely influential experience that confirmed my enthusiasm for northern environments and intensified my enthusiasm for arctic and subarctic prehistory. In a scholarly sense, the 1949 field research was richly promising, but it could not stand alone as a significant contribution. It demanded follow-up work, and as we returned home I began to formulate plans for my next trip to Newfoundland and places beyond. By midwinter I had drawn up a proposal for a second summer of fieldwork, and the Arctic Institute of North America generously agreed to support this extended effort. However, my faculty responsibilities at Dartmouth were slightly more restrictive in 1950, and I had only six weeks free for a return to Newfoundland. There would be other differences as well, for I had planned this as a family trip to include my wife Elaine and our eldest son Jack, aged nine. Also, in addition to further excavations at Port au Choix, I wanted to investigate some of the interior east of Deer Lake, country that I had not seen before. Our station wagon would be our basic form of transport wherever the rudimentary provincial roads might lead us.

From Hanover we drove northeast for three unhurried, scenic days through Maine and the Maritimes to North Sydney and the ferry terminus on Cape Breton Island. There we watched our car being hoisted as deck cargo onto the forward hatch of the SS *Burgeo* (the capacious car ferries of today did not exist at that time), and the ship sailed before midnight. The voyage across Cabot Strait was uneventful, and our approach to Port aux Basques through the next morning's mists reminded me of my first view of Newfoundland from the deck of the

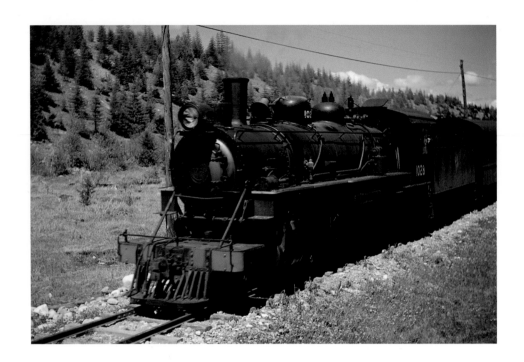

A steam locomotive on the narrow-gauge railway across Newfoundland between Port aux Basques and St John's. In the summer of 1950 my wife Elaine and our oldest boy Jack accompanied me to Newfoundland for a six-week trip, and upon debarking from the ferry in Port aux Basques we shipped our station wagon aboard the railroad to Corner Brook. Within a radius of about sixty miles around Corner Brook there was a network of mostly gravel roads, with good possibilities for archaeological exploration.

Blue Dolphin one year earlier. As there were only a few miles of unpaved roads around Port aux Basques, I had no plans to tarry there, so our car was immediately hoisted from the deck of the *Burgeo* to an open flatcar in the nearby railroad station.

The old narrow-gauge railway winding across Newfoundland from Port aux Basques to the capital city, St John's, on the east coast had recently been taken over by Canadian National Railways, but it was evident to me that its previous provincial management had been excellent. The small coaches were indeed a bit short of legroom and baggage space, but the equipment had been well cared for and the roadbed curved smoothly along the wooded valley of the Grand Codroy River, generally crossing over the western outskirts of the Long Range Mountains. Former provincial train schedules were still being maintained, and I could see that this railroad had been a passenger-oriented

Coasting along the western shore of Codroy Pond. This stretch of the line on the way to Corner Brook passed through beautiful pristine wilderness, a densely forested country with a large moose population.

The Bowater paper mill at Corner Brook

system. Twice that day, as we rolled north along St George's Bay, the train stopped to pick up random travellers, hunters, or woodcutters who had climbed onto the track and waved down the engineer. Otherwise, any house or small cluster of buildings seemed sufficient reason for stopping to transfer mail or a passenger. So it was a slow journey, but was made very pleasant by sociable passengers and beautiful scenery, especially when we came out of the interior bush and ran the final miles along the shore of Humber Arm, past the huge industrial complex of the Bowater mill, and into Corner Brook Station.

Mrs Vatcher welcomed us with a spacious front and centre room at the Glynmill Inn, and this time we presented a more acceptable sartorial appearance than I had the year before! Also, I must note, the company of Elaine and Jack was a great asset in this transaction, and their presence smoothed many subsequent social relationships to a degree that could

never be attained by a solitary male. Hence, in this summer of 1950 I gained many new insights into local family life wherever we travelled. Another guest at the inn was Lee Wulff, the American sport fisherman. We enjoyed chatting with him and learned about the new camp he was establishing at Castors River, a stream I remembered enthusiastically from the year before. Also that evening we were interviewed by Kenneth Pritchard, managing editor of the *Western Star*, published in Corner Brook, and he later turned out a very pleasing report on our archaeological ventures.

The next day we moved north to Bonne Bay, mainly to visit my old friends Emma Tapper in her Seaside Lunch Room, the Prebbles, the Murphys and Bryant Harding over at Norris Point, and Mr and Mrs Edgar Roberts of Woody Point, with whom we stayed overnight. Our boy Jack was given the last available bedroom, but Mrs Roberts warned us that he might have to relinquish it because it was generally reserved for Magistrate Wade, who happened at that very time to be holding court on the local Bonne Bay judicial circuit. As predicted, Magistrate Wade did indeed arrive in the middle of the night, and Jack was turfed out and ended up in his sleeping bag on the floor in our room.

For the next two weeks we shuttled around in the interior between Deer Lake and White Bay. It was primitive country, mostly forested, but in the previous year some forty square miles had been severely burned over, so I made no attempt to explore it. Also, I drew a blank when we later moved east to Grand Lake, which had been described in early literature as favourite hunting country of the Beothuks; in recent years, a modern power dam built across its outlet stream had drastically raised the lake level and submerged all the known Indian encampments. A few miles beyond Grand Lake the pioneering stage of the transisland highway ended abruptly at a roadblock, and we were forced to turn back to the Upper Humber Valley and the road north to Hampden and White Bay.

The Hampden trail grew progressively rougher and narrower as we climbed toward the height of land. Then it widened into a smoothly

In the summer of 1949 there had been severe bush fires over forty square miles in the area northeast of Deer Lake, and in 1950 the fire wardens were being especially alert in the heavily forested section extending north to White Bay. On several occasions these watchmen stopped in to check our camping operation for fire hazard; they were always most courteous in doing so.

*Coming from Hampden, heading down the
eastern slope of the upper Humber River
basin. The Long Range Mountains
dominate the far horizon.*

A grader working at Mile 6 out of Hampden. This pioneering gravel road through the back country between Deer Lake and White Bay was used solely for transporting pulpwood. The few vehicles we saw in 1950 were all owned by Bowater, Ltd, or by the new provincial government. There were virtually no other cars, public or private, on any of the roads in that early period.

graded gravel road, and we suddenly came face to face with a behemoth of a diesel truck loaded with bundles of pulp logs. I skirted around this monstrous vehicle cautiously, and as we eased downhill toward Hampden we passed others of the same ilk grinding slowly uphill. The spring logging drive had begun, and we were virtually in the middle of it. This pulpwood had been cut on the Baie Verte Peninsula and floated down to the company docks at the bottom of White Bay, where it was bundled and hoisted aboard the fleet of massive Hayes trucks; thence it was hauled up to the height of land, then coasted downhill, and off-loaded into the upper Humber River, where it could be collected behind log booms in Deer Lake; finally, it was floated downstream to the Bowater mill in Corner Brook. I had been warned to pass these 75-ton-laden trucks only when they were inching their way uphill, and to get

One of a fleet of Hayes diesel trucks hauling cut pulpwood from White Bay over the height of land to the upper Humber River, down which the logs would float to the Bowater paper mill at Corner Brook

off the road as fast as possible if one of them came rumbling toward us on the downgrade. Now I needed no further explanation of that hazard.

The waterfront at Hampden was an industrialized mess, so we retreated three miles back along the road and set up camp beside a pretty little trout stream, out of sight of the road but not out of hearing! The following morning I looked around for a gas station in the village and finally located a single, rusty, handoperated pump near the docks. As I searched for someone to help us, the owner came out of a shed, so I called out to Elaine to back up our station wagon alongside the pump, which of course she did neatly and with dispatch. The man stopped and watched this simple manoeuvre in open-mouthed astonishment. Then, with a slight shake of his head, he commented, "My, she's some driver!" After all, this was immediate frontier country and still on the very

A clutch of pulpwood hoisted ashore for loading onto the large flatbed trucks at Hampden

*The Bowater fuel dock in Hampden,
looking north across White Bay to the
settlement of Gold Cove*

Scouting for prehistoric artifacts in Leander Osmond's hillside garden in Gold Cove. This was the site of previous discoveries of stone tools relating to the Archaic or Beothuk Indian culture.

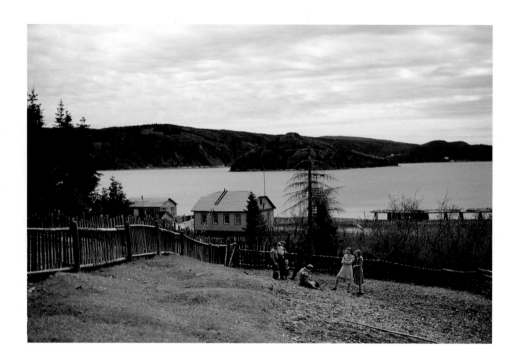

threshold of change into the modern world. I paid $4.32 for topping up the tank: nine imperial gallons at 48 cents a gallon.

While shopping for additional supplies at the general store we met several local men who already knew about our unusual visit. They told us that no archaeological finds had ever turned up in Hampden itself but there had been isolated discoveries in nearby settlements on the western shore of White Bay – and, most opportunely, during this conversation, in walked Hubert and Leander Osmond, who had just boated over from Gold Cove, about a mile across the bottom of the bay. They had found stone artifacts in their gardens and volunteered to take us there, so when our shopping was completed we climbed into their boat and proceeded over to Caribou Valley and Gold Cove. The shoreline around the bottom of the bay was littered with pulp logs stranded at the high-water line, and farther up the bay we could see remnants of the winter pack

A local fisherman in Gold Cove
caulking a new home-built boat

ice stranded along the shore. Out in open water a few small icebergs drifted on the ebb tide. The Osmond brothers showed us a couple of Indian artifacts from their gardens on both sides of the brook, but these sites had been picked over for years and they yielded nothing further to my quick inspection. Before leaving, we met the father of the clan, Arthur Osmond, who proudly informed us that he was hale and hearty at age seventy-one. In turn, Arthur introduced his second wife, a shy young woman of twenty-three, and their seven-year-old son.

As we looked out of our tents the next morning, a yearling bull moose materialized from the bush and shambled unhurriedly across our clearing. We thought this was a splendid beginning for the day, even if it was chilly and raining. The Osmonds met us at the boat landing as arranged, and we headed out of the bay to Browns Cove, about five miles to the north. This time we had a full boatload, mostly Osmond women and

95

children who had decided to come along for the ride. The Browns Cove settlement consisted of five families, of which Henry Langford's seemed to have senior status. His family included eleven children, most of whom were grown up now; one of his daughters, Charity, was married to Leander Osmond. Old Henry had operated a sawmill here on the point for thirty-two years, but it was now inactive and partly in ruins, and the landing stage was almost buried under piles of sawdust and rough-cut slab lumber. We spent the next several hours quartering through the settlement with meagre results; then Mrs Langford invited us all in for high tea, with her very best table settings. It was doubly pleasant, sitting there next to her kitchen stove, because the intermittent showers outside were nasty and cold.

Two most interesting artifacts were passed on to me that afternoon, and their discovery in relatively close proximity to one another implied the possibility of early culture contact between ancient Indians and Eskimos in the White Bay area. The first, which had been found by Leander Osmond at the north end of the Browns Cove settlement, was a bevelled and polished serpentine adze blade, undoubtedly made by pre-historic Eskimos to fit in a socketed bone haft. Then Henry Langford fetched several remnants of the collection culled from his gardens and presented me with the last remaining specimens, including a remarkable ground and polished stone gouge that signalled a prehistoric Archaic Indian occupation of Browns Cove. He had been uncertain about the identity of this tool, so I explained the multiple functions it had had in Archaic times, such as woodworking, animal skin preparation, and digging, whereupon he nodded and said, "My! That's some machine!"

Two days later we broke camp and headed back to the Deer Lake area, where I had previously observed a potential campsite on the west bank of the Humber River. There, on the sheep farm of James Nichols, we had a comfortable base of operations for the next week. The Nicholses were very friendly folk; we learned about sheep shearing in their sheds, and Jack found new playmates among their children. Mrs George Nichols, the seventy-six-year-old matriarch of the family, walked out to visit us

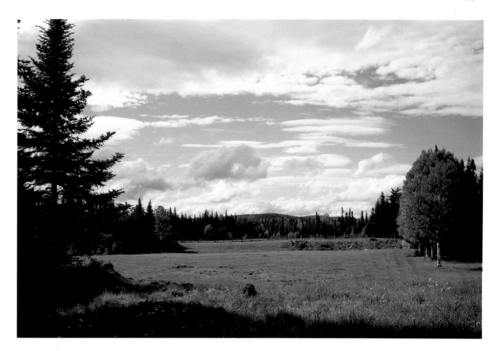

*The Nichols's sheep farm on the
Humber River at Deer Lake*

in camp, and one evening she drove with us into Deer Lake to see Moira Shearer in *The Red Shoes.*

With our station wagon parked in the field next to our camp, I was able to explore several miles of shoreline around the north end of Deer Lake, visiting some of the local gardens in the village where "Indian things" had been found. However, because of altered water levels and dense vegetative cover, most of my efforts were nullified. At this time of year mosquitoes and blackflies were a major annoyance in this interior country, and whenever insect repellents failed, I had to stumble around in a headnet and work clumsily in cotton gloves. Not too satisfactory!

Time and again, the local people around Deer Lake greeted us with warm hospitality and offered their unstinted help and advice. Back in the country we toured the Grand Lake dam with George Whalen, the chief caretaker, and we checked downstream at intervals along the

Central Main Street, Deer Lake

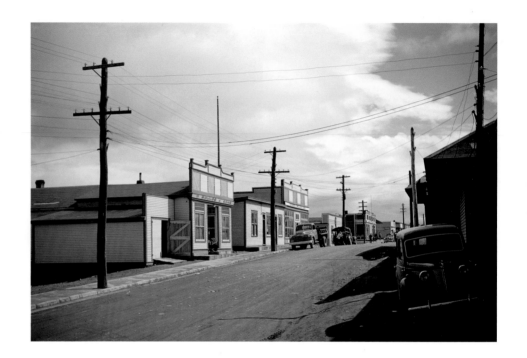

diversion canal, which conducts water to the forebay above the main power plant. There the water is channelled into huge penstocks and sluiced downhill to the turbogenerators on the shore of Deer Lake. Jasper Glover, the mechanical superintendent, showed us through this power plant, which at that time supplied all the electricity needed by the town of Corner Brook and the Bowater paper mill, and also the copper and lead mines back inland, around Buchans. Various residents around the north end of Deer Lake passed on helpful items of information, including Ted Bugden, Jim Kennedy, and old-timers Bill Pennell and William Squires, who remembered the local terrain in former days and clearly recalled several Indian sites that had emerged in the sand blowouts but were now under water. Mr Green, from the local hospital, referred me to his son Tom, of Lomond, who later took us on a tour of that settlement. Leaving Tom, we hiked down to the barachois of a near-

A typical stretch of the single-lane pioneer gravel road, running from Deer Lake and the Humber River over the height of land to Bonne Bay. The distant snow-covered tablelands separate Bonne Bay from the Gulf of St Lawrence along the west coast of Newfoundland.

by stream and had a picnic lunch on the warm sandy beach of the East Arm of Bonne Bay. While in Lomond, I also met H.B. Richards, principal of the Public School in Deer Lake, who was a serious student of colonial history, and we had an instructive exchange of ideas about the local history of Deer Lake and western Newfoundland. Later I gave him a lift to his office in town, and there he presented me with an excellent large-scale map of Labrador and a copy of W.E. Cormack's *Narrative of a Journey Across the Island of Newfoundland in 1822.*

Now the time had come to gather up our effects and move out to Bonne Bay on our way north to Port au Choix; and again we stayed with the Edgar Roberts family in Woody Point. Noel Murphy had expected that the cabin reconstruction in the *Tinker Bell* would be completed in time for us to cruise north along the coast, but unfortunately this could not be. So we turned back to Woody Point to await the next coming of

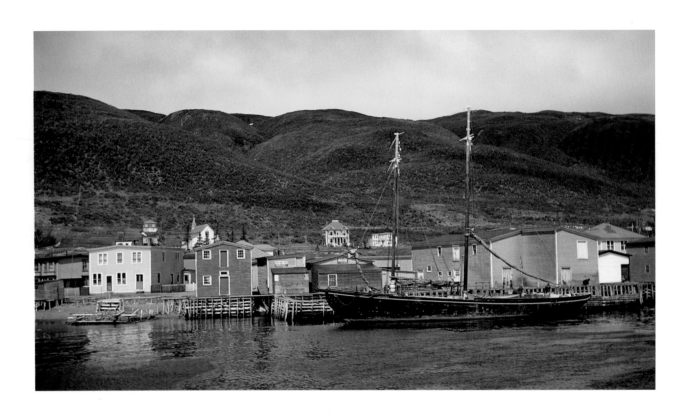

A portion of the waterfront at Woody Point

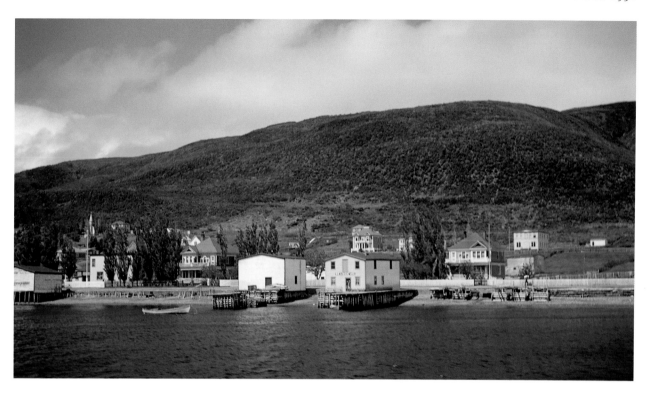

*The settlement of Woody Point. This was
the southern terminus of Blanchard's ferry,
which made trips on demand across to the
north terminus on Norris Point. Beyond
that, the undeveloped local network of
gravel roads diminished to foot trails
within a few miles, and the only
transportation along the Great Northern
Peninsula was by sea.*

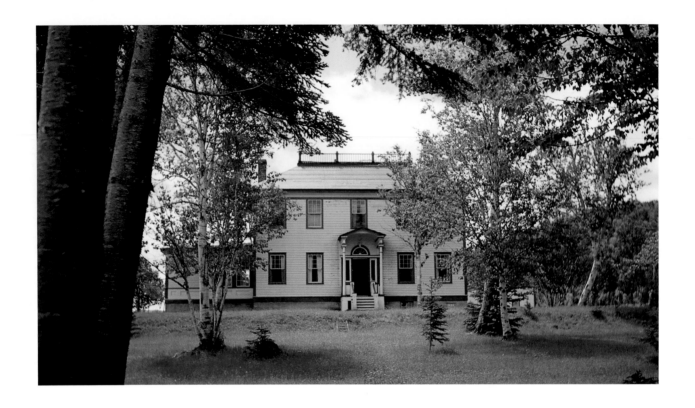

Killdevil Lodge, Lomond, Bonne Bay. In 1950 Lee Wulff, the well-known guide, used this handsome house as his base while developing several west coast fishing camps for sportsmen. I was told that the lodge had been built in 1920 by a Scot who at that time operated a large sawmill in the East Arm of Bonne Bay.

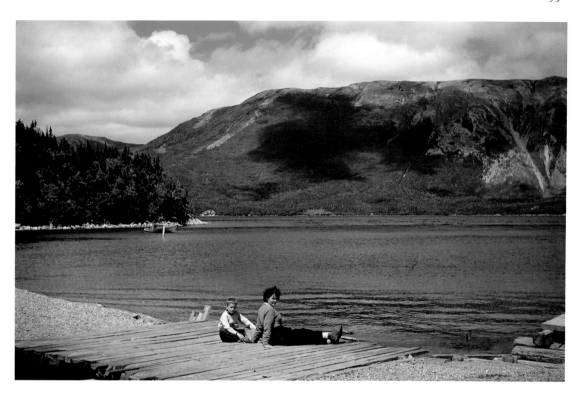

*My wife, Elaine, and our son Jack seated
on a trail along the beach at Lomond, on
the East Arm*

The Northern Ranger *berthed at Norris Point*

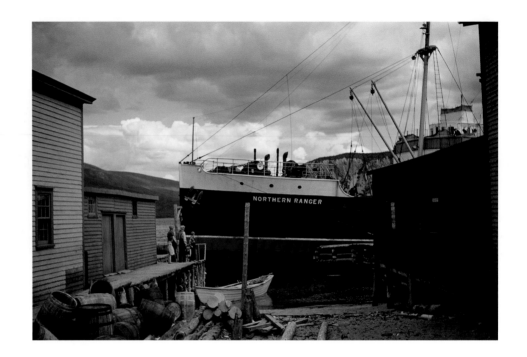

the *Northern Ranger,* and while we were there Bill Prebble kindly offered to store our car and extra field gear in his waterfront sheds while we travelled north. The *Ranger* was delayed in the Bay of Islands by stormy weather and hence was almost a day late in arriving in Bonne Bay. It was great to board the ship and immediately find several old friends from the strait settlements, including three Genge brothers from Flowers Cove and Ernest Billard from Port au Choix. By this time I realized that we no longer had time enough to go farther than Port au Choix, so I asked Amos Genge if he would take a small gift, a Zippo lighter, to Harold Whalen in Flowers Cove, and he was happy to oblige.

Ernest was the bearer of the sad news that Pius and Ella Billard's home had burned to the ground the previous fall, and the family was now living with Mr Darby while building a new house. Otherwise, all was well in Port au Choix. Since becoming part of the Canadian National Railways

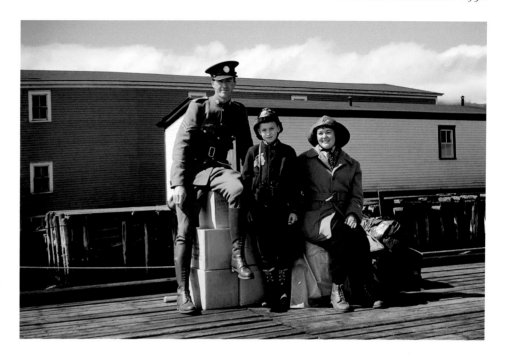

Elaine, Jack, and Ranger Noseworthy of the Newfoundland Rangers waiting to load aboard the Northern Ranger *for passage to Port au Choix. In this first year of Confederation, the new province still relied for police services on its trusted Ranger Force. Subsequently, this force was disbanded and law enforcement was carried out by the Royal Canadian Mounted Police.*

system at the time of Confederation, the *Northern Ranger* had been operating on a tighter schedule than ever before – a two-week circuit from Corner Brook to St John's and return. Some of the smallest outports across the north coast had been eliminated as regular stops, and now only the weather remained as a dominant factor affecting arrival and departure times. Hence, *Doyle's Bulletin* continued to supply vital intelligence to the outports. I was glad to see Captain Jim Snow and Chief Purser Boyd Tremblett again; they were both in fine fettle and seemed pleased with their new biweekly timetable.

It was midnight by the time we rounded Barbace Point, sighted Querre Island light, and entered the Back Arm at Port au Choix. The total darkness ahead seemed almost palpable, but when the *Ranger* signalled her arrival with two short blasts of her horn, flares of light began to punctuate the blackness on shore, and as we coasted into the bottom of

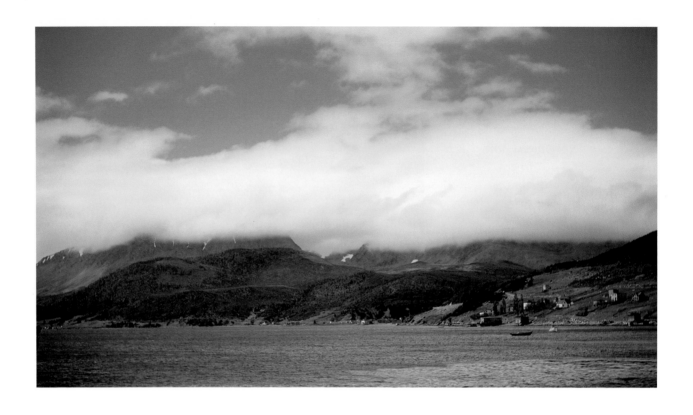

Departing from Bonne Bay on the
Northern Ranger, *looking south to the*
scattered settlement in the bottom of the
West Arm, with the cloud-shrouded
mountains along the horizon

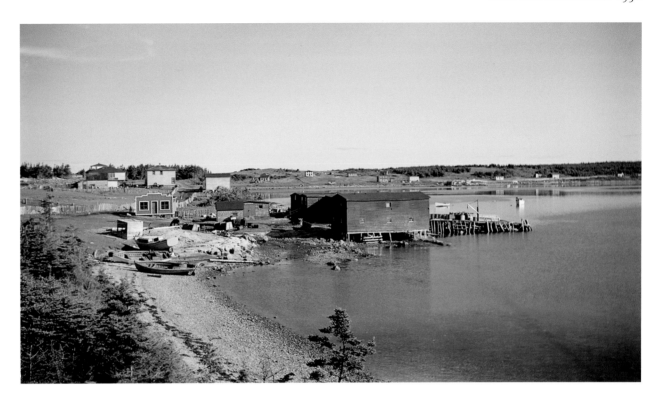

*A northwesterly view of Darby's wharf and
the Back Arm at Port au Choix*

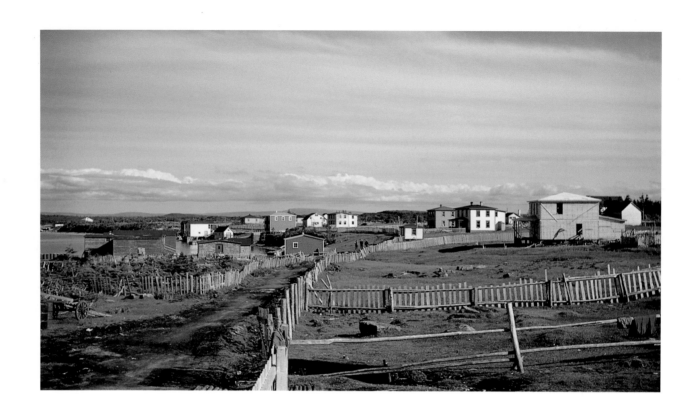

View eastward along "Main Street," Port au Choix. Darby's wharf is on the left.

The Anglican church at Port au Choix. This sits on the first raised beachline behind the waterfront street.

the bay I could see lanterns weaving back and forth on Darby's wharf. Then the propeller reversed, the ship shuddered and crunched against the fenders, lines were heaved to bollards at bow and stern, and block and tackle squealed as the gangway was lowered. Standing on the wharf below us were Mr Darby and Pius, Romeo, and Walter Billard, ready to unload local cargo shipments, but also to welcome us, for they had heard from the coastal network of our impending arrival. It was bone chilling at this hour, so Walter, after warning us not to get tangled in the fishnets that had been spread on the ground to dry, hustled us up the stygian path to his house, where Dete greeted us with a light supper in the cosy kitchen. Later, they ushered us upstairs to their own double bed, which was still warm from their recent presence. We felt truly at home with friends.

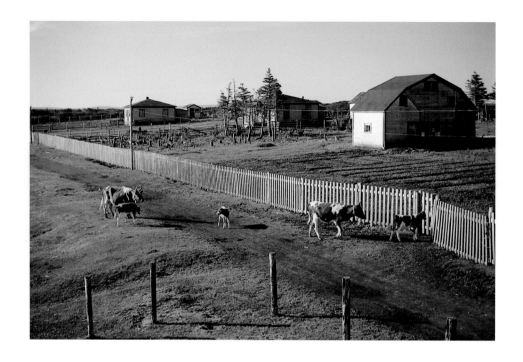

The waterfront street, Port au Choix, looking southeast toward Gargamelle neck. Farwell's barn, seen here, is on the site of a Maritime Archaic Indian cemetery dating to between 4400 and 3300 years ago. This site was rich in artifacts and skeletal remains, and was excavated by Dr James A. Tuck, of Memorial University of Newfoundland, in 1967 and 1968.

I was eager to begin work in Phillip's Garden as soon as possible, but I also had to select a campsite and organize our living arrangements. First, I checked the place that Tony and I had occupied the previous summer – the high pasture beyond the pond and against the woods – but the entire area was soggy with runoff, and as I looked over the adjoining fields I could see that none of them afforded the degree of privacy that we wanted. Next, I headed down to the waterfront and looked into Romeo's new store, a small frame structure that he had built at the entrance to Darby's wharf. As it was Sunday morning, and dark and cold outside, the Billard brothers and several of their friends had gathered for a kind of coffee klatsch, although in this case the social conventions were agreeably relaxed by rum and beer. I met several old friends from the previous summer, including Abe Hines from Garga-melle, Francis Offrey who had come up from Eddie's Cove, and Jim

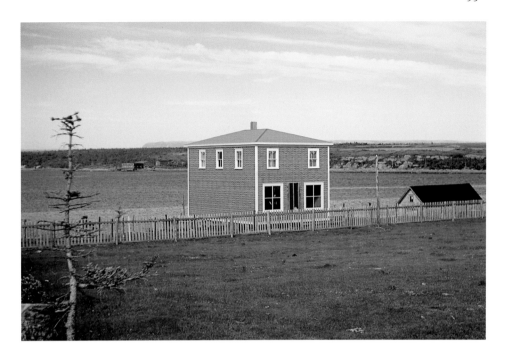

Jack Farwell's new house and store on the waterfront in Port au Choix. I rented the second-floor apartment, all newly furnished, and the ground floor provided space in which to catalogue specimens.

Allingham, in from his nearby lobster camp. In joining this group I knew that I had satisfied village protocol and had properly paid my respects to local society before concentrating on my work.

Just as I was taking my leave from the now quite jovial gathering, along came Millicent Billard, Romeo's wife, together with her mother, Mrs Bert Farwell, to tell of a house we could rent during our stay in Port au Choix. Jack Farwell had just completed a two-storey frame building across the road from Walter's house, where he planned to live in the second-floor apartment while operating a general store and lunch counter at ground level. The second floor had been completely furnished for Rita, Jack's bride-to-be, although the marriage date had not yet been set; the ground floor was empty and could be used as laboratory space. Elaine and I inspected the building, and we could not have imagined a more perfect place to stay for the next two weeks. Jack

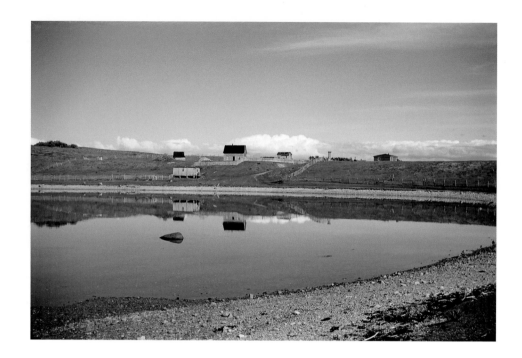

Looking east across Old Port au Choix to the isthmus that separates it from the Back Arm. The first house on the left is James Billard's, and the one on the far right is Harold Northcott's.

Farwell said the rent for that period would be fifteen dollars, and we moved in that afternoon. Walter helped me split up a good pile of stove wood and haul a supply of water upstairs from the pump outside, and he brought us an extra kerosene lamp of his own. Then, while we were having dinner at Walter and Dete's, Mrs Farwell and Millicent laid a fire in the new stove and hung curtains in the front living room. That evening Romeo and Walter came by with a bottle of rum; several more Billards arrived later, and we had a celebratory "time" to christen our new home. We felt richly honoured to be the first occupants, and everyone seemed happy to have us there.

After one more ceremonial visit – this time with James and Eugenie Billard on the isthmus above Port au Choix – I could begin fieldwork in Phillip's Garden in earnest. We arrived at the site around noon, and I was glad to see that it had not been disturbed since my visit the year before.

James Billard, the patriarch of the family, with two of his Northcott grandchildren, Gerard and Jenny

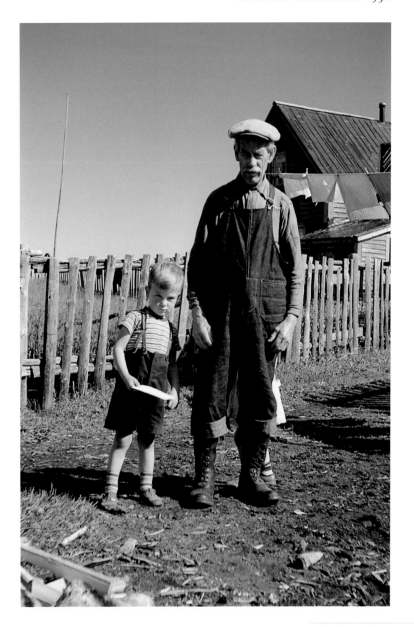

Elmer and Jack excavating a test square in Phillip's Garden

The sea was flat calm, so we had lunch down on the landwash, enjoying the tranquil swish of the sea on the shingle, and afterward I staked out two main trenches for my work areas during the next two weeks. As always, I enjoyed the digging, but the weather was miserable. In between the few intervals of sunshine and warmth, showers blew in off the Gulf of St Lawrence almost every day and turned the culture-bearing horizon into a layer of black mud. Everything buried in it was covered with a sticky coating – the artifacts, scrap flakes, food bones, and even my trowel – so when the work became interminably slow there was nothing to do but stop and hope for a dry spell the next day. In spite of such delays I made sporadic progress, and by the end of our stay in Port au Choix I was fairly satisfied with the results I had obtained.

Regardless of the weather, something of interest occurred daily in the village. Walter and Pius came in one morning with a heavy boatload of

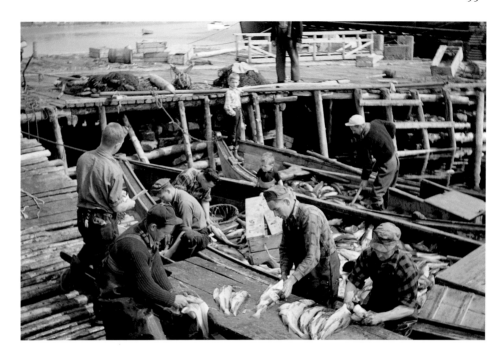

Walter and Pius Billard splitting their day's catch of codfish at Darby's wharf, Port au Choix

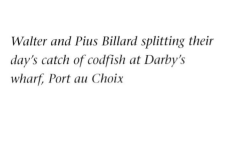

cod, which they estimated to weigh 25–30 quintals (a quintal is equivalent to 100 kilograms, or 220.5 pounds), and we watched them dress out part of this catch while our Jack helped them by forking the fish from boat to splitting table. On another day the lobster boat from Halifax arrived for a scheduled pickup at the St John Island pool, whence it would turn south on a fast ninety-hour run to Gloucester, Massachusetts, and the Boston market. But first, the *O.K. Service V* tied up to Darby's wharf while Francis Offrey helped the crew fill the fore and aft holds with large blocks of ice from insulated storage bins on the wharf. These blocks had been sawn out by hand the previous winter from a pond behind the village. Captain Leary invited us aboard to inspect his ship, and the next afternoon he took us along on his fifty-minute run to the lobster pool at the north end of St John Island. The various pool managers, including Steve Whalen from Flowers Cove,

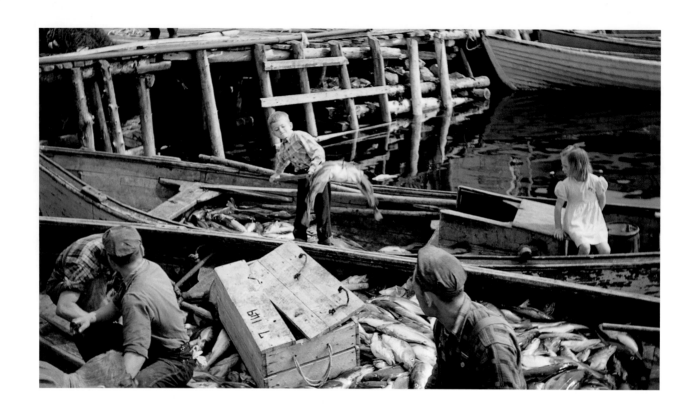

Jack Harp offloading some of the Billard
catch

Jack Harp and a friend from the village of Port au Choix checking out the loading operations

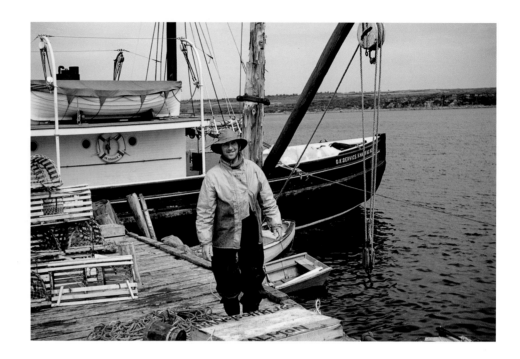

Francis Offrey of Eddie's Cove helping to load the O.K. Service V *at Port au Choix*

brought their tows in under the stern, and the hundred-pound crates were hoisted from the water directly into the ship's holds – some 460 crates full of live lobsters were loaded during the next four hours.

While the loading progressed, Harold Northcott, who also had come along as a passenger, borrowed a boat from one of his friends on the island and ran Elaine, Jack, and me a mile down the shore so that I could take a quick hike overland to Sesostris Bay and appraise it for possible future reconnaissance. On returning to the ship along the eastern shore of the island, we had to run against a combined northeast headwind and a tide rip, and as Harold fought through the severe chop, our engine suddenly died and we were left wallowing in the deep troughs. I got the three of us down in the bottom and held on, while Harold, who was imperturbable, jockeyed the choke and gas feed of the unfamiliar engine until it finally coughed into life and the boat responded to his helm. It

The O.K. Service V at Darby's wharf filling its hold with ice before taking aboard its cargo of lobster crates. This ice was harvested from a local pond immediately behind the village at Port au Choix. It had been stored in an insulated ice house on the wharf.

This page and facing page: *The lobster pool at St John Island*

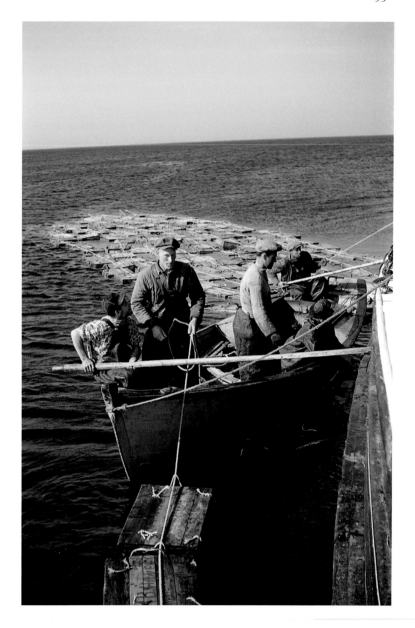

was as cool an act of seamanship as I had ever witnessed, and it doubly enhanced my already high regard for these hardy fishermen of the outports. They know their business.

Before the end of our stay in Jack Farwell's house, we began to discuss various ways in which we might partially repay the marvellous hospitality shown to us in Port au Choix, and Elaine decided that she would like to do something for her women friends there. I have asked her to take over at this point and tell the following story in her own words:

Having proven myself to be a complete loss at locating artifacts, after a couple of days' concentrated digging had yielded only two lobster claws, my suggestion that I abandon further excavation and return to the village was uncontested.

My days of wandering around the settlement were always rewarding, and there was hardly a house I passed from which someone didn't invite me in for a chat over a cup of tea and some memorably delicious raisin bread, or freshly baked white, spread with molasses. We could quickly relate to one another as mothers, and as our own three-year-old, Geoff, had been left at home with mine, they could understand my missing him, and so let me play with their youngsters and babies. Jack, meanwhile, was rapidly making new friends and having the time of his young life.

My unseasonable garb, a thick woollen coat, scarf, unbecoming felt hat, and heavy blue jeans, must have amazed the ladies as much as their seeming indifference to the damp, chilly weather did me, attired as they were in only lightweight summer dresses. They said that I was the first American woman they'd ever met, so I'm sure that my odd appearance created a dreadful impression of my country's sense of style. But before long they became used to their inquisitive, muffled-up visitor, and we had lots of good times together.

Aside from keeping house (and feeling a bit guilty that we, not the future Mrs Jack Farwell, were the first to inhabit her new home), much of my time was spent in the lively company of our first greeter, Dete Billard, still to this day a special friend, and the equally ebullient Millicent Farwell Billard, both

Dete Billard (Mrs Walter) and her children, Port au Choix. Her son Buddy (on the right) was a member of my summer field crew in 1963.

close neighbours. The latter stunned me one evening at dinner at her parents' house by dictating, from memory, accurate pattern directions for a size 10 sweater that I wanted to knit for Jack. Elmer had so admired the seed-stitch, rolled-neck ones worn by all the local men that Millicent and her mother offered to make one for him if I'd supply the nearly waterproof homespun yarn. As time drew near for us to leave, we assumed they'd mail it to him, but instead, somehow, between themselves they whipped up a beauty in a 48-hour marathon, and it is still being worn now, over fifty years later!

Many mornings, opening our front door was a joy, for there on the step might be some just-laid eggs from Mr Darby's few hens, or a still-warm loaf of Mrs Harold Northcott's featherlight bread, or, most exciting of all, a salmon so freshly caught that it provided the most elegant breakfasts we'd ever had.

Before we left, we wanted to express in some positive way our gratitude for the incredibly warm manner in which we three outsiders had been treated by everyone, and I finally decided to have a tea party for the ladies. Back home that would have presented no problem, but here we were with but three aluminum mugs on hand, and the only remotely suitable food offering from our camp larder, several small tins of Crosse and Blackwell's date-nut bread! Nevertheless, I went around delivering invitations and most reluctantly asking the guests to please bring their own cups and saucers. The ladies along the main waterfront were easy to reach on foot, but one lived far out along the eastern shore of the Back Arm, so an offer by an elderly gentleman to give me a ride over in his motorboat was eagerly accepted. About halfway across the stretch of open water I asked him why his five-year-old grandson seemed to have his small hand on the tiller, only to learn, to my consternation, that indeed the child was steering the boat! Later, I managed to make it back to the central village on my own and finally came to the last house. A little girl came downstairs from the living quarters and answered the door. She smiled shyly and then turned to shriek upstairs, "Ma, Mr Harp's woman is here!" – thus honouring me with true acceptance in the local scheme of things.

On the afternoon of the party I had the greatest surprise of my life: every single guest arrived bearing a present for me, and here I was trying to do something for them! They brought hand-embroidered pillow slips, jars of bakeapple

Ella Billard (Mrs Pius) and her children

*Bertha Billard in front of the
Anglican church*

Mrs Bert Farwell fattening her
"Christmas calf"

preserves, cookies, cupcakes, potholders, an afghan that is still in use today, and other gifts that really overwhelmed me. That day I learned once more about a very special Newfoundland trait that has been demonstrated to me many more times in subsequent years when I've been fortunate enough to be among these people: one can never approach, let alone match, their generosity and good will.

As I think back to those good days in Port au Choix, I feel once more the social warmth of that small outport village and the happiness we derived from our friendships there. It may sound as if we were in a fairly constant party mode, but my archaeological operations did not suffer unduly because of these extracurricular activities. The day before Elaine's tea, on a lovely afternoon, a large birthday party was held for Ginny Billard, Ernest's eleven-year-old daughter, in the high pasture back of

Men and women at a birthday party

their house, and it seemed that most of the children in the village were there. Everyone had a wonderful time as the children romped through their games and climbed around on the rail fences, and as the women folk-danced to scratchy records played on an upright Victrola. Then, unfortunately, Eugene Billard fell off the top rail of the fence and broke his leg. Elaine was involved in the first-aid splinting, and the boy was carried downhill to his house. No professional medical aid was available from near or far, except by means of a two-day trip in an open motor-boat. So it was decided to hold him immobilized in bed until the arrival of the *Northern Ranger*, which was due within that same period. We would depart with him on the *Ranger*, and we assured his parents that we would see him safely delivered to Dr Murphy in the hospital at Nor-ris Point.

128

Local children attending the birthday party

So the general leave-taking continued, for we were sure that Eugene was stabilized and as stoically comfortable as he could be in the circumstances. The next evening the clan foregathered at Walter and Dete Billard's, with all kinds of refreshments, including our first-ever moose stew, and we talked away the nighttime hours of waiting until the *Ranger* sounded her horn at 5:30 AM. Exactly twelve hours after that we entered Bonne Bay and transferred the young patient into Noel Murphy's care at Norris Point. The doctor operated immediately that evening and the boy recovered fully.

Then we were on our way back home, retracing every mile of our coming, through the hospitality of our new friends, our stay in Corner Brook, the narrow-gauge railway to Port aux Basques, the ferry over Canso Strait, and southwest through the Maritimes to New Hampshire.

Local mothers, including Elaine Harp, dancing at the birthday party

It had been a great summer and a successful venture in every way, and my original research plans had been satisfactorily fulfilled. Next, the foreseeable future would be devoted mainly to my teaching duties and related academic matters, and I would not be thinking immediately of new research projects. Now we looked forward to home, naturally, but there was an unexpressed hope that sometime we might return.

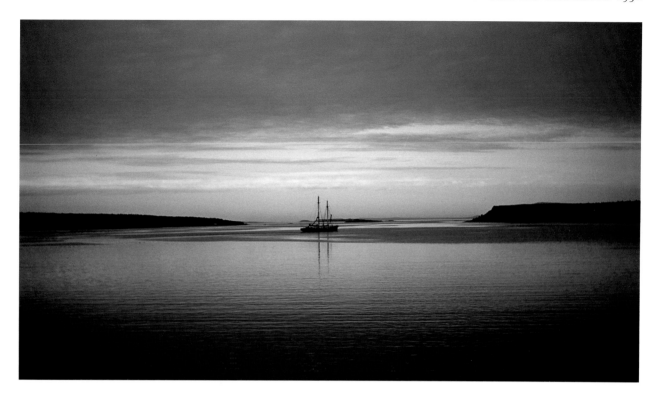

*A lumber schooner taking an evening
departure from the Back Arm*

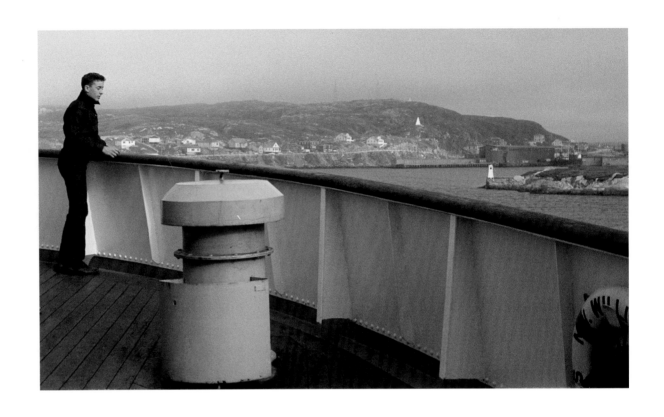

Entering Port aux Basques eleven years
after our last visit in 1950

Part Three: The 1960s

The next few years were among the busiest that I have ever experienced. When my graduate studies were completed, Dartmouth College asked me to return to Harvard as a special student in the two-year program concentrating on the Soviet Union. In the middle 1950s I fielded two exploratory expeditions to the Central Arctic for the purpose of tracing the origins of Dorset Eskimo culture. Then I was invited to Denmark as a Fulbright research scholar for the academic year 1959–60, and our entire family spent a wonderful year in urban renewal while we lived in Copenhagen. After returning home and settling back into our normal New England existence I soon began to think again about field research, and the time seemed ripe for a return to Newfoundland. The Arctic Institute agreed to support me for an additional year, so once more on a morning in late June we watched a dark, rocky coastline emerge from the mists, and presently we eased through the intricate channel into Port aux Basques. The time was 1961, and after an absence of eleven years, here we were again.

My first view of Port aux Basques and our debarkation from ship to shore confirmed the advance reports that had come to me from abroad. Compared to its former somnolence, this channel port now stirred with noisy activity around its newly enlarged wharves and freight-handling facilities; many more houses blanketed the slopes above the harbour basin, and traffic on the waterfront street looked chaotic. Obviously, Newfoundland had made substantial contact with the outer world.

We drove our cars out of the MV *William Carson*'s hold, pushed through the harbour confusion, and came out to the coast road heading

At this time, construction of the west coast highway was still in its early stages. As we set out north from Port aux Basques, an excellent two-lane highway threaded through the Anguille hills from one beautiful subarctic vista to the next, but within a very few miles the surface turned to gravel.

north. I had been told that road building was making steady progress all across the province, but also that we should expect to hit unfinished gaps and unpaved sections in whatever direction we drove. In fact, there was deceptively good pavement for the first fifteen miles north of Port aux Basques – but then, abruptly, rough gravel, which continued the remainder of the way to Corner Brook. The second stretch of pavement connected Corner Brook and Deer Lake, along the vital power lines between Grand Lake and the Bay of Islands, and this was the last segment of paved road we saw that summer. On this trip we travelled in two cars: Elaine and I and our two youngest, Vicky and Doug, drove in our wagon, and in the other car Geoff, our second son, accompanied three of my Dartmouth students: Timothy Bissell, Throop Brown, and Steven Kimbell.

Mr and Mrs William Prebble on their front porch at Woody Point, Bonne Bay

The renewal of old friendships was the most pleasurable part of our return to the field, and first of all we paid our respects to Mrs Vatcher and Dr Murphy at the Glynmill Inn. Farther on we stopped at Woody Point to enjoy a fine steak supper with Emma Tapper in her Seaside Lunch Room, later topped off by some of Mrs. Prebble's eighty-fourth birthday cake and a toast with Bill Prebble's single malt stock, and we finally checked into Ed Roberts's new housekeeping cabins. The next day we continued north past Gros Morne and the spectacular escarpment bracketing St Pauls Inlet, and stopped for the night with our old friends at Wentzel's Sea Pool Cabins in Portland Creek.

This section of the new highway along the very edge of the sea was still in a pioneer stage of construction. It had been bulldozed across the undulating surfaces of outwash fans and was a cramped two lanes wide,

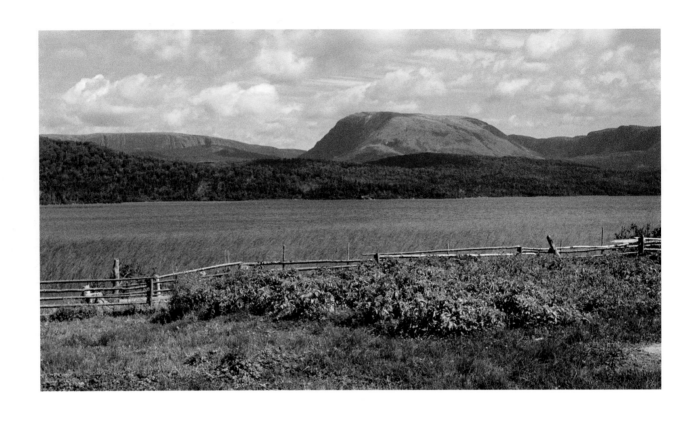

Gros Morne, a few miles north of
Bonne Bay

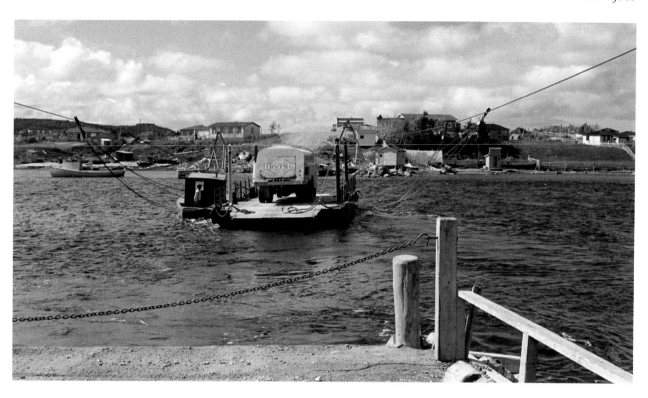

The car ferry at St Pauls Inlet. As of 1961, several major streams on the west coast had not yet been bridged for highway traffic.

*A view of Cow Head from the
coast highway*

Road building through the bush a short distance north of Point Riche Peninsula. This was the northern terminus of the west coast highway in late August 1961. In the summer of 1963 we were able to drive farther north to the Viking site at L'Anse aux Meadows, at the extreme tip of the Great Northern Peninsula.

† *William J. Lundrigan, Ltd, incorporated in 1947, was a group of companies that operated out of Corner Brook. One of Lundrigan's specialties was building and paving highways.*

with questionable shoulders. Cars and trucks were still few and far between, so local drivers tended to rattle happily along at high speed in the middle of the road, quite oblivious to danger. The many dips and hollows in the road were blind traps, and for survival I quickly learned to slow down and edge toward the ditch until I could see over the brow of these hillocks. However, very few approaching drivers observed this precaution, and twice during the summer we were forced off the road. Finally, about noon on 25 June we came to the Point Riche turnoff, and less than a half-mile farther to the north we could see the roadhead being actively bulldozed into the bush by Lundrigan† crews. So the omens had served us well; we had arrived in Port au Choix in the very first days when it could be reached overland by road. For the past eleven years the isolation of the Great Northern Peninsula had been nibbled away by various forms of modern technology, but now, with the sudden

By midsummer of 1961, Port au Choix was connected by gravel road to the outer world of the south, but local transportation in the vicinity of the village was still being carried out by traditional means: horse and wagon, dogsled, and open motorboat.

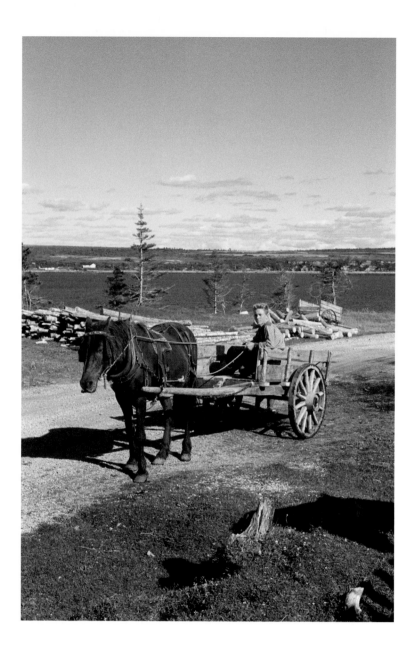

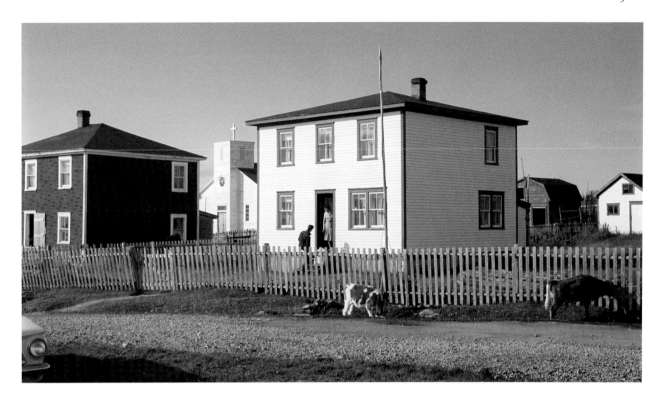

Our expedition headquarters at Port au Choix, rented from Cassie Noel. Most of the houses in the outports were surrounded by picket fences in order to keep free-ranging local animals out of front yards and gardens.

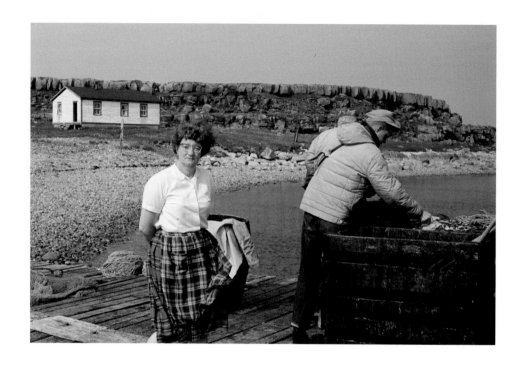

Cassie Noel, our landlady, on her wharf at Old Port au Choix

coming of an open road from the south, nothing could stop the flood of modernization.

We passed through the village along the old waterfront trail, still unpaved and deeply rutted, and up the western slope to Cassie Noel's house, which I had rented fully furnished. This turned out to be a very satisfactory arrangement because there was room for five to sleep indoors and also a large meadow alongside the house where we set up tents for those who preferred to stay outdoors; and we still had space for a baseball field. Our next-door neighbours to the east were Pat and Mildred Rumbolt; their numerous handsome children included Dallas, who later was an excellent fieldhand for me, as well as Lorna and other playmates for Vicky and Doug. Some of these childhood bonds have endured to this very day. Furthermore, ours was one of only three houses in the village that could boast of a bathroom with standard fix-

Neighbourhood children playing in our side yard in Port au Choix; Vicky Harp third from left

Children make good neighbours. Left to right: *Dallas Rumbolt, Doug Harp, Lorna Rumbolt, Vicky Harp*

Left to right: *Ernest Billard, Pius Billard, Fintan Gould*

tures. These luxurious pieces were served by gravity feed from a pond back in the woods, and to supplement the icy water we kept a kettle steaming constantly on the kitchen stove. When someone filled the bathtub or flushed the toilet, the feed pipe occasionally belched out a clutch of mouldy leaves or some dead beetles, but after the first horrified shrieks of surprise these intrusions were matter-of-factly accepted.

Elaine was our cook that summer, and to help her in the kitchen we hired Bernice Northcott, daughter of Harold and Diddy, who developed into a competent and pleasant household aid during the next two summers. Our neighbour Mildred Rumbolt was indispensable as she patiently coached Elaine in lighting the kitchen wood stove and *finally* taught her how to keep the fire going all day. So we had an excellent weatherproof support base for our field operations, and the crew had no worries about housekeeping or camp chores. We were free to dig to our heart's content in Phillip's Garden, or as long as the rain held off.

Pat Rumbolt forking cod from a barrel at Cassie's wharf

*Ange Cadet visiting in our front yard
at Port au Choix*

Three of the guests at a party we gave for our friends in Port au Choix. Left to right: Mrs Gould, Cassie Noel, Mrs Eugenie Billard

Meanwhile, our village social life resumed seamlessly as old friends dropped in to greet us, and during the next several days Elaine and I called on all the Billards: Ernest and Liz, Pius and Ella, Walter and Dete, and Romeo and Millicent. Also, we visited Jack Farwell, the Northcotts, and the matriarch Eugenie Billard (her husband James had died during our long absence). These old friends had made Port au Choix seem like a second home to us.

The village itself seemed unchanged at first view, but another look showed that adaptations were already being made in response to the pressures of the outside world. For example, the main waterfront "street," although still essentially a narrow, unpaved wagon path, was already rutted and pot-holed from the early stages of car traffic, including an astonishing but very welcome two mail trucks each week from outside. Most of Mr Darby's old establishment on the shore had been

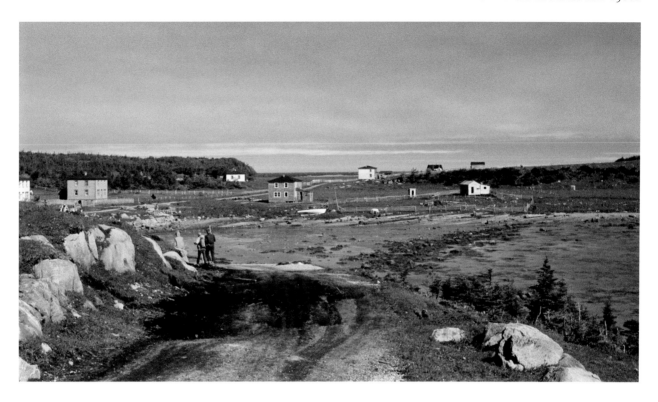

"Main Street" of Port au Choix, extending along the waterfront of the Back Arm. The most distant house on the far ridge was the home of James and Eugenie Billard.

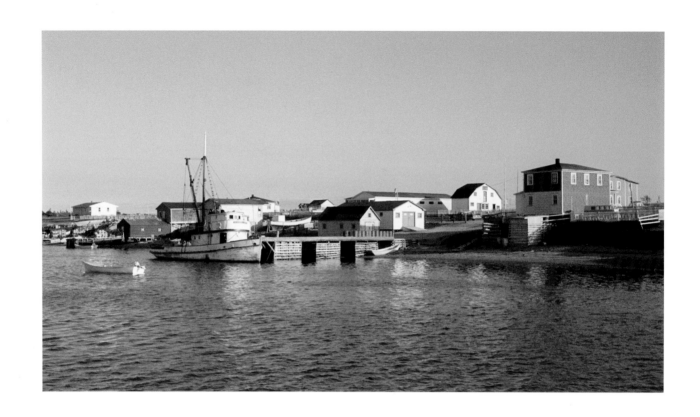

View of the Port au Choix shoreline from the government wharf

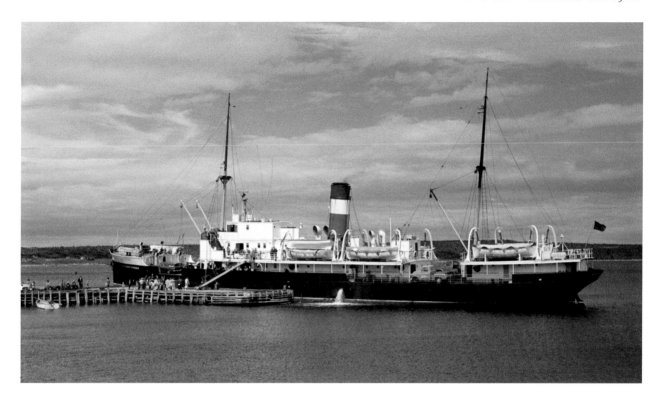

SS Northern Ranger *at the government*
wharf in the Back Arm

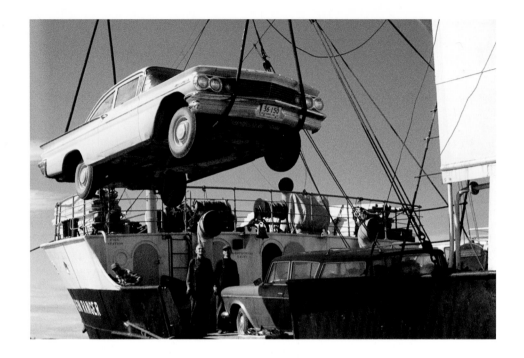

Car being hoisted onto the Northern Ranger. *Since the road extended no farther than Point Riche, the coastal boat was the only way to transport cars up and down the Northern Peninsula.*

torn down and replaced with a larger government wharf, new storage buildings, and a wide approach ramp for freight vehicles. Even the *Northern Ranger*, when it arrived several days later, was under the aegis of new management and sported the blue, white, and red-striped funnel of Canadian National Railways. Walter Billard had built a boxlike movie theatre just across the road from his house, and Theo Farwell had put up a new soft drinks parlour to the east of his parents' home. Both of these new social centres had altered the dynamics of Port au Choix; but, in all frankness, neither of the buildings had enhanced the peaceful charm of the old settlement in the Back Arm. However, they did mark the coming of modern economic advantage for the people.

Our house was well settled by noon the second day, so we all hiked out to Phillip's Garden to check the condition of the site and to set up the lean-to shelter for storing our equipment and supplies there. The site

On our morning hike to Phillip's Garden,
climbing over the limestone outcrops along
the outer shore

*Excavations in House 5 on the middle
terrace, Phillip's Garden*

Elaine Harp lounging on top of the scrub fir bordering Phillip's Garden

itself was beautiful and green, and was unchanged, except for the presence of a half-dozen horses grazing across the meadow. This same remuda later appeared every few days on a regular circuit of the peninsula, but it was a mixed blessing. Occasionally, Geoff would lasso a steed and enjoy a bareback trot around the meadow, but one day the horses browsed their way into the clearing behind our house where we had two sleeping tents set up. Then they accidentally tripped through some of the tent guylines, and in their ensuing panic completely shredded my favourite Aberlite tent.

However, back at the site, we settled down to the main business of digging, although the following days turned out to be erratic – interrupted by frequent showers, more or less as usual. We tried to be patient with the fickle summer weather that swept across the strait from Labrador, but when the primary culture layer in Phillip's Garden turned

*Elaine Harp in a field of flowers,
Keppel Island, off Port Saunders*

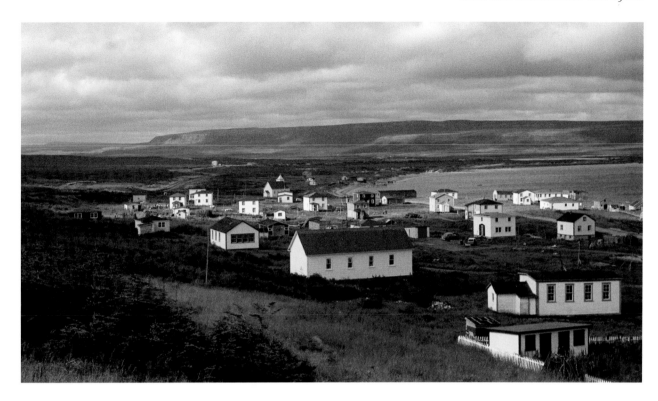

*View of Forteau from the hillside, looking
northwest toward the interior of Labrador*

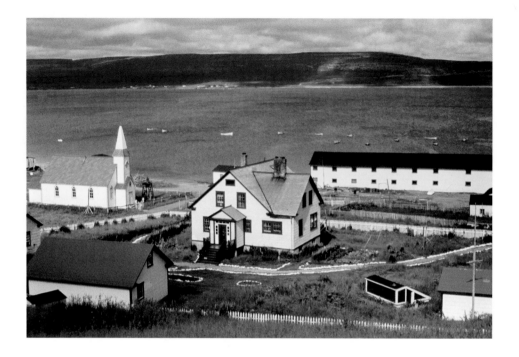

View of the Anglican church, the Grenfell Nursing Station, and the community fish plant, with the northern shore of Forteau Bay in the distance

into sticky black mud we often had to stop work and return home for a session of cleaning and cataloguing specimens. To the professional, this kind of regimen can be tolerated as a fact of life; also, it can be fascinating and enjoyable when excavation is as richly productive as it was in Phillip's Garden. However, to the average student crew member it became repetitive drudgery after a few days. To minimize this undergraduate ennui, I had planned to break the two-month field schedule with a short vacation trip in midseason, and this year we all boarded the *Northern Ranger* and sailed away to Labrador.

During our years of absence from Newfoundland I had been in touch with Dr Curtis from time to time, and one summer he had visited us in Hanover. On that occasion he had said that if we ever came back to Forteau we should plan on staying at the Grenfell Nursing Station, and this is what we did in early August 1961. Here is Elaine's report on that

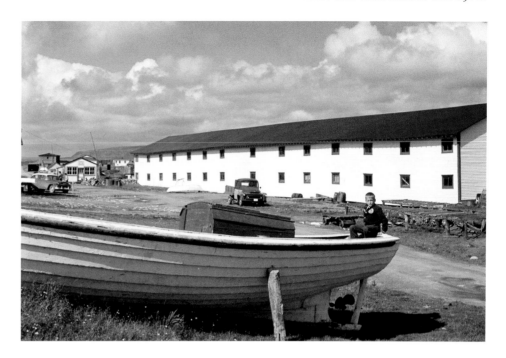

The community fish plant at Forteau was built in the 1950s, after the confederation of Newfoundland with Canada, as a result of the new federal emphasis on cooperative industry throughout the province.

experience, an essay that was published in the July 1962 issue of *Among the Deep Sea Fishers.*[†]

How shall 1 remember Forteau?

By many things: the warmth of Mary Taylor's welcome and her continued kindness to a group of total strangers; her taking the time at the close of an endlessly busy day to teach my daughter to knit, fresh-from-the-oven cookies being sneaked upstairs to Victoria and Doug at bedtime by Hazel, Harriet, or Ethel, myself sneaking downstairs at 3 a.m. to retrieve from the clothing supply closet a much-needed flannel nightie I had contributed earlier, before the weather turned chilly; a cake-decorating "class" I held one rainy afternoon for the staff and ambulatory patients in the cozy warmth of the kitchen – Aunt Mary Fowler, the doyenne of the Station, as keenly interested as anyone; sending to St. Anthony via the R/T "sched" for the children's birthday presents (to

[†] *Reprinted here by permission of Aruna Thampy, acting executive director, Grenfell Regional Health Services, St Anthony, Newfoundland*

*Mary Taylor, RN (in charge of the
Grenfell Nursing Station) in front of
the Anglican church*

Young women from Forteau village in uniform as hospital aides at the Grenfell Nursing Station

Bessie and Raymond Flynn, a most hospitable couple, who maintained the Grenfell Nursing Station

The Flynns' house beside the Grenfell Nursing Station

Mr and Mrs Rob Roberts of Forteau Bay and their six children – as good and friendly a family as we met anywhere on the coast

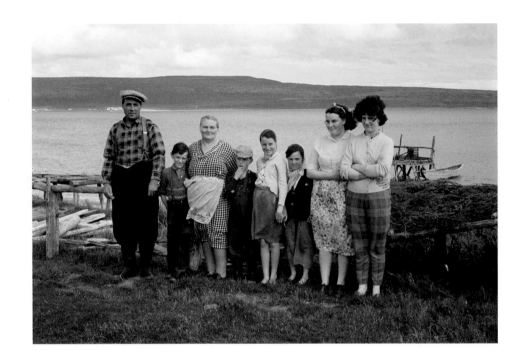

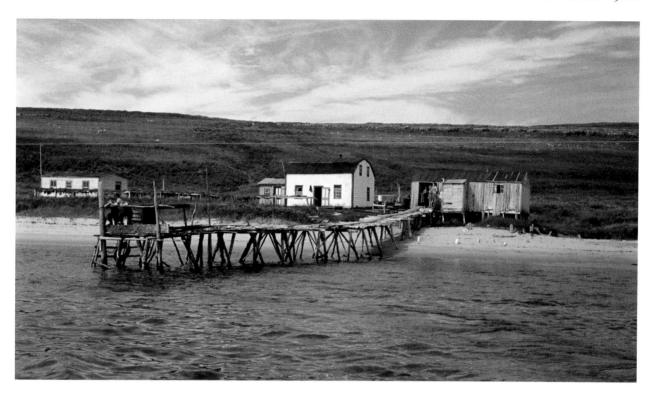

The Roberts's house and holdings in
Forteau Bay

Rob Roberts, our local boatman,
with two of his children on their
front porch

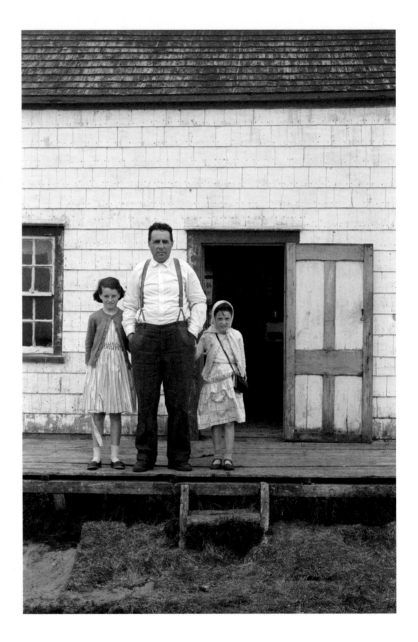

*Mrs Rob Roberts setting her dinner
table with her best china*

Rob Roberts's elder daughters in their kitchen corner

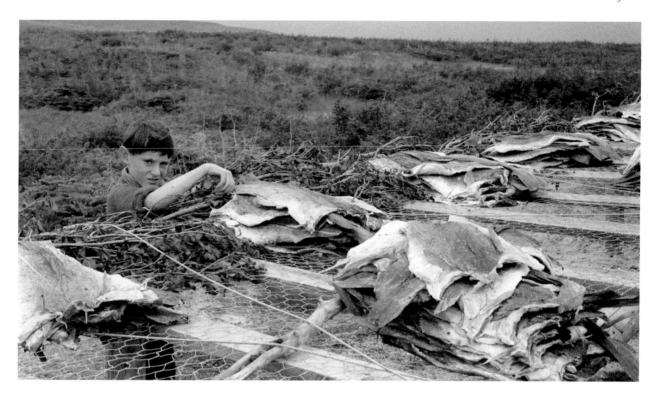

*Rob Roberts's son stacking dried split cod
at a family flake*

*Clothes drying on a fence in
Forteau village*

us a most glamorous way of shopping); and the utter delight of their recipients of the hooked wall mat and komatik model chosen by Miss Andrews and delivered by plane; fellow conspirator Willis Flynn and I, very early one morning, frantically stuffing a million feathers back into the kitchen rocking-chair pillow which had been shredded during the night by Mary's puppy – lest the righteous wrath of the staff, shortly arriving to get breakfast, descend upon his head.

The sights and sounds beyond the Station: family washing, embellished by gaily patterned hand-hooked rugs, hung out to dry on fences, a winter's supply of dog food cached high above the ground on a stilted platform; a solitary hawk riding the air currents above Crow Head, exploring a valley of sand dunes of unbelievable heights and shapes on the way to Buckle Point, gathering bakeapples on the paisley-shawl-colored barrens above L'Anse aux Morts; sorting, matching, and selecting muskrat pelts on Rob Roberts' "bridge"; my

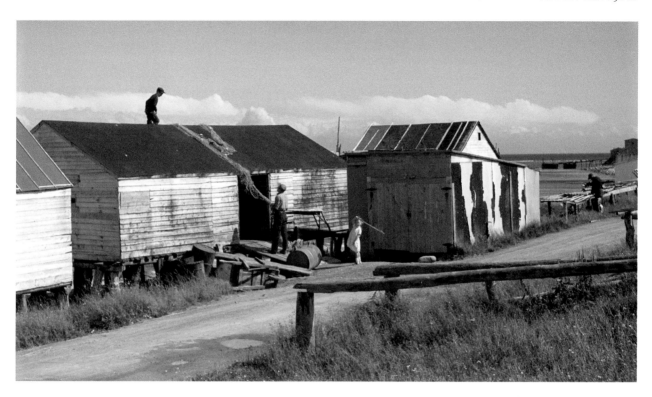

*Spreading fishnets to dry on a shed roof,
Forteau Bay. These wooden buildings were
the old-fashioned storage sheds for the nets
and other equipment of each individual
fisherman.*

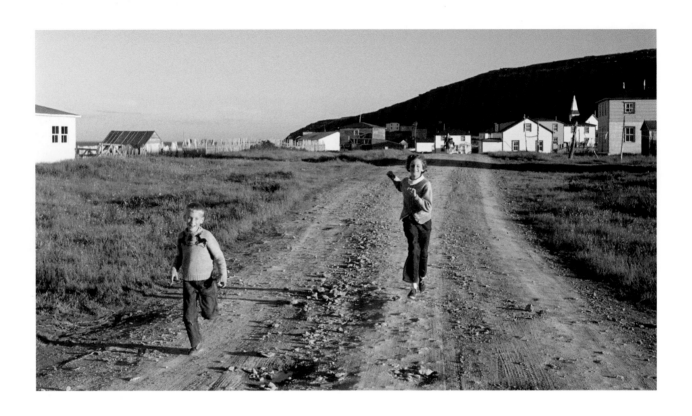

*Doug and Vicky Harp running along the
roadway leading west from Forteau village*

Shell-decorated graves in the Forteau cemetery

Mr and Mrs Robert Trimm who lived in the small settlement at English Point in the northwest corner of Forteau Bay

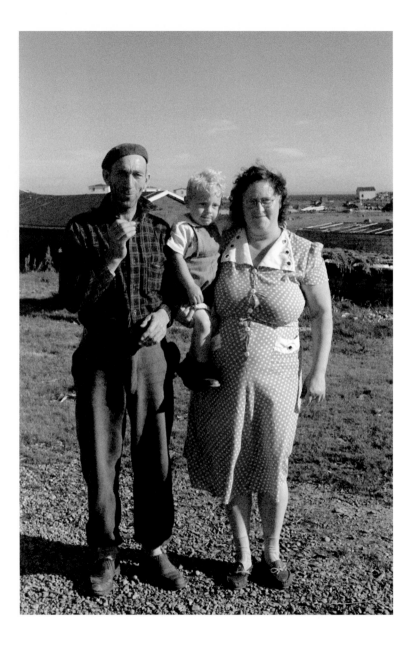

Culling out salt cod at wharfside in Forteau Bay

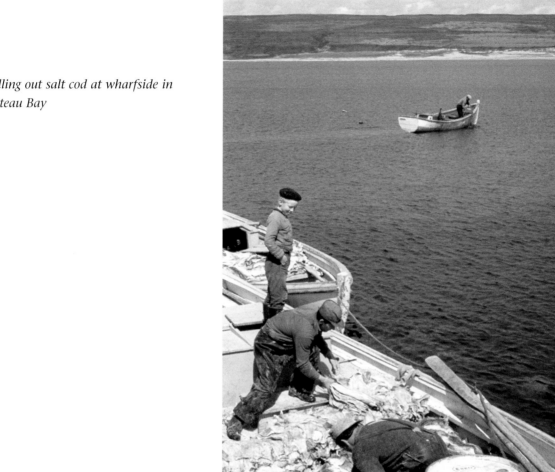

William Davis on his wharf at
L'Anse-Amour

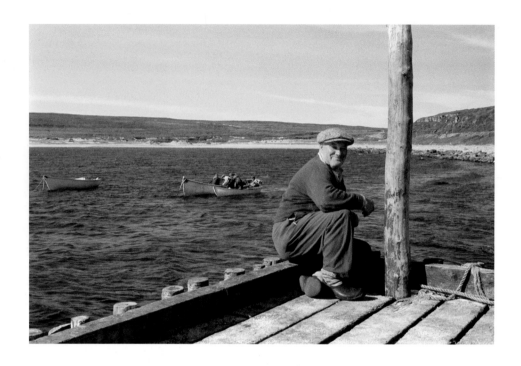

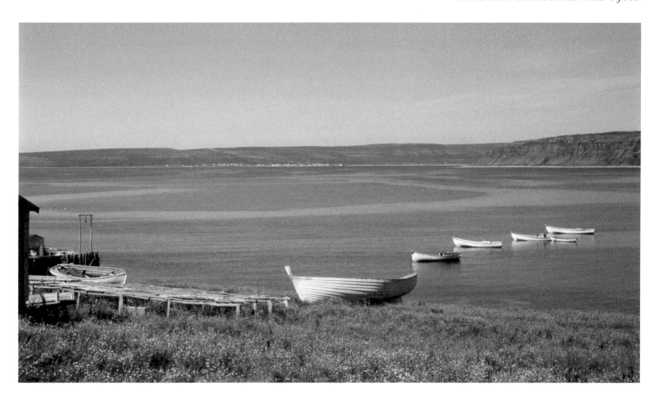

*Local fishing boats at anchor, L'Anse-
Amour. Forteau village is on the far shore.*

*Sealskins on stretching frames being
washed and softened in the brook at
L'Anse-Amour*

Geoff Harp's trout catch in the pan,
L'Anse-Amour

Exploring in the sand blowouts
behind L'Anse-Amour

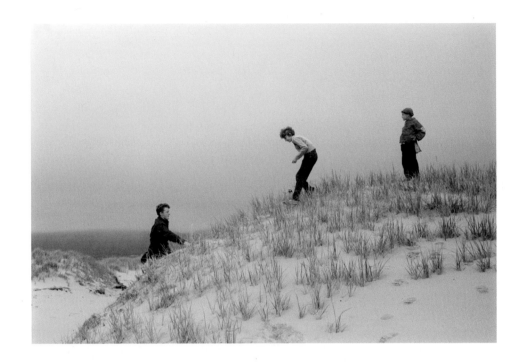

children, and everyone else's, barefoot, collecting a fortune in sand-dollars in a rose-tinted sandy cove; in stormy weather, the whoo-whump, whoo-whump of the Point Amour foghorn; every evening a Delco generator stuttering into activity and shattering the quiet, on moonlit nights a husky's eerie bone-chilling howls arousing echoes among all the settlement dogs; on clear mornings the staccato beat of engines in fishing boats setting out at dawn; the red Mission floatplane throttling down for a landing on the pond; and finally the distinctive, asthmatic wheeze which always precedes the blowing of the *Ranger's* whistle, followed by our scramble down the ironrunged ladder at the end of the government wharf, in total darkness, into the pitching, heaving mail boat — and then reluctant goodbyes and inadequately expressed thanks to everyone for all they had done to make our stay at Forteau quite perfect and unforgettable.

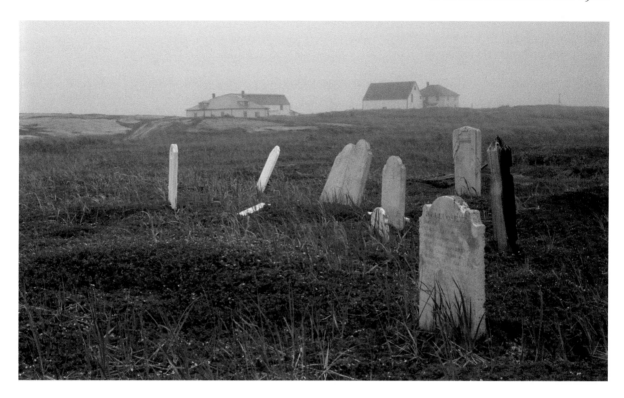

*Old graveyard at the Hudson's Bay
Company post at Blanc Sablon, Quebec*

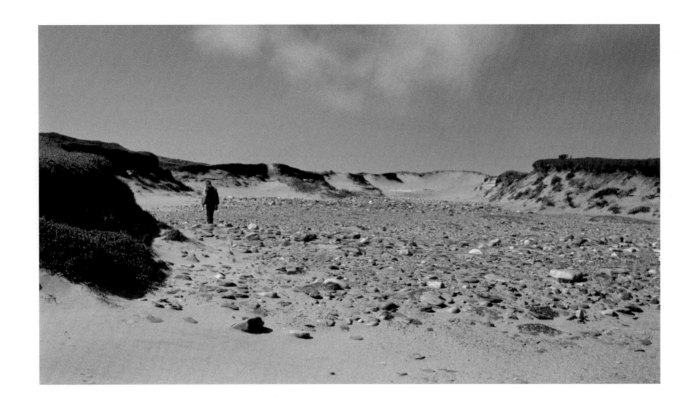

Blowouts in the coastal sand barrens at Blanc Sablon. Numerous archaeological sites have been discovered in these coastal sand barrens, which characterize every river mouth in southern Labrador. These erosional deposits were laid down as river delta formations in early postglacial time; they became exposed with subsequent crustal upwarping.

Mr Russell, manager of the Hudson's Bay Company post at Blanc Sablon, together with his son (right).

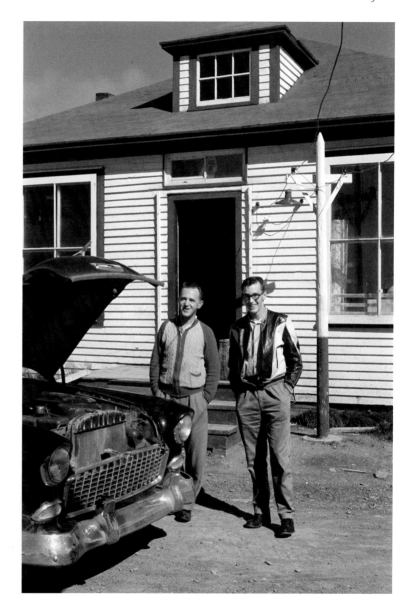

Passengers boarding the Northern Ranger *from a boat at Reef's Harbour. Very few of the Newfoundland outports had docking facilities for larger vessels such as the* Northern Ranger *or the* Springdale, *so the steamer customarily heaved to at a safe distance offshore while mail, freight, and passengers were ferried back and forth by a small boat.*

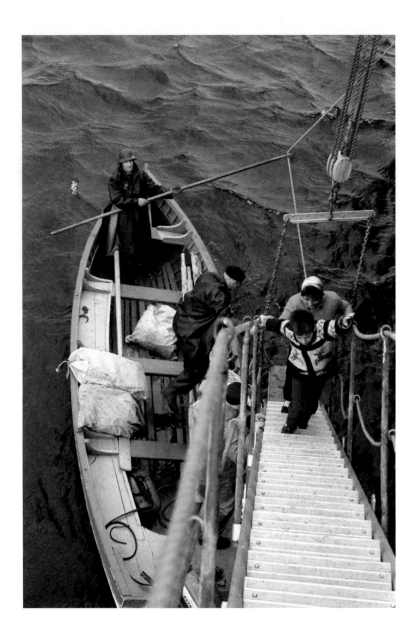

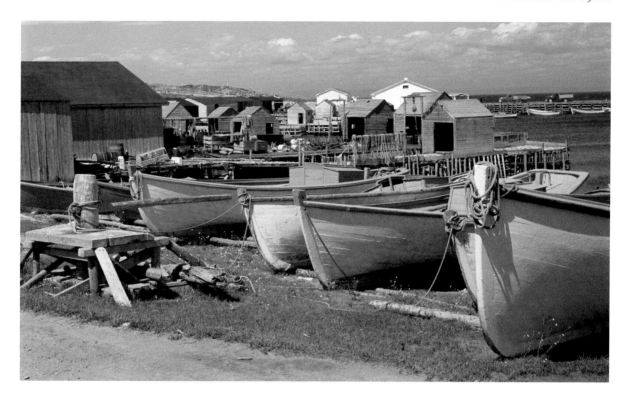

Fishing boats winched onto land, Sandy Cove. Beyond are individual fishermen's "rooms."

Open barrel of cod livers at Sandy Cove

My field research that summer of 1961 was augmented by some valuable gifts from local friends. Fintan Gould and his brother had discovered a Dorset Eskimo burial cave in Gargamelle Cove back in 1954, and they had carefully dug out an extensive collection of stone, bone, and ivory artifacts, as well as the partial skeletons of several individuals, ranging in age from immature to adult. Fortunately, at the behest of Fintan's mother, who was a local schoolteacher, the brothers had kept good written notes about their excavations, and their collection had been saved almost intact in the Gould home. When I examined the cave, I could not find any additional specimens because the Gould boys and numerous others who followed them in later years had shovelled it out thoroughly; however, I was most grateful when Fintan turned his discoveries over to me for study and keeping. In addition to these prehistoric Eskimo materials, I was presented with partial skeletal remains from two more Archaic Indian burials, which had been accidentally exposed at various times by Pius and Romeo Billard. The Indian skeletons were random discoveries and all of them were incomplete and fragmentary, but in each case there were grave furnishings of bone and stone artifacts that positively identified their ethnic origin. All told, these Indian burials – including the skeleton that Mr Darby had given me in 1949, the Eskimo burials in Fintan's cave, and an infant Dorset Eskimo burial that we later discovered in Phillip's Garden – demonstrated that western Newfoundland had been occupied at various times by two discrete aboriginal populations. The Archaic Indians, whose antecedents came out of the subarctic boreal forest, were the first to occupy the island, while the Dorset people came out of the Arctic in later centuries.[†]

After the profitable trip to Labrador, our working days in Port au Choix and Phillip's Garden resumed in their pleasant and productive way, and by this time I had begun to sketch plans for two more expeditions to Phillip's Garden. Meanwhile, as we were fully accepted members of the community, our local friends dropped in at any time without ceremony, and we reciprocated. I realized daily what a valuable presence

[†] *See Harp and Hughes, "Five Prehistoric Burials," for a more detailed analysis of all these prehistoric burials.*

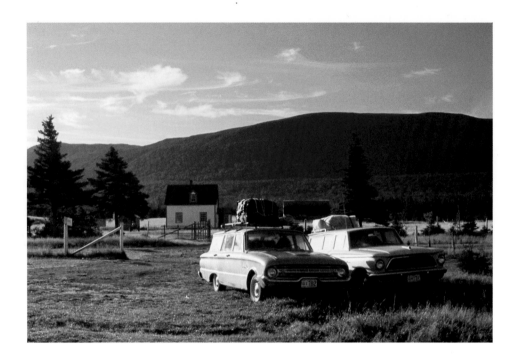

Mike Wall's homestead on the south branch of the Codroy River, with our expedition cars parked out front

Elaine was, not only as a fine cook but also as a wife and mother with her children, helping us to integrate everywhere with the outport communities. Through the summer some special people from the past came for brief visits. Dwiddy (Edwina) and her sister Gerine Murphy were honoured guests at the site; Bill Parsons came from Bonne Bay, and Robert Trimm crossed over from Forteau. Dr and Mrs Graham visited from Port Saunders for an evening, and Abe Hines came by twice with cases of beer for sessions of storytelling. We also experienced a different kind of visitation with the arrival of the "gospel boat." This handsome seagoing cruiser, built in Scotland, was travelling around the outports to bring Bible messages to the people, and its crew consisted of two American missionaries and a young man from Forteau – a son of Jack Buckle whom I had met in 1949. A couple of my boys enjoyed debating religious principles with the missionaries, but others were glad when

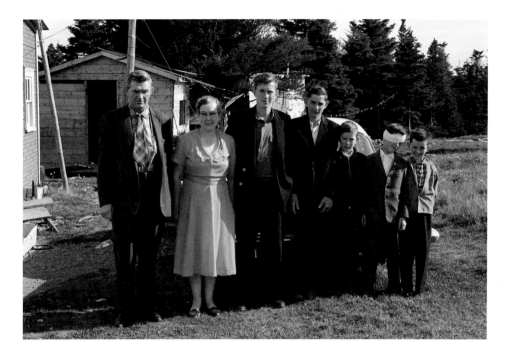

Mr and Mrs Mike Wall and their five sons

they finally shut off their highly amplified loud speaker and the village could quiet down for the night.

At the very end of August our working summer shut down too, and we celebrated by holding a "time," a party for our local and other nearby friends. Then it was off to Corner Brook for our usual transfer to the outside world, as well as an interview for CBC with Fred Scott, who had come across from St. John's. Our last night in Newfoundland was spent in Mike Wall's cabins in the Codroy Valley and was made hilarious and largely sleepless because the narrow-gauge Newfoundland Railway passed by our back porch at a distance of about fifteen feet. But what a wonderfully hospitable couple Mike and Mrs Wall were! They seated us all together, eight of us, in their kitchen for a bountiful supper and did so again the next morning for a genuine country breakfast. The bill for two cabins was twelve dollars and the sixteen meals cost twenty.

For the second summer in a row I was able to rent Cassie Noel's house on the Back Arm of Port au Choix. It was a most convenient expedition base, close to our friends in the village and within thirty minutes' walking of Phillip's Garden.

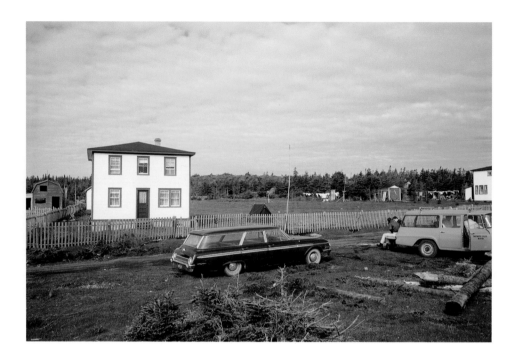

The National Science Foundation generously supported my research project for two more years, so again our cavalcade rolled into Port au Choix. We arrived on 23 June 1962, this time as an all-male group, which included son Geoff, one of his schoolmates, and six college students.[†] Elaine had opted for the more benign environment of Cape Cod, and of course Vicky and Doug were with her. We moved directly into Cassie Noel's house, which I had leased for a second time, and following the recommendation of local friends I had hired Mary Wells, a resident of Brig Bay, as our cook. In previous years she had served as cook and housekeeper for the parish priest in Port Saunders, but now she adapted cheerfully to my crew of slightly irreverent young Americans. Mary lived with village friends but spent all the long days and evenings at our house, cooking, baking, menu planning, and shopping; she was the overseer of our personal laundry and did the mending and the general

[†] *Ernest S. (Tiger) Burch, Jr, George C. Capelle III, Alan V. Davies, William W. Fitzhugh, Nicholas J. Listorti, and Kenneth E. Sack*

Mary Wells kneading bread dough. She was our excellent cook and house mother at Port au Choix for two summers – 1962 and 1963.

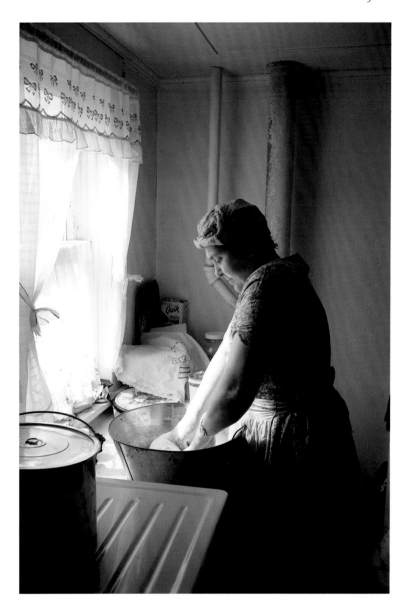

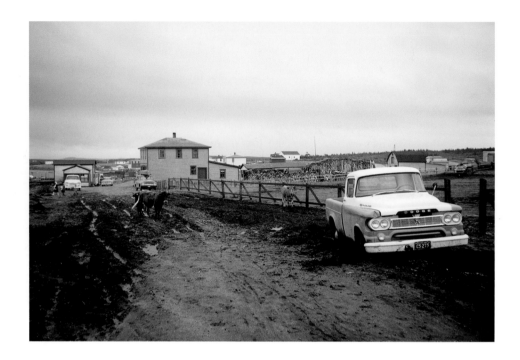

The new highway brought cars into Port au Choix, which quickly turned the narrow lanes into muddy roads.

housekeeping, and I had arranged for Bernice Northcott to come again and be her full-time helper. Mary was a wonderful friend to the boys, a real house mother, and we were totally happy with her warm and agreeable company. In particular, I was most grateful for her ever-ready willingness to help and also for her strong loyalty.

Within two days after our arrival I managed to satisfy the social amenities by visiting or otherwise greeting all our old friends, downing an unusual volume of beer and other welcoming libations, and also distributing the presents that Elaine had sent for her favourite people – a list that encompassed most of the village. Then we trucked off to organize operations at the site. Although we had driven from New Hampshire in two vehicles, this year I had a new expedition van that could carry all seven of us for short hauls, and so by driving along the trail to Noel's fish plant in Old Port au Choix and parking there, we saved a half-hour

Cleaning cod at Cassie Noel's fish plant in Old Port au Choix

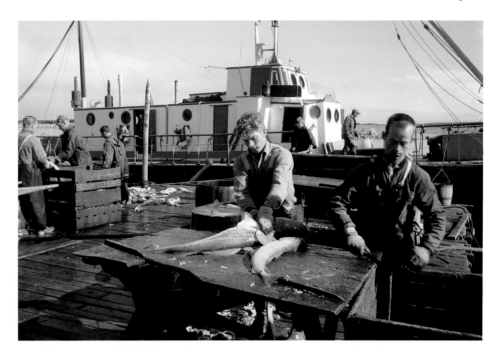

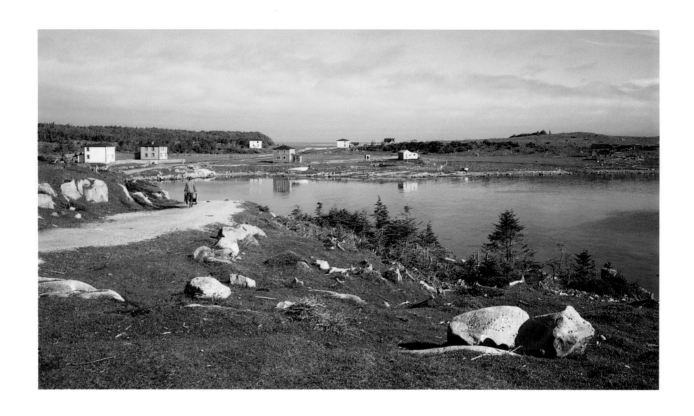

View across the bottom of the Back Arm.
The houses farthest in the distance are on
the isthmus that separates the Back Arm
from Old Port au Choix.

This house on the hill between the Back Arm and Old Port au Choix stands on a Dorset Eskimo site.

*Water-eroded limestone terraces such as
this are exposed around the periphery of
the Point Riche Peninsula. They mark the
location of ancient wave-cut beachlines
and testify to upwarping of the land in our
postglacial era. We crossed over this
segment every morning as we hiked to
Phillip's Garden.*

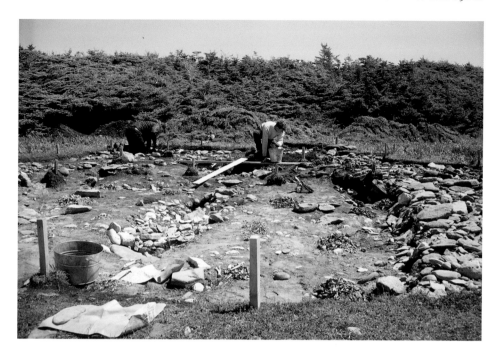

Interior view of House 2, Phillip's Garden, looking south from front to rear. Note the sunken hearth area along the central axis and the terraced wall along the right side of the house.

of walking. At first there was a problem with deep ruts and mud holes crossing the boggy flat below Harold Northcott's house, but for several mornings we hauled out loads of rocks and boulders to plug the soft spots and finally make them passable in any weather. From the fish plant to Phillip's Garden there was the familiar half-mile of very pleasant hiking – through deep soft grasses sprinkled with early wildflowers, over the wave-cut limestone terraces bright with orange lichens, and around impenetrable thickets of tuckamore. At the site we staked out the regular excavation grid for House 6 on the middle terrace, and I used it as a demonstration area where beginners could be coached through proper procedures. Afterward, I distributed two-man teams among several houses on both the middle and upper terraces, and we excavated on the two levels throughout the summer, gaining a widespread sample of

Tiger Burch cataloguing artifacts at our kitchen table

information from five different house pits. The weather continued to be typically uncertain and rainy, but on sunny days the flowering meadow called Phillip's Garden was a superb workplace.

On the bad days we frequently had a fishing party operating a few miles away in Hawkes Bay or in the East River or the Torrent River, where the trout were large and plentiful and an occasional salmon came to net. Nick Listorti and Geoff were ardent fly fishermen, and they sometimes drove the van over in the dawn hours for a pre-breakfast session on one of "our" streams. I enjoyed an occasional afternoon on the water too. Previously I had tried to bargain with the Fisheries Board in St John's for special fishing privileges for the crew, but I never succeeded in getting any reduction in the expensive salmon licences required of outsiders. The bureaucracy would make no concessions. However, we could

*Geoff Harp with his catch from the
East River, Hawkes Bay*

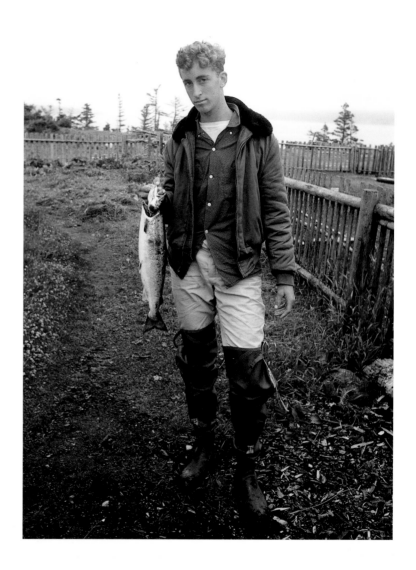

Pat Rumbolt, our next-door neigh-bour, mending a fishnet. Ernest Billard's grey house and store are seen in the background.

buy non-resident trout licences for five dollars for the season, and I was entirely willing to pay that moderate charge, even for the little fishing that we might do.

Meanwhile, back in the village our social life seemed to be controlled by all kinds of commitments. Ange Cadet, one of the early French settlers on Point Riche, was now living a door or two away from us, and he enjoyed dropping in for a nightcap and a few phrases of my mediocre French. The "gospel boat" with our friends from last year tied up again at the government wharf to broadcast its familiar messages for several more evenings. Although there was a small Anglican church on the ter-race behind Walter and Dete's house, where a travelling minister visited periodically, Port au Choix at that time was a predominantly Catholic community. The parish church, graveyard, and school were close behind our house, with only Pat Rumbolt's house separating us from the church-

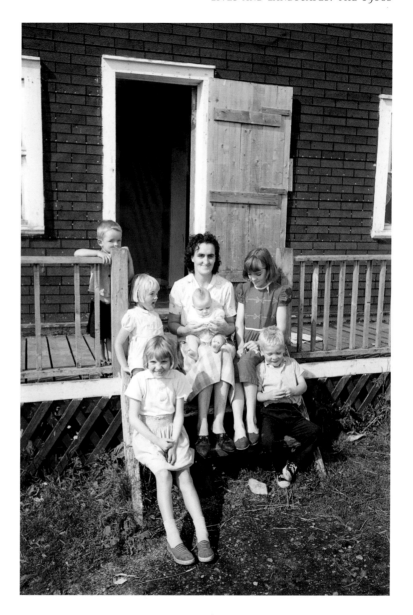

Mrs Pat Rumbolt with her children (except for two older boys) on her front porch

yard. In an undefined manner, we were accepted as informal members of the parish, and the preceding year Elaine and Vicky had been specially invited by the priest to a mass christening ceremony for nineteen local infants. They had attended the afternoon event enthusiastically – each in her best (and only) summer frock, hat, and white gloves – and reported to me later that most of the mothers involved spent their time chatting to neighbours across the back of their pews while Father Nixon concentrated on the ritual of baptism.

Shortly after our arrival in 1962, Dete Billard came to see me to ask if I would please write some kind of tribute to Father Nixon, who had given years of devoted service to the community and was to be honoured soon on a special occasion. So I interviewed Dete to get some basic facts about Father Nixon, then hauled out my portable typewriter and tried my best to compose a worthy testimonial. Two days later Mr Rose, the village schoolteacher, came to Phillip's Garden with an official typewritten invitation to "Mr Harp and Party" to attend a special mass and dinner party in honor of Father Nixon's twenty-fifth anniversary as a priest.

On the appointed day we came home early from the site so that the boys could get cleaned up, and then went over to the church for a jubilee high mass. Many notables from up and down the coast were there, including five additional priests, local administrators from Bonne Bay and Corner Brook, the Cuban doctor and his family from Port Saunders, and Constable Noseworthy of the RCMP. At one point during the service Mr Rose came to the lectern and read the testimony that I had written. Afterward the crowd moved to the school next door and stood around chatting while the parish ladies finished preparing and then served a festive dinner. Millicent Billard was in charge of the entire affair, and it was most efficiently organized and prettily decorated right down to the lavish feast and the new paper curtains on the windows. I was called in to dine first with a select group of bigwigs, while my crew had to wait starving outside with the rest of the crowd. The last of the

guests were fed by 10 PM and then the dance and the "time" carried on into the morning hours. I faded out by midnight.

On 14 July unkind fate brought double trouble to the village. That morning one of Blanchard's heavy trucks delivering salt from Bonne Bay slipped off a soft shoulder into a deep mud-hole in the boggy flat below Harold Northcott's house, making the road impassable. For the next thirty-six hours all movement out to Cassie's fish plant had to proceed on foot, as did we on our way out to Phillip's Garden. Then, late that very same Saturday afternoon, Eugenie Billard, widow of James and matriarch of all the local Billards, died. She was eighty years old, and although I had not seen her since our going-away party the previous summer, I remembered her happy storytelling on our earlier visits. The next night Tiger Burch and I attended her wake in the little house on the crest of the isthmus looking over Old Port au Choix. After hiking along the road in the cold light of a full moon and stumbling around the marooned salt truck, we were let in through the back door and ushered into the dark parlour. There were several women in attendance, but in the general gloom they were barely visible in their mourning garb. And there, laid out on the sofa in the dimness of a single candle, was small, frail-looking Eugenie, covered to her chin with a sheet. We expressed our sympathy to Diddy Northcott, one of Eugenie's two daughters, sampled a token of the food spread out in the kitchen, and left to make way for others. There were no other men present.

The next evening there was a touching sequel to Eugenie's story. Harold Northcott came into our house and diffidently sat on the kitchen bench, listening to my conversation with Dr Robert Black of the Geological Survey of Canada, who had dropped in unexpectedly a while before to tell me about his recent investigations around Forteau Bay. After several minutes of withdrawn silence, Harold dug into his pocket and produced an oblong plate of some soft metal, probably a zinc alloy, which he said was meant to be the nameplate for his mother-in-law's casket, and would I please engrave some words on it so that the family

could keep it as a souvenir. That sounded to me like a tall order, but I had to say, "Of course, I'll be glad to try, although I've never done this sort of thing before." So for the next three hours, by the light of our Coleman lantern, I sketched some trial designs at various scales and finally began scratching away with Geoff's steel marlin spike, trying awkwardly to engrave a simple notice of birth and death. There was no space on the plate for embellishments, but the message was at least legible, and Harold seemed pleased and grateful. I was fairly satisfied because I had not been too sanguine about doing this job successfully. The plaque read:

Eugenie Billard
Born 7 Sept., 1882
Died 14 July, 1962

It was tacked onto the casket before it was lowered into the ground. I was later told that a family member dropped into the grave and removed the plaque before burial occurred.

By Tuesday the weather was sunny again, the salt truck had been man-handled out of the ditch and the road was clear, and at ten o'clock the funeral cortege came slowly over the brow of the hill. The casket was transported in a pickup truck, with Ernest Billard leading the way on foot, bearing a large wooden cross, and trailing behind was a line of relatives and friends that seemed to include the entire village. Tiger, Geoff, and I attended the funeral mass and the interment ceremony at the graveside, and afterward we hiked out to Phillip's Garden to join our crew.

The remainder of that summer was mostly routine and our digging continued to be very productive. We took our midseason break the first week in August by driving across the province to St John's. The trans-island highway was still in various rudimentary stages of construction, so the going was rough and dusty except for a beautiful paved stretch through Terra Nova National Park. We suffered a flat somewhere out in the bush, picked up a flying gravel crack in the windshield, and slid off once into the ditch as the road shoulder collapsed while I was passing an

Eugenie Billard's funeral procession moving along the main street of Port au Choix

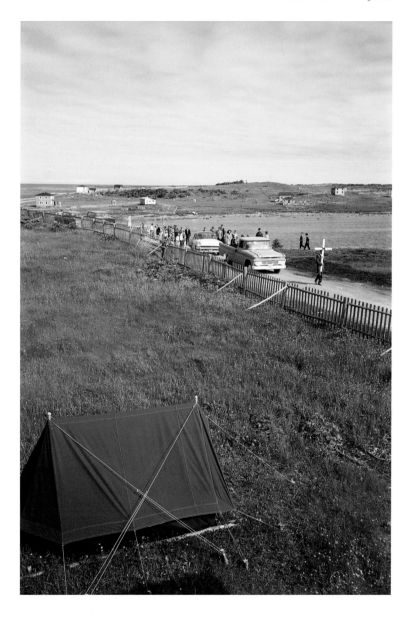

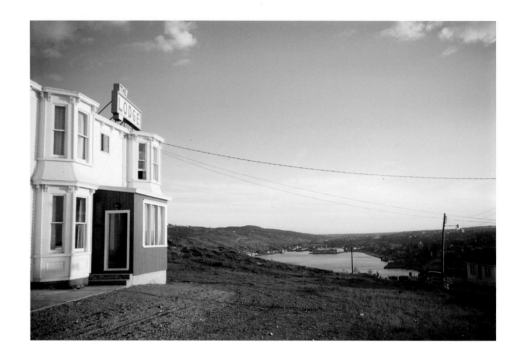

Front of the Lodge on Signal Hill, looking down St John's harbour

approaching road grader. But the operator cheerfully dug out his towing chain, hauled us back up, and within minutes we were on our way again, enjoying these small adventures of the trip. In St John's, my friend Fred Scott of CBC invited me out to his house for an evening, and he kindly ushered us around to some of the major sites in the old town on the sea-front. We also climbed Signal Hill to inspect the Marconi station and the Queen's Battery, and later visited the Newfoundland Museum downtown. Among our many pleasant experiences, I remember discovering the Vogue Art Gallery on Water Street and having a long chat with its proprietor, Les Gourley, a member of a well-known local family, a professional musician, and a talented landscape painter.

All told, the trip across the island was a great success, and we arrived back on the west coast at the end of eight days. I had expected to press on through to Port au Choix, but it was almost midnight when we came

A dory and fishing wharves at Norris Point, Bonne Bay

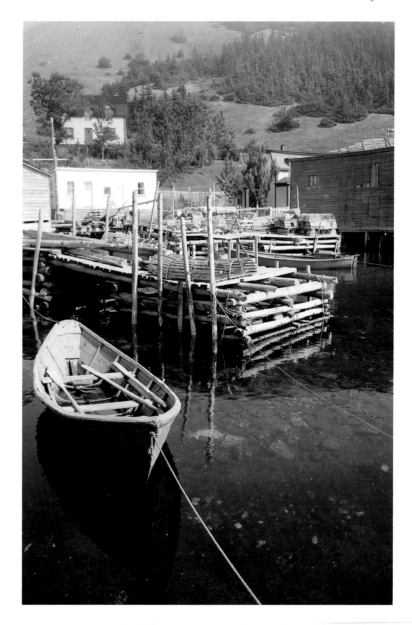

The expedition crew on the bow of Blanchard's ferry at Norris Point. Left to right: *Geoff Harp, George Capelle, Tiger Burch, Kenneth Sack, David Ahern, and Nicholas Listorti*

Blanchard's ferry at the loading dock at
Norris Point, en route to Woody Point

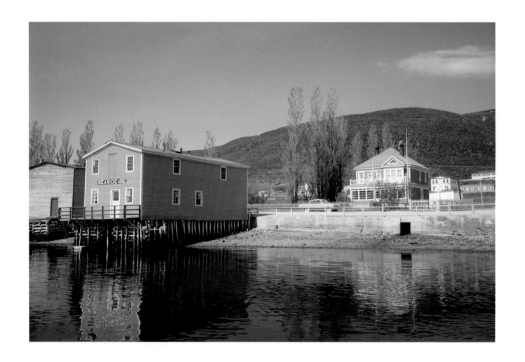

Ed Roberts's house and the Seaside Lunch Room, Woody Point. This small, pleasant restaurant, situated next to Blanchard's ferry landing, was operated by Emma Tapper, who was Ed Roberts's sister-in-law and, I was told, the only licensed female guide for hunters and fishermen in the province. In the recent past Emma had guided for Lee Wulff as he was establishing his Newfoundland organization for sport fishing and hunting.

to Portland Creek. I knew the Sea Pool Cabins, owned and operated by Angus Wentzel, having stayed there before, and we were welcomed even at such a late hour. Although all the rooms were taken for the night, Mrs Luther and Angus opened the cocktail lounge and the boys sacked out there on the floor. As chief honcho, I was accorded special rights and was taken into the motel office, where a daybed had been made up for me.

By the end of August the work schedule at Phillip's Garden was complete, and we began to pull up stakes and pack the field equipment. Our summer operations had been completely successful; in basic physical terms, 116 squares had been excavated and 7395 specimens had been catalogued. We did not lay on our customary going-away party because two nights before our departure Dete and Walter Billard had a full-scale "time" honouring their daughter Brenda's eighteenth birthday. We were

Expedition van waiting in line at Port aux Basques to board the ferry William Carson for the day trip across Cabot Strait to North Sydney, Nova Scotia

all invited, and by midnight the gathering was swinging high and building into an all-night affair; however, my fellows came back to the house at a fairly reasonable hour. The following evening we drove over to Eddie's Cove West to say goodbye to Francis Offrey, another "brief" visit that continued on past midnight. We were joined by some men from a Lundrigan construction crew who had come in from the roadhead for their regular Saturday night partying. I had a good time swapping war stories with Bill Knox, a lively, humourous Irishman who seemed to take a liking to my "silver hair," and as a souvenir of that evening he gave me a hatchet that he had fashioned from a piece of spring steel. As we departed the next morning en route to Bonne Bay, a group of children waved goodbye to us from the schoolyard, and so the field summer of 1962 ended in the same neighbourly manner as it had begun.

The ferry William Carson *at the wharf in North Sydney*

Toward the end of June 1963, we returned for the final field season at Port au Choix. Our travel routine was the same as before, although the roads were greatly improved because a new widened roadbed was being constructed. As before, we stopped briefly to see all our friends along the way, but in Woody Point I was saddened to learn from Mrs Prebble that her husband Bill had died the previous October. He was a fine gentleman and the last of the pioneer settlers in Bonne Bay. Also, over in Norris Point I learned that Bryant Harding's old home had burned to the ground a week before our arrival. Two days later we drove into Port au Choix and moved directly into a house at the east end of the village.

Late last summer, Cassie Noel had informed me that her house would not be available for a third time because she had a long-standing agreement to sell the property to the Catholic Church for use as a residence for Father Nixon or his successors. So I had arranged to rent the home of

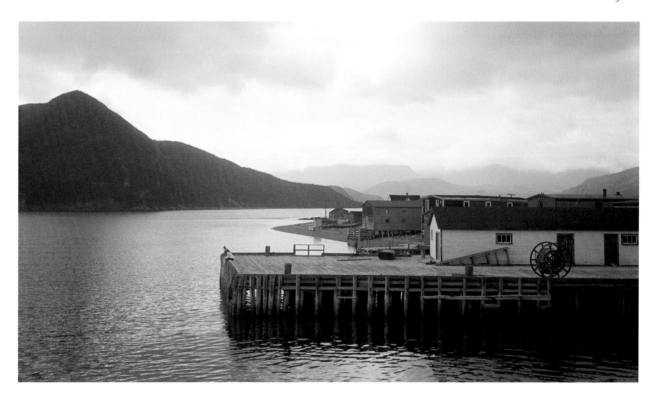

*Steamer wharf at Norris Point looking
across to the tablelands above
Woody Point*

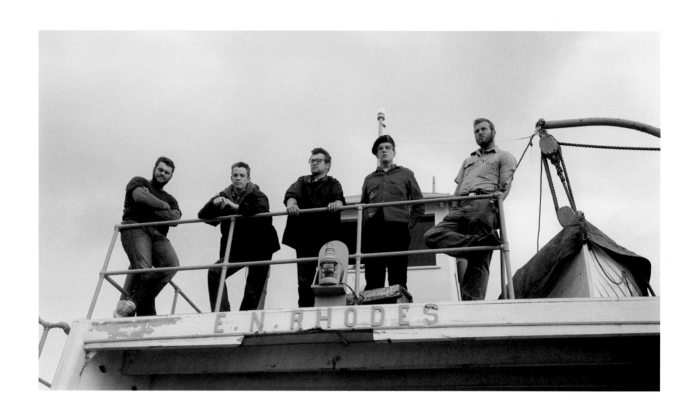

The 1963 expedition's crew on the Bonne Bay ferry. Left to right: *Nick Listorti, Jerry Milne, Bill Bryant, Ray Newell, and John Cook*

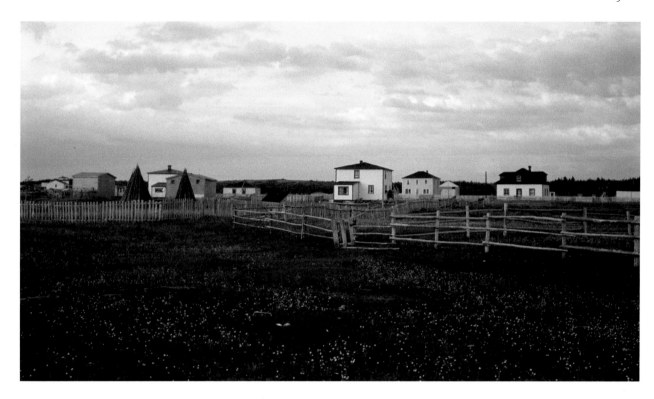

View north across Gargamelle flats, Port au Choix. The Rumbolts' yellow house (toward the right) *was our headquarters in the summer of 1963.*

A postprandial game of chess in our living room in the Rumbolts' house

Bill Fitzhugh doing homework in the "new archaeology" by Mickey Spillane

John Cook splitting stove wood in
our backyard

Mary Wells, our cook from Brig Bay, and her father, Mr Gaslard

Lawrence and Mildred Rumbolt, the keepers of the Point Riche light-house, who customarily vacated it every summer and moved out to the light with their family. This was a more spacious house than Cassie's, though not as completely furnished because the Rumbolts had moved most of their possessions to the lighthouse. However, it was very comfortable and convenient for us, with large open yards for parking our vehicles or pitching horseshoes, and with space to set up one or more tents for visitors; and there was a substantial pile of wood to be split for the stoves. We did not have our previous advantage of running water, but the small hand pump at the kitchen sink was adequate, as was the outhouse. Mary Wells knew all about this change, and when we arrived she was already ensconced in our kitchen and had prepared a welcoming supper of fresh lobster, with the help of her niece, Gloria Atkins, a very nice local girl and a willing worker, whom I was glad to hire for the

Mary Wells and Gloria Atkins having lunch in our kitchen at the Rumbolt house

entire summer. Thus, we were off to an auspicious start for the final season, and for those of us who had been here before it was very easy to resume our previous roles as adoptive villagers and slip back into old, comfortable social patterns.

As for the fieldwork, I had more help now than ever before: there would be ten of us digging full time, including myself. Two of my students, Alan Davies and Bill Fitzhugh, could only stay until mid-July, but Nick Listorti, Ray Newell, John Cook, and Bill Bryant were full-time regulars. Also, Geoff and his best friend Jerry Milne, a Hanover neighbour, were with us, and I had hired three local boys who trained and worked happily with us all summer long: Bud Billard, John Gould, and Dallas Rumbolt. I split this gang into two teams and appointed John Cook and Nick Listorti as crew chiefs, because they were the most experienced field men. Henceforth, these two squads could operate inde-

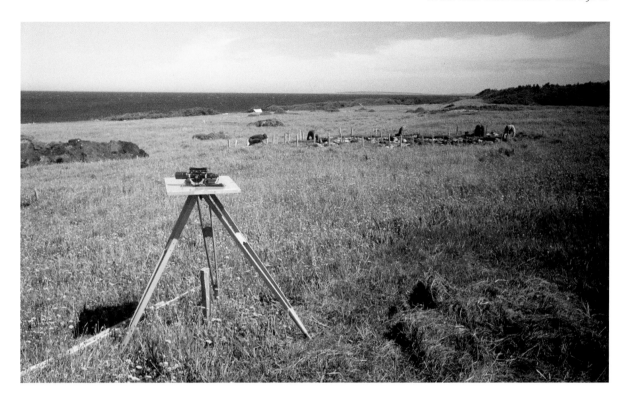

Mapping archaeological features at
Phillip's Garden

Every few days a small string of horses grazed through Phillip's Garden as they made their way around the peninsula. Formerly there had also been a flock of sheep, but in the summer of 1962 they had all been slaughtered by a pack of wild dogs.

A friendly visit to Port au Choix from the northwest detachment of the RCMP, which had taken over provincial police duties from the Newfoundland Constabulary. Left to right: *Constables Dion and Kennedy.*

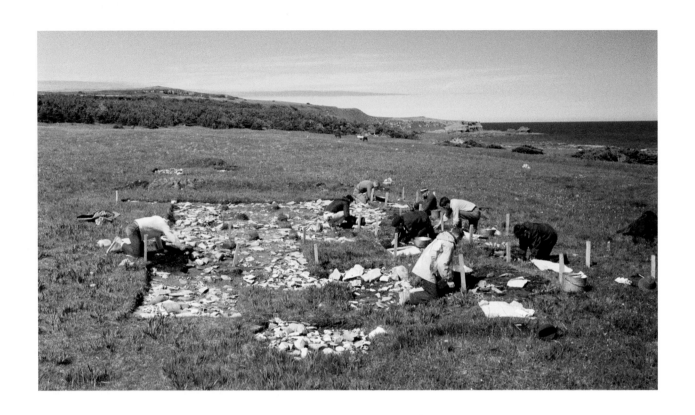

*All of the crew at work in a training
session in House 11, Phillip's Garden*

John Gould (right) *and Jerry Milne* (left) *excavating at House 12*

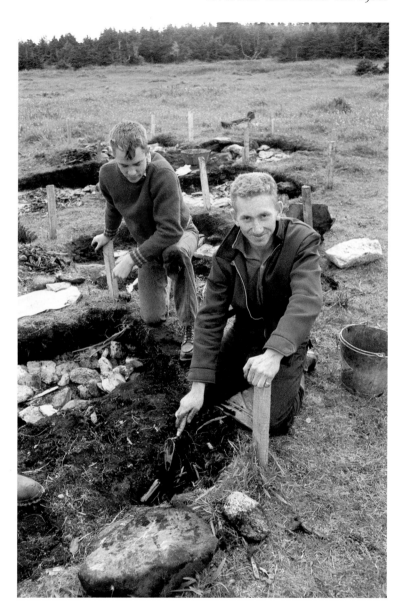

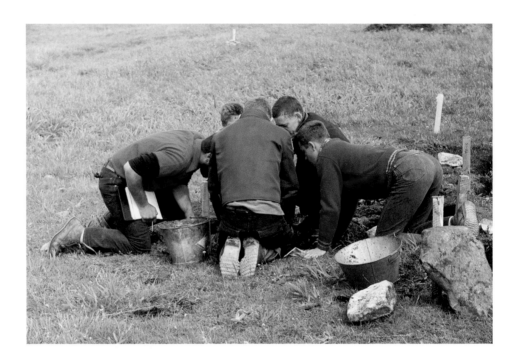

Discovery of a Dorset beer bottle in John Gould's excavation square in House 12

pendently in different houses, and I could shift the emphasis of our digging to meet any new problems that might arise. In this fashion, our excavations continued through the flowering phases of summer as Phillip's Garden was suffused with the pale lavender of blossoming iris and then, late in July, became a golden meadow of buttercups. The pleasure of digging in that richly productive site amidst the natural beauty that surrounded us was often tempered by the wet and stormy weather. However, we had all toughened up and become more stoical about such interruptions, and we put the delays to good use by updating our records and cataloguing specimens during the down times. Our house was better than a tent camp on days like that.

Although I have commented before on our busy social life in Port au Choix, the year 1963 shattered all previous records. By this time, of

Dallas Rumbolt, the youngest field-hand at Phillip's Garden, taking home his prizes at the end of the summer

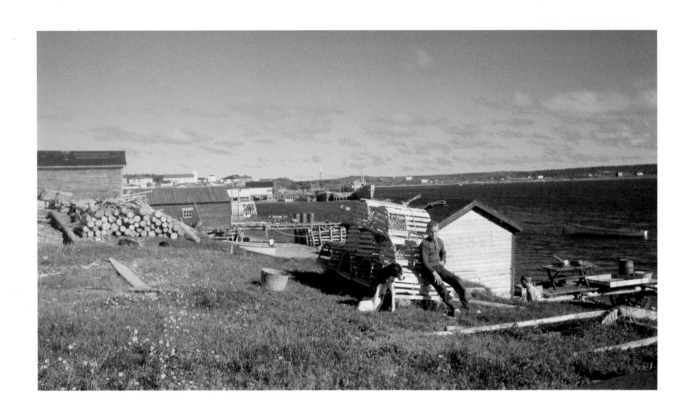

Morning view of the Back Arm and the
Port au Choix waterfront

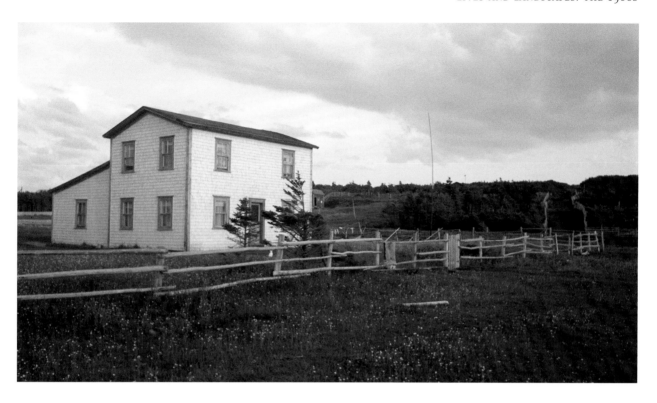

*A typical white clapboard house on
Gargamelle Neck, Port au Choix*

Rainbow over Joe Breton's outhouse and barn. Note the tipilike stack of firewood in Joe's backyard; also the characteristic bedding rows in the potato garden in our backyard (near side of the fence). *The planting rows contain heaped-up earth from the trenches that were originally dug out as pathways for the gardener to walk along while tending his or her crop.*

course, our presence on the coast was more widely known; also the village had recently been connected to the outside world by a new and extensive network of roads that attracted a stream of friends as well as many strangers. The first to arrive were Horace and Hazel MacNeil from St Anthony, with their family and a schoolteacher friend, Erma Hunsberger. They drove up in their van in mid-July and set up camp in our side yard. I took them on a full conducted tour of Phillip's Garden and afterward brought them back for dinner at our house; then, unfortunately, I had to leave for a previous commitment. Cassie Noel had asked me to be the official photographer at the wedding of Annette Billard, daughter of Pius and Ella, to Don Evely, a road engineer for Lundrigan's. I had no experience as a fancy society photographer and had no flash equipment for indoor work, but I elbowed my way around in the happy crowd for the next several hours, hoping that my fast lenses and film

Bernice Northcott's new house in Old Port au Choix

The MV Springdale, *in the distance, is entering the Back Arm, heading for the deep-water channel that lies close to the eastern shore. Closer at hand, a sunken schooner lies aground in the shoal of the western half of the bay, having obviously disregarded the deep-water channel. Local authorities reported to me that the demon rum had been responsible for this lapse.*

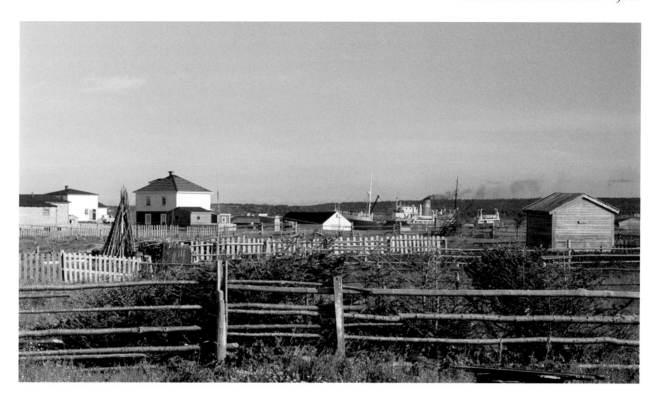

The Springdale (background) *arriving in*
Port au Choix

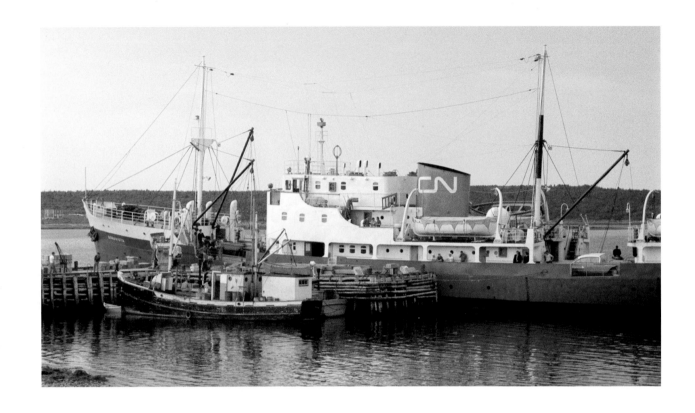

The Springdale *moored in the Back Arm.*
This was the new government wharf that
had been built on the site of Darby's
wharf. As before, the wharf continued
to be the chief commercial centre of Port
au Choix.

A fishing boat from Nova Scotia at the fish plant, Old Port au Choix

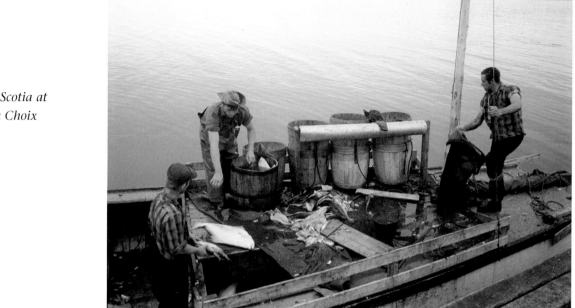

would compensate for these shortcomings. Finally I ended up with a sketchy, not outstanding documentation in coloured slides which I later sent to the young couple as a wedding gift. I hope they liked them. The next morning Horace and I enjoyed a good long reminiscence of the summer of 1949, while he loaded up his family for the trip back home. They would be waiting for us in St Anthony sometime in the next month and would ship us around Quirpon to L'Anse aux Meadows in the mission boat, for the road had not yet been extended north of St Anthony.

The next visitor was Ella Manuel, a writer from St John's whom I had first met briefly in Lomond in 1950. She wanted to interview me for CBC radio and did so for the next two days, hauling her tape recorder back and forth between her room in the village and the site, although I never heard of any resulting broadcast.

Young girls at Port au Choix, including our summer helper Gloria Atkins (centre)

Then came my longtime Dartmouth colleague Professor Robert McKennan, who was driven up from River of Ponds by Austin Patey, his fishing guide. I turned over my small back corner bedroom to him and moved outside into one of my favourite Black's tents. Bob was tickled at the prospect of getting out into Phillip's Garden and working side by side with us for several days, enjoying the classroom ambience of students with a familiar and popular college professor. Also, since he knew about proper field technique, having accompanied me up the Thelon River into the Barren Grounds in 1958, he was a very good extra hand.

The next afternoon a big tall man unexpectedly entered the back door, momentarily blocking out the daylight, and when I looked up there was Helge Ingstad with his wife Anne Stine, their daughter Benedicte, and their professional photographer Hans Hvide-Bang, all from Oslo. Helge Ingstad was widely known as the Norwegian explorer

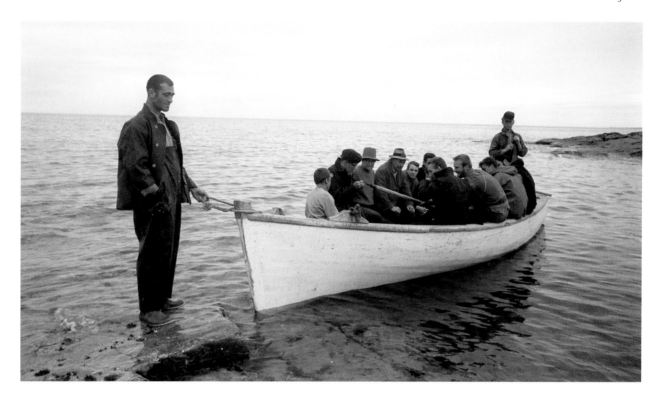

Francis Cornick taking the crew for a boat ride

Anne Stine, who with her husband Helge Ingstad, had come from the Viking site at L'Anse aux Meadows to visit our excavations in Phillip's Garden

Helge Ingstad at Phillip's Garden

Anne Stine and Helge Ingstad at Phillip's Garden

who in 1960 discovered the Viking site at L'Anse aux Meadows, at the northern tip of the Great Northern Peninsula. Anne Stine was the trained archaeologist who was in charge of their very significant excavations there during the period 1961–68. I had met Helge before and indeed he had visited us in New Hampshire, so it was good to see him again here in Port au Choix at a time when we were both actively engaged in significant projects. I was intensely interested in their Viking finds, and they wanted to learn more about my research on the Dorset Eskimo occupation of Newfoundland. So we spent several hours in Phillip's Garden showing them around and exchanging ideas and evidence about our particular sites. Before they departed for L'Anse aux Meadows we made flexible plans for my group's trip to the Viking site in early August.

Diggers Galore! Clockwise from left: *Dallas Rumbolt, Geoff Harp, Bob McKennan, Nick Listorti, Claire and Farley Mowat*

One evening later that same week, in popped Farley Mowat and his wife Claire, up from their home on the south coast. I had corresponded with Farley over the past year or two, trying to answer his questions about Dorset Eskimos and their possible contacts with the first Vikings; now he wanted to get some hands-on feeling for a Dorset site. I offered to set up a tent for them in the side yard, but they wisely opted for a room at Millicent Billard's, because the weather was too uncertain. Farley came back to our house later with a bottle of rum, and being a great raconteur and extremely sociable, he quickly endeared himself to my crew, and later to our local friends. The next day at the site he and Claire knelt dutifully in the squares I had assigned to them and diligently trowelled away in the muddy black culture layer, both of them eager to participate in and absorb this field experience.

Local children on their way to church for the wedding of Brenda Billard and Gabriel Gould

On Saturday morning the crew moved out to Phillip's Garden, but I had to stay in town to attend yet another wedding, again as a family friend and society photographer. This time it was Walter and Dete Billard's daughter Brenda, who was being married to Gabriel, the younger Gould brother, and as the day progressed the affair became an increasingly monumental "time." The church ceremony was a high nuptial mass, and the dinner was spread in two sittings at Walter's and Pius's houses. I was delighted to be included with the inner family at the first sitting and to be placed between the bridegroom's mother and Uncle Joe Breton – another of the old French patriarchs on the Point Riche Peninsula, who at that time was our next-door neighbour. During the wedding events I repeated my amateur photographic performance in much the same manner as before and again with results that were not totally satisfactory.

Joe Breton and Bert Farwell, two old-timers

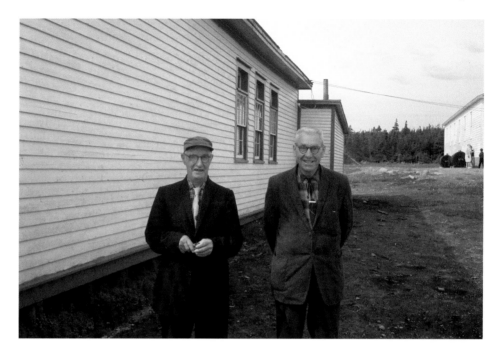

In the late evening hours, the house began to bulge at the seams as the crowd grew, libations flowed, and decibels ranged off the scale. At some point I got into conversation with Felix Ryan of Port Saunders, Fintan Gould's father-in-law, and as kindred spirits with war stories to tell we moved out to his home, where there was some peace and quiet. Before returning to the main party later on, I went back to our place and fetched my tape recorder, hoping that I might catch some of the goings-on – the stories, poems, and songs that were being performed noisily by almost anyone at this late, relaxed hour. Against the odds of uncontrollable noise, I managed to get several songs rendered by old Ike Jenneaux, Bert Farwell, Rufus Guinchard, and Onnie White (Dete Billard's youngest sister). Some bits and pieces of these performances have since been transcribed, but by and large the tapes proved to be sadly deficient; the tumultuous ambient noise almost totally drowned out

the voices that I wanted to capture. The next morning the village was predictably moribund, but normalcy slowly returned as a scattering of the most faithful emerged from various houses to begin their Sunday observances. Later on, the Mowats dropped in to say goodbye and then departed for Fleur de Lys, where Farley wanted to inspect the nearby soapstone quarry attributed to the Dorset Eskimos.

Several days later we too packed up and headed north to the end of the road in St Anthony, with a brief stop for lunch in Harold Whalen's restaurant in Flowers Cove. The trip was historic, at least for us, because this was the first summer that one could drive the entire length of Newfoundland's west coast, from Port aux Basques to St Anthony, a road distance of 441 miles. In St Anthony the inn was full and there were only three beds scattered around the village, so the manager suggested that I try the air force base south of town. "What base?" I asked. I had not seen any signs of a military establishment anywhere around St Anthony harbour. But he directed me to a nondescript road that led south out of town and up into the hills toward Hare Bay. We followed this for a mile or so back into the interior until St Anthony was totally out of sight, and suddenly we were halted by a steel perimeter fence and an armed sentry. Not knowing what else to do, I searched out my U.S. Navy ID and the guard saluted us through to the main station. Inside we were directed to Captain Keenan, the billeting officer, who was immediately welcoming and was pleased to fix us up in the visiting officers' quarters, with all due privileges at mess and in the clubs. This station on the mid-Canada surveillance line was manned by the 921st Air Control and Warning Squadron (ACWRon) of the USAF Air Defense Command (Lt. Col. Rockwell, commanding officer), and we were welcomed and made to feel most comfortable there for the next two nights. I enjoyed being immersed again in military surroundings without the concomitant responsibilities; besides, there was the luxury of hot showers and getting an expert haircut.

The International Grenfell Association hospital in St Anthony. The right half of the main structure is the old building that I first saw in 1949.

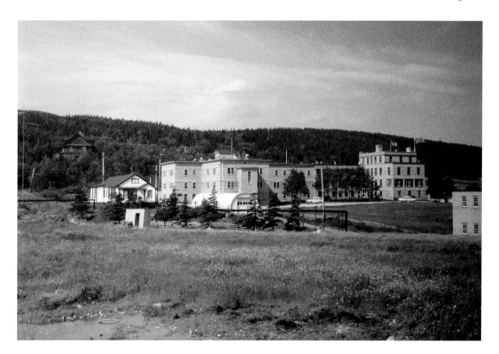

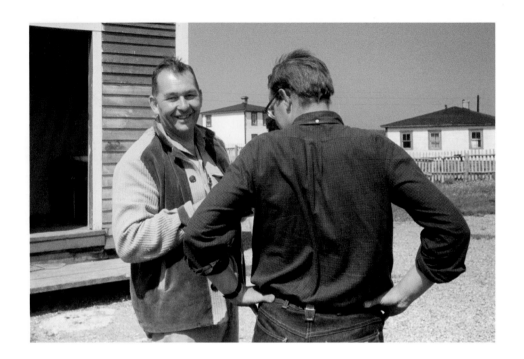

Horace MacNeil, assistant superintendent of the International Grenfell Association at St Anthony, talking to my student Ray Newell (with back to camera)

The next morning we went down to check on Horace MacNeil and found him at home recovering from a bout of pneumonia; however, he had already arranged for the mission boat, the MV *Albert Gould*, to be held in readiness for our trip to the Viking site. While in the village I tried to see Dr Gordon Thomas, who had succeeded Dr Curtis as superintendent of the International Grenfell Association, but unfortunately he was away travelling. So we loaded our gear aboard the *Gould* and had a three-hour trip north to St Lunaire, then swung west through Quirpon tickle. Off to starboard the rusted hulk of a large cargo ship lay careened under the cliffs of Great Sacred Island, and inshore of us to port was L'Anse aux Meadows. The *Gould* hove to there and we were ferried ashore by a Mr Anderson of the local village; beyond the landing, a five-minute hike took us over to Epaves Bay and the Ingstad excavations.

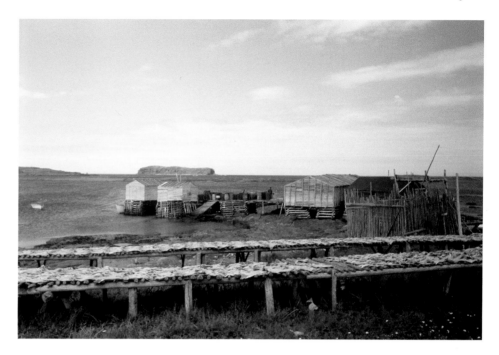

Fish rooms and flakes near L'Anse aux Meadows.

We spent the next four interesting days there, camped along the grassy terrace above the beach. Ingstad was there alone with his field assistants: Hans Hvide-Bang the photographer, and Charles Bareis and John Winston, who were both graduate students at the University of Illinois. Anne Stine and her daughter Benedicte had finished their summer in the field and were already on their way south. Benedicte stopped off for a week to visit Elaine at our house in New Hampshire, and Anne Stine visited us there later in September.

Helge had hired a fascinating local man, George Decker, as caretaker and guardian of the site, and I much enjoyed this great humourous man, aged about seventy, who was a treasure trove of local legend. We sat in his kitchen one wet, nasty day, having a bite of lunch and a few sips of cognac, as he told us how his family had lived in L'Anse aux Meadows

George Decker, the Ingstads'
caretaker at the Viking site, L'Anse
aux Meadows

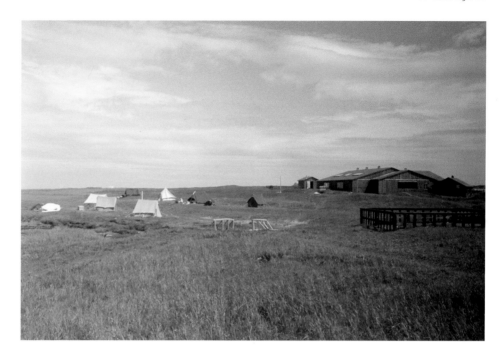

General view of the Ingstad and Harp encampments at L'Anse aux Meadows. The large building in the background was constructed over the foundation of one of three eleventh-century Viking multiroomed halls.

for about 150 years, and some of his forefathers had traded peacefully with remnants of the decimated local Beothuk Indians. On Sundays he appeared at the site wearing an Oxford grey double-breasted suit with brass buttons, a peaked military cap, and a mock-ferocious expression, for which we called him "Big Chief," much to his delight. Although he had had only nine months of formal schooling as a boy, he was highly intelligent and had educated himself by extensive reading.

Meanwhile, under Helge's tutelage, we had a detailed conducted tour of all the excavations, including the main longhouse, which at the time was protected by a sheltering building that the government had erected; also, we examined the iron forge, the remains of other outbuildings of undetermined function, and a large midden area. We wanted to contribute some physical help to Ingstad's crew, so we spent an afternoon

The remains of a Viking smithy, in 1963 protected by a new building

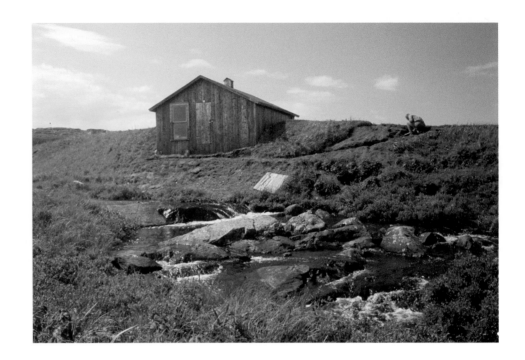

under their direction digging in a trench outside the main dwelling; the results were disappointingly meagre. My crew had been spoiled by the profuse wealth of Dorset Eskimo remains in Phillip's Garden — all the castoffs of material culture discarded by numerous seal hunters over several centuries — whereas here in the Viking site the paucity of remains indicated that the occupation had been comparatively short, perhaps only a season or two. However, the settlement had clearly extended through a winter, and Ingstad explained to us the most significant features of the original longhouse, particularly the heavily insulated sod walls, the long central hearth, the ember pits for sustaining fire over a long period of time, and the lateral sleeping platforms. I appreciated the fact that Anne Stine had followed meticulous excavation procedures, and I dare say no scrap of evidence, however small, had escaped the attention of her field crew.[†]

[†] *Details of the Ingstad excavations are published in Anne Stine Ingstad,* The Discovery of a Norse Settlement in America *and* The Norse Discovery of America.

250

Our return to Port au Choix was far more complicated than coming to L'Anse aux Meadows had been. First, Mr Anderson brought his open boat around the point in Epaves Bay and anchored offshore in front of the site, while we ferried all our load out from the beach in a small outboard runabout. Then we cruised across Sacred Bay, around Cape Onion, and into Ha Ha Bay to the government wharf at Raleigh, which took about an hour and a half. There I hired a truck to take us to the south shore of the isthmus, after first stopping in the post office to phone St Anthony to order a taxi to meet us late in the afternoon down in the bottom of Pistolet Bay, at a place where the new highway came close to the beach. From the south shore of the isthmus, we had a warm and pleasant sail across the bay, even though we were sprawled over the top of a cargo of firewood that Harvey Taylor was transporting into the Main Arm. The taxi was waiting at the dockside, and the driver took Nick Listorti and John Cook twelve miles into St Anthony to fetch our two cars. So we moved back into town for one more night at the ACWRon VOQ, which gave me a chance to pay proper farewell visits to Horace and Hazel MacNeil and to the base commander. These friends, both old and new, had contributed invaluable logistical support to the summer's operations, and I wanted to express my deep appreciation for their generous assistance.

And then we went "home" to Port au Choix, a six-hour drive, and it was a pleasure to be there again in our favourite Eskimo site, Phillip's Garden, happily occupied in our own productive excavations. But the season was drawing inexorably to a close and the calendar became an urgent concern. Then, as frequently happens in any time-bound venture, one of our most important discoveries occurred in the last few days before our scheduled departure. I happened to be working in the interior of House 12 when I trowelled into the burial pit of an Eskimo child. This find was unique in the history of Dorset Eskimo investigation, being the first and only known purposeful Dorset burial. It consisted of the skeleton of a 21-month-old infant crunched into a fetal position in a shallow pit, accompanied by a fragment of adult mandible

and a very good collection of Dorset artifacts as grave furnishing, all covered by a limestone slab. But the weather was dark and raining, and it took me the better part of two days, between showers, to expose the burial completely and prepare it for removal.

Then three new guests arrived: Grant Head, Prince Dyke, and Adolph Grant, geographers doing a survey for Memorial University. They camped in our side yard that night and in the morning joined us for breakfast. Later the same day along came Dr Henry B. Collins of the Smithsonian Institution, the premier arctic archaeologist of our time, who had just made an inspection tour of the Viking site at L'Anse aux Meadows. Henry had also planned to visit my operation in Phillip's Garden, and he had been driven here from St Anthony by one of Horace's staff. His one-day stay was too brief for all of us, but at least he came at a propitious time, because he was here for the removal of the infant burial the very next day.

Moreover, the night of his arrival I was delighted to have his company at the celebration of another wedding. This time it was the marriage of Onnie (Eleanor) White, Dete Billard's sister, to Pat Dobbin in Port Saunders, and when we arrived the party was running at full steam. It was the highlight of Henry's visit, and he, a gentleman of the Old South, had the time of his life in the midst of this jovial crowd of Newfoundlanders. I fondly remember standing in the ritual lineup, inching our way upstairs to the candle-lit bridal chamber to greet the new couple, and there was the bride, smiling happily and beautifully dressed, sitting on the nuptial bed amidst piles of gifts, while her husband stood by to receive our good wishes as the line turned back downstairs. This wonderful event capped our social season that summer.

In the morning, cold and rainy, I took out the burial, and we transported it carefully back to our house, where it could be spread out for drying and further inspection. Henry and I left at 10 o'clock that night so that I could drive him to Portland Creek, where he hoped to connect with a bus and continue south the next morning to Stephenville. At Wentzel's Sea Pool Cabins there was no news about any bus schedule,

but just then two cars stopped at the motel with people whom we had met at the wedding "time" the previous night. They were headed for Corner Brook and were happy to take Henry along, so he made his plane connection after all. I arrived back in Port au Choix in the wee small hours.

The last few days in Phillip's Garden were constantly busy. John Cook concentrated on his analysis of the food bones found in House 4, having so far collected a huge pile of some 25,000 specimens that derived mostly from harp seals; I worked with the alidade and plane table, levelling-in a number of corner stakes to finish the topographic survey, with Dallas Rumbolt carrying the rod; and the rest of the crew completed their trowelling in House 12 where the burial had been found. Finally we backfilled all deep post holes and storage pits where people or animals might possibly fall in and hurt themselves, but we left the shallow house floors exposed. I am not a believer in totally back-filling an archaeological excavation and obliterating all signs of it in order to restore a pristine environment. Some young modernists aspire to this degree of restoration, but it can be very confusing to future scientists who may want to work in the same site. Nature will refill and rebuild the place in time, and I prefer to wait patiently for the process to fulfill itself.

By the weekend I had written final reviews of all the house excavations, taken photographs, and cleared the equipment tent, which I then gave to Bud Billard. On Saturday morning we literally pulled up stakes and built a tall ceremonial bonfire down on the beach. That seemed to be a suitable and honorific way to conclude a long and very successful dig, and as we all stood around it on the beach I noticed that the boys fell silent when the structure burned through and collapsed in a tower of sparks and smoke. I suspect they felt a touch of nostalgia, as did I, at the ending of this marvellous summer.

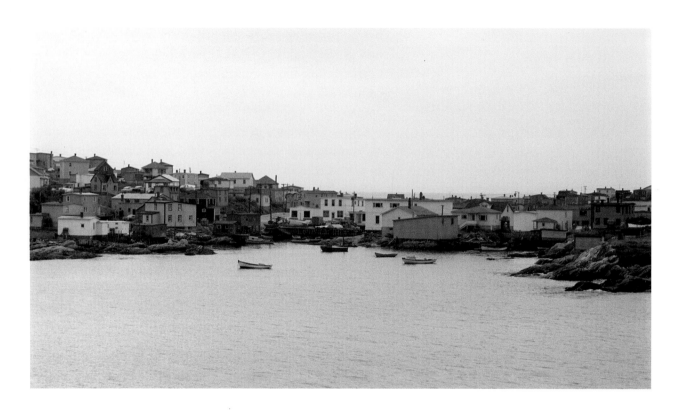

Port aux Basques harbour

Millicent Billard (Mrs Romeo), Elmer Harp, and Theodore Farwell having luncheon in Millicent's house in Port au Choix, 1997

Bibliography

Ben-Dor, S. *Makkovik: Eskimos and Settlers in a Labrador Community: A Contrastive Study in Adaptation*. Newfoundland Social and Economic Studies no 4, Institute of Social and Economic Research. St John's: Memorial University of Newfoundland, 1966

Bird, Junius B. "Archaeology of the Hopedale Area, Labrador." *Anthropological Papers of the American Museum of Natural History* 39, no.2 (1945): 117–88

Brox, O. *Newfoundland Fishermen in the Age of Industry*. Newfoundland Social and Economic Studies no 9, Institute of Social and Economic Research. St John's: Memorial University of Newfoundland, 1972

Chiaramonte, L.J. *Craftsman-Client Contracts: Interpersonal Relations in a Newfoundland Fishing Community*. Newfoundland Social and Economic Studies no 10, Institute of Social and Economic Research. St John's: Memorial University of Newfoundland, 1970

Dominion Bureau of Statistics. *Eleventh Census of Newfoundland and Labrador 1945: 1 (Population)*. St John's: Government of Newfoundland, 1945

Faris, J.C. *Cat Harbour: A Newfoundland Fishing Settlement*. Newfoundland Social and Economic Studies no 3, Institute of Social and Economic Research. St John's: Memorial University of Newfoundland, 1972

Felt, L., and P. Sinclair, eds. *Living on the Edge: The Great Northern Peninsula of Newfoundland*. Social and Economic Papers no 21, Institute of Social and Economic Research. St John's: Memorial University of Newfoundland, 1995

Firestone, M.M. *Brothers and Rivals: Patrilocality in Savage Cove*. Newfoundland Social and Economic Studies no 5, Institute of Social and Economic Research. St John's: Memorial University of Newfoundland, 1967

Government of Newfoundland and Labrador. *Historical Statistics of Newfoundland and Labrador* 1, no.1 and 2 (1970), no.7 (1994)

Harp, Elmer, Jr. *Evidence of Boreal Archaic Culture in Southern Labrador and Newfoundland.* Anthropological Series 61, Bulletin 193. Ottawa: National Museum of Canada, 1963

– *The Cultural Affinities of the Newfoundland Dorset Eskimo.* Anthropological Series 67, Bulletin 200. Ottawa: National Museum of Canada, 1964

Harp, Elmer, Jr, and David R. Hughes. "Five Prehistoric Burials from Port au Choix, Newfoundland." *Polar Notes: Occasional Publication of the Stefansson Collection* 8 (1968): 1–47

Howley, J.P. *The Beothucks or Red Indians: The Aboriginal Inhabitants of Newfoundland.* Cambridge: Cambridge University Press, 1915

Ingstad, Anne Stine. *The Discovery of a Norse Settlement in America: Excavations at L'Anse aux Meadows, Newfoundland, 1961–1968.* Oslo: Norwegian University Press, 1977

– *The Norse Discovery of America.* Oslo: Norwegian University Press, 1985

Iverson, N., and D.R. Matthews. *Communities in Decline: An Examination of Household Resettlement in Newfoundland.* Newfoundland Social and Economic Studies no 6, Institute of Social and Economic Research. St John's: Memorial University of Newfoundland, 1968

Jenness, Diamond. "A New Eskimo Culture in Hudson Bay." *Geographical Review* 15, no.3 (1925): 428–37

Kennedy, John C. *Holding the Line: Ethnic Boundaries in a Northern Labrador Community.* Social and Economic Studies no 27, Institute of Social and Economic Research. St John's: Memorial University of Newfoundland, 1982

Labrador and Hudson Bay Pilot. Ottawa: Canadian Hydrographic Service, Surveys and Mapping Branch, Department of Mines and Technical Surveys, 1965

Lloyd, T.G.B. "Notes on Indian Remains Found on the Coast of Labrador." *Journal of the Royal Anthropological Institute of Great Britain and Ireland* 4 (1875): 39–43

– "On the Stone Implements of Newfoundland." *Journal of the Royal Anthropological Institute of Great Britain and Ireland* 5 (1876): 233–49

Nemec, Thomas F. "Political Brokerage along the Southeastern Avalon Peninsula." In *From Red Ochre to Black Gold*, ed. D. McGrath, 122–32. St John's: Flanker Press, 2001

Omohundro, John T. *Rough Food: The Seasons of Subsistence in Northern Newfoundland*. Social and Economic Studies no 54, Institute of Social and Economic Research. St John's: Memorial University of Newfoundland, 1994

Philbrook, T. *Fisherman, Logger, Merchant, Miner: Social Change and Industrialism in Three Newfoundland Communities*. Newfoundland Social and Economic Studies no 1, Institute of Social and Economic Research. St John's: Memorial University of Newfoundland, 1966

Pocius, G.L. *A Place to Belong*. Montreal: McGill-Queen's University Press, 1991

Sider, G.M. *Culture and Class in Anthropology and History: A Newfoundland Illustration*. Cambridge: Cambridge University Press, 1986

Sinclair, P. *From Traps to Draggers: Domestic Commodity Production in Northwest Newfoundland, 1850–1982*. Social and Economic Studies no 31, Institute of Social and Economic Research. St John's: Memorial University of Newfoundland, 1985

Skolnik, M., ed. *Viewpoints on Communities in Crisis*. Newfoundland Social and Economic Papers no 1. Institute of Social and Economic Research. St John's: Memorial University of Newfoundland, 1968

Smith, P.E.L. "Transhumant Europeans Overseas: The Newfoundland Case." *Current Anthropology* 28, no.2 (1987): 241–50

Story, G. *People of the Landwash: Essays on Newfoundland and Labrador,* ed. M. Baker, H. Peters and S. Ryan. St John's: Harry Cuff, 1997

Strong, W.D. "Stone Culture from Northern Labrador and Its Relation to the Eskimo-like Cultures of the Northeast." *American Anthropologist* 32 (1930): 126–44

Szwed, J. *Private Cultures and Public Imagery*. Newfoundland Social and Economic Studies no 2, Institute of Social and Economic Research. St John's: Memorial University of Newfoundland, 1966

Tuck, James A., and Robert Grenier. *Red Bay, Labrador: World Whaling Capital A.D. 1550-1600*. St John's: Atlantic Archaeology Ltd, 1989

Wadel, C. *Marginal Adaptations and Modernization in Newfoundland: A Study of Strategies and Implications in the Resettlement and Redevelopment of Outport Fishing.* Newfoundland Social and Economic Studies no 7, Institute of Social and Economic Research. St John's: Memorial University of Newfoundland, 1969

— *Now, Whose Fault Is That? The Struggle for Self-Esteem in the Face of Chronic Unemployment.* Newfoundland Social and Economic Studies no 11, Institute of Social and Economic Research. St John's: Memorial University of Newfoundland, 1973

Wintemberg, W.J. "Eskimo Sites of the Dorset Culture in Newfoundland." *American Antiquity* 2 (1939): 83–102

— "Eskimo Sites of the Dorset Culture in Newfoundland, Part II." *American Antiquity* 4 (1940): 309–33

Index

Page numbers in italics refer to illustrations